Humor
in
Borges

Humor in Borges

RENÉ DE COSTA

Wayne State University Press
Detroit

HUMOR IN LIFE AND LETTERS SERIES

A complete listing of the books in this series can be found at the back of this volume.

Copyright © 2000 by Wayne State University Press,
Detroit, Michigan 48201. All rights are reserved.
No part of this book may be reproduced without formal permission.
Manufactured in the United States of America.
04 03 02 01 00 5 4 3 2 1

Library of Congress Cataloging-in-Publication Data
Costa, René de.
 Humor in Borges / René de Costa.
 p. cm.—(Humor in life and letters series)
 Includes bibliographical references and index.
 ISBN 0-8143-2888-1 (alk. paper)
 1. Borges, Jorge Luis, 1899—Humor. I. Title. II. Humor in life and letters.
PQ7797.B635 Z6637 2000
868—dc21
 99-047070

CONTENTS

For my Alev

PREFACE

People who never laugh cannot be taken seriously.
Seneca

This book has a very simple thesis: that Jorge Luis Borges was often funny. As with Franz Kafka, there is a flip side to his most serious writing. And while their fictions have spawned now popular terms like "Borgesian" and "Kafkaesque" to describe almost any baffling mix of the normal and the strange, both authors also laced their writings with humor.

Not surprisingly, Borges found Kafka funny. Back in 1937, reviewing Willa and Edwin Muir's translation of *The Trial,* he wearily remarked how everyone routinely likens Kafka's tales to nightmares. Somewhat tongue-in-cheek, he agreed, noting that they are indeed nightmarish, right down to the strangest details, and went on to comment on the low-ceilinged courtroom, which obliges the public in *The Trial* to straggle in like hunchbacks. He polished off the observation with a telling quote from the novel, that "some people had even brought cushions along, which they put between their heads and the ceiling, to keep their heads from getting bruised" (*El Hogar,* August 6, 1937).* These words from *The Trial,* in Borges's laconic reframing, are made to sound like the punch line in a stand-up comedy routine, and the catalyst for this sort of deadpan humor is the sudden incongruity of a slew of seat cushions positioned like helmets on the heads of people in a courtroom!

Borges recycled this Kafka joke in 1942, making it his own in one of his now classic stories, "La biblioteca de Babel" [The Library of Babel], where he gives us an infinitely tall tower in which the height of the ceilings on every floor are "scarcely" that of an "average librarian" and whose restrooms are so narrow that one must perforce do everything "standing up."

The story, under the guise of a farewell memoir in the tired voice of a wizened professional librarian, begins with this straightforward, seemingly

* Subsequently, many others have registered Kafka's comic facet, following in part the lead established by a former intimate, Felix Weltsch, in "Religiöser Humor bei Franz Kafka," an essay included in Max Brod's *Franz Kafkas Glauben und Lehre* (Winterthur: Mondial, 1948).

architectural description of his workplace, which is his world, or, as he hyperbolically says, his *"universe"* (italics in original; henceforth, except where noted, all italics are mine):

> The *universe* (which others call the Library) is composed of an indefinite, perhaps an infinite, number of hexagonal galleries, with enormous ventilation shafts in the middle, encircled by *very low railings.* From any hexagon the upper or lower stories are visible, interminably. The distribution of the galleries is invariable. Twenty shelves—five long shelves per side—cover all sides except one; *their height,* which is that of each floor, *scarcely exceeds that of an average librarian.* The free side gives upon a narrow entrance way, which leads to another gallery, identical to the first and to all the others. To the left and to the right of the entrance way are two miniature rooms. One allows *standing room for sleeping;* the other, the satisfaction of *fecal* necessities.

Standing room for sleeping! And in an identical cubicle, one can take care of the urgent "satisfaction of *fecal* necessities" [necesidades fecales]. Standing up, of course, and provided one is not above "average" in height. What Borges elides, and what the reader adds, is what triggers the humor. The zany nature of this workplace becomes even more evident when we realize that on exiting these minute cubicles, one runs the risk of falling into the void, since the enormous ventilation shafts at the center of the galleries are encircled by "very low railings."

This is merely one kind of humor, one level of a coarse joke imbedded in an otherwise serious piece of writing. But it is there, and it is Kafkaesque. And too, as with Kafka, not everyone "sees" this as humor. Some see nothing at all; others simply see what they take to be a mistake. In fact, there is a bastard line of reprintings of this story, fathered by some anonymous typesetter who, blind to the ironies of the cramped cubicles, or perhaps blinded by them, changed the deliberately crude "fecal" into something more polite: "final."*

* The lack of a trustworthy edition of Borges's complete works is part of a much larger problem affecting all modern literature and is exacerbated by the Hispanic world's multiple publishing centers and a long tradition of sloppily produced and often pirated editions for local markets where say, a Mexican, a Spanish, or a Peruvian typesetter will as a matter of course think he is doing the reader a favor by translating a "foreign" expression into the local parlance. The problem is particularly acute in the case of Borges, since he himself during his lifetime tinkered with his texts, modifying both titles and contents as he moved them from one collection to another, suppressing some items, polishing and adding others. In his mature years, the growing demand for his work and the gradual loss of his eyesight made it virtually impossible for him to exercise control over new editions and left him helpless with regard to the editorial practices prevalent throughout the Spanish-speaking world that perpetuated this tradition of tinkering.

These little jokes embedded in the otherwise serious-sounding text of "The Library of Babel" are not there by chance but by design, and Borges's writings are not just occasionally funny, seasoned with a sprinkling of comic relief here and there. Rather, in all of his work, throughout his entire career, there is a flip side where we find him exploiting the possibilities of humor, from the most elevated of witticisms to the lowliest of scatological jokes, conducting his readers from the sublime to the ridiculous, often within the space of a single sentence, and sometimes through the most elaborate of literary constructs. Yet the scholarly and critical commentaries on Borges's work rarely (if ever) deal directly with his humor, preferring instead to pass over it so as to get on to other supposedly more serious things: his philosophical themes; his social, political, and cultural stances; his narrative strategies; his cosmopolitanism; his mirrors; his labyrinths; his concept of literature, culture, God, the universe . . . and, now that he is dead, his love life, or lack of it.*

Not so much ignored as willfully overlooked, the humor I've alluded to has generally gone uncommented. It's as though it were somehow unseemly to take notice of a serious fellow like Borges doing something as low as cracking a joke, and even more so actually to laugh at it, since laughter implies complicity. It is this complicity however, that Borges relies on to win the reader over, to involve us in his tricks.

A personal anecdote is perhaps not inappropriate here. Some years ago, on one of Borges's many trips to Chicago, there was a small cocktail party in a typical railroad flat with a long central corridor leading to the various rooms. As the magic hour of departure approached, the guests suddenly began to take their leave, after first making a quick trip to the bathroom. When I asked Borges if he'd like to do the same, he quickly stood up, and as we were navigating our way through the corridor, he continued our conversation

* For this reason, rather than trying to choose the least poor of the many available recent editions, I have preferred to cite from the more reliable first editions, which were at least once supervised by the author. Much the same problem affects the various translations into English (made from whatever popular edition the translator happened to have at hand), with the notable exception of those of Norman Thomas de Giovanni, diligently prepared in collaboration with Borges and often enriched by perceptive comments in the endnotes. More recently (1998), Viking Penguin, consolidating the rights to Borges in English, has brought out a new translation by Andrew Hurley so as to give a "single voice" to their *Collected Fictions*. Here "fecal" > "final" becomes "physical."

* Two recent biographies, by former friends of Borges, give male and female perspectives on this: Marcos-Ricardo Barnatán, *Biografía total* (Madrid: Temas de Hoy, 1995), and María Esther Vázquez, *Borges, esplendor y derrota* (Barcelona: Tusquet, 1996). María Kodama, Borges's widow, reports knowing of more than a dozen additional biographies in the works, including one by herself. The latest to appear in English is by James Woodall, *Borges: A Life* (New York: Basic Books, 1996), which has a central chapter on "Love and Marriage."

concerning the importance of rhyme in poetry. As we crossed the threshold to the bathroom, he instinctively began to open his fly, suddenly reciting this little rhymed ditty:

> La mierda no es pint*ura*
> el dedo no es pinc*el*
> no sea hijo de p*uta*
> límpiese con pap*el*

[Shit is not paint / the finger's not a brush / be a saint / and wipe your tush].

As he zipped himself up, he went on to comment that without rhyme these lines would be simply dirty, that it is rhyme that creates the tension between the high and the low, which triggers humor. And Borges obviously wished to be humorous, to generate an appropriate frame for the incongruity of the two of us in the bathroom.

Without wishing to seem unseemly, my purpose in this book is to add another dimension to our appreciation of Borges so that a new generation of readers can appreciate his humor. To do this as efficiently as possible—without the negative effect of trying to explain a joke—I have thought it expedient to cite the passages of his work I find most humorous, drawing attention to the presence and function of the textual or verbal ambiguities they contain that might otherwise pass unnoticed. Sharing the pleasure and amusement that reading and rereading him have taught me about the many ways he may be read is what this book is all about, what makes Borges not only fun but funny.

RdC
Chicago-Valencia

ACKNOWLEDGMENTS

Borges's writings have challenged some of the best minds of our time, and I have learned much from their reflections on the subtleties of his work. I have learned even more about his wiliness while discussing these writings with the sharp young minds of my students at the University of Chicago. This little book is the outgrowth of years of research and teaching, discussion and debate, laughter and frustration with my students, colleagues, and friends, many of whom were not always happy with its thrust.

There is something peculiar about humor that makes one feel upset about not having gotten a joke the first time around, something that makes one feel "inferior" or perhaps even humiliated to be found in need of an explanation. For this reason, I feel a special debt of gratitude to my kind and stalwart early readers, my good friends George Haley, Humberto Robles, Ralph Johnson, Richard Stern, Norman Thomas di Giovanni, John Coleman, Saúl Yurkievich, Klaus Müller-Bergh, Vicente Múñoz, Dianna Niebylski, and Rosalba Campra, with whom I have enjoyed many a laugh over Borges's comic side and my own struggle in writing about it without rendering it (I hope) entirely humorless.

To those who have written about Borges without laughing, I am also indebted, for without them there would have been no stimulus to do this book.

NOTE ON TRANSLATIONS

Full references are contained in the bibliography. Throughout the text, when discussing a work that has been translated into English, I give both the Spanish- and the English-language title; the date, however, will correspond to its original publication in Spanish. Conversely, works that have yet to be translated into English—or whose titles have been radically altered—will be cited with their original titles, followed by a literal translation into English. Since translations are always approximations, and since this study is based on a reading of the original texts in Spanish, I have sometimes found it necessary to retranslate certain passages.

Chapter 1

Making the Serious Funny

I don't know what humor is. Anything that's funny—
tragedy or anything, it don't make no difference.
 Buster Keaton

Since Borges's humor is important precisely because it is embedded in deliberately weighty subjects, my procedure will be to contextualize the comic in the serious. To do this correctly, it will be necessary to read what he actually wrote, which often entails practicing a kind of literary archeology, going back to the sources, in most cases the first edition of a text either in its original periodical publication or in its early collected form. In other cases it may be fruitful to trace the evolution of a piece, noting the successive modifications introduced by Borges to "perfect" it, usually to make its humor more apparent. Looking closely at his revisions and variants will make it evident that Borges worked at being funny, ironizing what others take seriously, finding a humorous thread in the grandest themes of philosophy and literature.

The textual history of the previously mentioned "Library of Babel" is a case in point. Its earliest version is an essay titled "La biblioteca total" [The Total Library], first published in the August 1939 issue of *Sur,* a deadly serious Buenos Aires cultural review (1931–70) founded and funded by Victoria Ocampo—the veritable Virginia Woolf of Argentine literature— and to which Borges was a regular contributor from first to last. Yet, "The Total Library" reads like a précis for Tom Wolfe's outhouse takeoff on the Bauhaus (*From Bauhaus to Our House* [1981]), deriving in this case from

15

Walter Gropius's pie-in-the-sky "Total Theater" project, whose presentation text Borges happens to have translated into Spanish for the inaugural issue of *Sur,* way back in the Argentine summer of 1931. There, thanks to his "ingenious design," Gropius boasts, "my *Totaltheater* (patented in Germany) will permit the directors of the future to stage a performance with scenes taking place simultaneously on its elevated stage, in its proscenium, and in the semicircular space surrounding the spectators." Supposedly, the elevated stage of this "Totaltheater," which was commissioned by Erwin Piscator, would be capable of rotating a full 180 degrees, while an equally ingenious phalanx of multiple projectors (also "patented," as Gropius redundantly adds, and Borges maliciously repeats), mounted around the perimeter of the seating area would permit films to be shown on the walls and dome of the theater so as to involve the spectator completely in the totality of the theatrical action.[1]

The zaniness of the "Totaltheater" idea must have impressed Borges deeply, for some fifty years later, in a 1985 conversation with Cristina Grau (*Borges y la arquitectura* [1989]), he returned to it in the context of a joke:

> Everyone back then was talking about that Totaltheater of Gropius, an ingenious architectural dome with a circular stage set amidst the spectators, and how it was going to "revolutionize" the art of representation. Perhaps, to the list of monsters generated by the principle of combination, the Chimera, the Minotaur, the Trinity, the Hypercube . . . , one more should be added, the "revolution-ary" theater that would enrich this vain teratology with a new monster, the actor with two faces, four hands, four feet.

Back in the 1930s, Borges's irreverence was more subdued, using the "Totaltheater" as the seed for his 1939 article on "The Total Library," an essay that in turn generated "The Library of Babel," a narrative first published in *El jardín de senderos que se bifurcan* [The Garden of Forking Paths (1942)]. Both pieces are laced with quiet humor. At first, his "total library" was envisioned as a vertical Tower of Babel, consisting of a single hexagon, infinitely tall. So it remained when it was incorporated into *Ficciones* [Fictions (1944)]. It was not until 1956, when a growing readership warranted a second edition of this work, that Borges had the opportunity of modifying his original description of the library, making it grow from that point on not only vertically but laterally, as an infinite series of interconnected hexagons, parodying in this way yet another utopian architectural project from the 1930s, Le Corbusier's labyrinthian *Musée à Croissance Illimitée* (1936), a mazelike continuous-rectangle corridor theoretically capable of radiating ever outward to accommodate a museum's ever-growing collection, which, like Borges's Library of Babel, could ultimately cover the entire globe.

Significantly, the reference to "fecal" necessities was retained in the revised 1956 version, as was the passage a few paragraphs later referring to the librarians' resourceful use of the infinite spiral stairwell at the center of each hexagon as a toilet ("letrina para el bibliotecario sentado"), for those traditionalists who preferred to defecate in a more comfortable seated position. Had Borges not meant to be funny in the first place, he could easily have taken these coarse references out in the subsequent editions of 1942, 1944, and 1956. Not only did he continue to leave them in, he progressively enhanced them, making their humor even grosser, and hence more apparent—a pattern, as we shall see, that marks many of his revisions.

For obvious reasons, I have not thought it useful to trace back to their anonymous sources such things as the prudish typesetter's changing *fecal* for *final*, thus inadvertently transforming the scatological into something eschatological. That is another kind of humor, not unlike what Borges himself invoked in another story in *Fictions*, "La lotería en Babilonia" [The Lottery in Babylon], a sinister place where "no book is published without some divergence among each of its copies; the scribes are secretly sworn to omit, to interpolate, to introduce variants." Here, suffice it to say that the bastard variant of fecal, "final," is the word now canonized by the "scribes" of both the Spanish and Argentine publishers of Borges's complete works. And in France, Gallimard has allowed a new scribe of our time (Professor Jean-Pierre Bernès, of the Sorbonne), to tone down the once accurate translation of its own still circulating "Folio" paperback edition of *Fictions*, substituting what is there "besoins fécaux" [fecal necessities] for the more polite household euphemism, "gros besoins" [the Big One, or Number Two], in its leather-bound Pléiade "critical edition," thus cleaning up Borges's fun as he takes his place in posterity nestled between Balzac and Corneille. Not surprisingly, Borges equips his "Lottery in Babylon" with a special retreat for these bumbling scribes, "una letrina sagrada llamada Qaphqa" [a sacred latrine called Kafka].

It's one thing to make a joke and quite another to explain what makes it funny. Some readers get Borges's jokes and some don't. Those who do would probably subscribe to Thomas Hobbes's "sudden glory" theory of humor: "Laughter is nothing else but sudden glory arising from a sudden conception of some eminency in ourselves by comparison with the infirmity of others" (*Leviathan* [1651]). Conversely, those who don't get the jokes will probably feel "infirm" or perhaps even ashamed to need an explanation. Whether the emotion be glory or shame, however, it is sudden and fleeting, and no matter how little or long it takes us to get a joke, if it's a good one, we usually can't wait to share it or explain it to someone else. Hence, the motivation for this book.

Exactly what produces this "sudden glory," what makes humor work, although never a central concern of literary criticism, has nonetheless attracted

the attention of many thinkers since Aristotle. The twentieth century opens with the twin salvos of Sigmund Freud (*Jokes and Their Relation to the Unconscious* [1905]), who makes everything fit into what he calls "joke-work," and Henri Bergson (*Laughter* [1901]), who chalks it all up to the "mechanization" of modern man. Theory has come a long way since then, and in recent years the subject of what makes jokes funny has become something of a growth industry, which now even sports its own scholarly journals (*Humor* and *Humor Studies*), a full-fledged professional organization (the International Society for Humor Studies [ISHS]), and the Wayne State University Press series on Humor in Life and Letters, of which this volume is a part. Although no single guru of humor theory has yet emerged, imposing discipline on the ranks, its many practitioners have by now developed numerous insights— some of which have proved helpful to me in getting, or explaining, the joke mechanisms in Borges's work.

Borges himself was well acquainted with the multiple and sometimes contradictory theories that graze the pages of scholarly writing on the subject. His own preference, as stated in a review of Max Eastman's *Enjoyment of Laughter* (1936), seems to have been for Schopenhauer:

> This book is at times an analysis of the procedures of humorists, at times an anthology of jokes: good ones along with others. The author annihilates the very annihilable theories of Bergson and Freud, but does not mention that of Schopenhauer (*The World as Will and Representation,* chapter XIII of the first volume, VIII of the second) which is far sharper and more credible. Few remember it. I suspect that our era (influenced by the selfsame Schopenhauer) does not pardon his intellectuality. He reduces all laughable situations to the paradoxical and unexpected inclusion of an object into a category to which it is foreign and to our sudden perception of the incongruity between the conceptual and the real. (*El Hogar,* November 19, 1937)

The affinity is not surprising. Schopenhauer's explanation of humor as a perceived "incongruity" turns out to be similar to the structuring of poetic imagery in the avant-garde: the calculated "juxtaposition of opposites." This procedure, first formulated by Pierre Reverdy to explain what sparks metaphor in literary cubism, and later appropriated by André Breton for his pseudo-dictionary definition of surrealism in the 1924 *Manifesto,** is also at the core of Spanish and Argentine ultraism, artistic movements of the 1920s in which the young Borges was directly involved as a major player. Schopenhauer,

* "The value of the image depends upon the beauty of the spark obtained [l'étincelle obtenue]; it is, consequently, a function of the difference of potential between the two conductors."

a century before and writing about laughter in *The World as Will and Idea* (1819), says this: "Now the more correct the subsumption of such objects under a concept may be from one point of view, and the greater and more glaring their incongruity with it, from another point of view, the greater is the ludicrous effect which is produced by this contrast" (bk. 1, chap. 13). Reverdy's succinct formulation says much the same about cubist metaphor, stating that it does not arise from a "comparison" (Aristotle) but rather from the bringing together of two more or less "distant" realities: "the greater the distance between the two realities thus confronted, the stronger the image" (*Nord-Sud*, March 1918) or, as Breton would say, "the greater the spark."

Indeed, the very same explosive principle is at work in what Max Eastman later advanced as the "derailment" concept of humor, where things are not "distant" or "incongruous" per se, but only in the specific setup in which they are forced together, or driven apart. In his view, it is context that conditions laughter, and the art of the humorist, like that of the poet, consists in setting things up for an epiphany, sparking a slow "ah" into the lightning flash of an "aha," or an eruptive "ha-ha."

In 1982, the University of Chicago sponsored a symposium on "Borges's Beginnings," a gathering of some two dozen specialists before an audience of some two hundred supposedly less specialized readers, with the idea of focusing on his early years, his literary formation in the 1920s under the aegis of the avant-garde. Borges, who was present throughout the sessions, made no effort to mask his amusement at how everyone was taking him so seriously, and when the time finally came for him to take the podium, to deliver a talk with the announced title "On Being Borges," he managed to transform the solemnity of the moment into a seriocomic spectacle, first by repeatedly interrupting the speaker who was presenting him, Ricardo Gullón, with impromptu corrective remarks about the circumstantial details of their first meeting in Texas in 1961 (which brand of beer they drank and in which bar), and later, when it was his turn to speak, by adding humorous asides to the subject of his own talk, which was himself. He began politely enough: "Friends, dear friends, you've been inventing me all the time, and I'm grateful to you all." For over an hour Borges held the public spellbound, periodically breaking the solemnity of his discourse with ironic asides, and sequences of enraptured silence were punctuated with waves of laughter as he worked the audience, obviously enjoying his control over us and our response. He was having fun and, thanks to him, so were we. His writings are similarly marked by this performance technique, alternating the serious with the comic, and having fun along the way.

■

In 1921, when still just twenty-one, he returned to his native Argentina after some seven years in Europe—in Switzerland during the war, and in Spain after the armistice. These were years in which he learned Latin, French, and German, and came into contact with the avant-garde—dada in Switzerland and its Spanish variant, ultra, in Seville and Madrid. Back in Buenos Aires, he set in motion a local variant of ultraism, publishing a pensive essay on the new aesthetic in *Nosotros,* a staid and traditional literary journal of the establishment, and a dada-like manifesto in something of his own design called *Prisma,* a huge broadside styled as a "wall magazine," which he and other budding poets one night pasted up all over the city. Both publications contained a showcase of the new poetry in a coordinated campaign to bring the flashy new movement to the attention of the elite and the man in the street. True to form, Borges would later disparage this effort, reducing it to a nonevent, joking that "not even the walls read their poetry."

The incident and its retelling in countless interviews and in a 1970 autobiographical essay, "Up from Ultraism," for the *New Yorker* highlight an aspect of the dynamics of Borges's idea of having fun: a transformation of the serious into the comic through self-parody. The process is interesting. In 1925, in a prologue to Norah Lange's book of poems (*La calle de la tarde*), putting ultraism behind him, he relies on baroque language, hyperbole, and hypallage ("*ciegas* paredes" [*blind* walls]) mythically to exalt the recent past: "In this still glowing yesterday, which three drawn out years have not dimmed, Ultraism was dawning over the lands of America and its urge for renewal which was novel and mischievous in Seville, echoed with faith and passion in us. That was the epoch of *Prisma,* the mural page which gave a transitory vision to the empty niches and blind walls and whose white shape on the buildings was like an open window." By 1970, again by his own telling, the episode would be an out-and-out joke, with the mythic heroes of yesterday now reduced to little boys, and their adventure shrunk into a mock-heroic Halloween prank, "sallying forth" at night, "armed" with pastepots provided by Borges's mother:

> Our small ultraist group was eager to have a magazine of its own, but a real magazine was beyond our means. I had noticed billboard ads, and the thought came to me that we might similarly print a "mural magazine" and paste it up ourselves on the walls of buildings in different parts of town. Each issue was a large single sheet and contained a manifesto and some six or eight short, laconic poems, printed with plenty of white space around them, and a woodcut by my sister. We sallied forth at night—González Lanuza, Piñero, my cousin, and I—armed with pastepots and brushes *provided by my mother,* and walking miles on end, slapped

them up along Santa Fe, Callao, Entre Rios, and Mexico Streets. Most of our handiwork was torn down by baffled readers almost at once. (*New Yorker,* August 13, 1970)

It would be all too easy to follow Borges's lead and dismiss this turnabout as a natural result of time, with the mature writer, now "up from Ultraism," ridiculing what he wished to dismiss as a youthful extravagance: "I can now only regret my early Ultraist excesses. After nearly half a century, I find myself still striving to live down that awkward period of my life." Yet, in the very same essay, he also speaks warmly of his beginnings, and even recalls his first published book of poems, *Fervor de Buenos Aires* (1923), as containing the seeds of his later work: "Looking back on it now, I think I have never strayed beyond that book. I feel that all my subsequent writing has only developed themes first taken up there; I feel that all during my lifetime I have been rewriting that one book." Once again, Borges is manipulating his readers with contradictory "facts" about himself, working his audience, making us think.

This technique of manipulation is especially evident in his interviews, which are numerous and inevitably repetitive, with practically everyone covering the same obligatory bio-bibliographical territory, asking much the same tried-and-true questions, over and over and over again. This wearisome experience, however, enabled Borges to perfect his responses, to anticipate the next question on the repertory and to manipulate the interview for his own pleasure (and ultimately, the pleasure of the reader), playing with the interlocutor like a spider with its prey, always though with exquisite courtesy. What makes these interviews especially amusing is Borges's knack for maneuvering the discourse in such a way that everyone ultimately gets the joke—everyone that is, except the hapless interviewer, who is often so enmeshed in a web of fixed ideas that he cannot see himself as victim and unwittingly transcribes his own torpidity.

This is precisely what happened to Jean de Milleret in his 1967 *Entretiens avec Jorge Luis Borges.* One of the principal myths that informs this set of interviews, like so many others, is that Borges was "discovered" by France in the 1950s and that were it not for this fortuitous event he would forever have remained unknown. The facts that belie the myth are that Borges was one of the major movers of the avant-garde in Spain in the 1920s; he was a regular contributor to the prestigious international review *Sur* since the 1930s. Moreover, he was first translated into French at the very beginning of his narrative career way back in 1939, albeit by Néstor Ibarra, a Spanish Basque of Argentine lineage who was born in France.[2] What is more, back in his ultrast beginnings, his early poetry, written directly in French, was published in the dada review *Manomètre* (1922) along with

Philippe Soupault and Tristan Tzara. His crass French interviewer, Jean de Milleret—a freelance journalist based in Buenos Aires—knew nothing of all this at the time of the interview, and his ignorance is as glaring as his chauvinism. While talking about the surge of translations of Latin American literature in the 1960s, the so-called "boom" years, Borges takes control of the interview, baiting the hook by injecting into their first conversation his own version of an ironic one-liner by Paul Groussac, a French émigré, who rose to become the director of the Argentine National Library and who somewhat Eurocentrically lamented: "Becoming famous in South America does not make one any less unknown." Milleret takes the bait and replies with alacrity: "Yes, but it's not that way today and you were one of the first to benefit [from translations into French]. What's more, it's gratifying for me to certify that the French were the first to discover you." Tongue in cheek, Borges assents, noting with polite surprise: "You're right, Ibarra *is* French; since he was *born* in France."

A few days later, in their second interview, Borges again takes control, bringing up what is so dear to Milleret—Gallic acumen—ironically remarking that it was, after all, the "French-born" Ibarra who was the first to note that his writing style was subtle, requiring a careful reading. As if on cue, Milleret agrees, imperiously pouncing on what he considers to be the shortcomings of Borges's native Argentina, a real cultural backwater:

> *Milleret.* It's likely that for the average local reader your writing was too deep, especially back in the epoch of your beginnings, when culture did not enjoy the social diffusion which it has rapidly attained over the last dozen years. But dense does not mean hermetic and you were understood first in France, then in Germany, in the United States, in Sweden, in all the countries of high culture.
> *Borges.* [with veiled irony]* That's right, France started it all. If my texts had not been translated into French, I'm sure that no one, in any other country, would have ever thought of translating them. I am obliged to say that I am much obliged to Roger Caillois [another French émigré, whom Victoria Ocampo brought to Argentina during World War II, setting him up with his own Buenos Aires–based review, *Lettres Françaises,* after a 1942 dispute with Borges in the pages of *Sur* over the genealogy of the detective story] since he was the first to present me to the world: Spanish continues to be, for literature, a somewhat provincial language, no?

* The bracketed intercalations are mine.

Milleret. Without diminishing the importance of Caillois which, of course, was capital, it's necessary not to forget Ibarra and Verdevoye, among others.

Borges. Yes, they did translate me into French; without that, the publishing houses of London, New York, Munich and Rome, never would have dreamed of translating me.

Milleret. [waxing eloquent] That's the traditional role, the historical role of Paris, City of Lights, the place which nourishes the mind, and which constitutes the historical mission of France. Remember Du Bellay: *France, Mother of the Arts, of Arms and Letters . . .* Given its small population, its limited economic power in relation to the monsters of today, it retains its cultural mission which has never been surpassed and which is what makes it such a great country.

Borges. [prime mover of Spanish ultraism in the 1920s] Yes, I do owe a lot to France, and I recognize as much. Because the Spaniards, for example, didn't take me seriously until I was discovered by Paris.

What Borges has here so deftly done with Milleret he has repeatedly done with countless others, putting into practice what in Argentina is called the *cachada,* a kind of extended mockery, leading the victim on, prodding and poking as in a bull fight, without however going in for the kill with an annihilating punch line, but instead keeping him at bay. And so, after Borges has had his fun with the naive Frenchman, he politely changes the subject, and they go on to talk about other writers and their relation with Spain. The interviewer contentedly publishes his scoop, unaware of how roundly he has been ridiculed!

In general, interviews are interesting when the interviewer, or the interviewee, is intelligent. Borges manages to make all of his interviews interesting, because he almost always replies not to the interviewer but to a hypothetical third party, the intelligent reader with whom he establishes a kind of complicity, making those who perceive this irony feel that they somehow belong to that special few described by Hobbes, those who experience a "sudden illumination," recognizing the comic in the serious.

The downplaying of humor has been a constant in literary criticism ever since Aristotle, where tragedy gets all the attention. Cultivators of comedy have taken this as a kind of challenge. For example, Umberto Eco's Borgesian parody of the detective story paradigm, *The Name of the Rose* (1981), had its medieval monks murdering one another over the delights of Aristotle's supposedly "lost" treatise on comedy sequestered by a "blind librarian" tellingly named Jorge de Burgos. And, in "La busca de Averroes" [Averroës's

23

Search], an essay-story in *El Aleph* (1949), Borges has the famous medieval Arab humanist—whom he sets up for laughs by downplaying him to a pathetic court physician, "un médico árabe"—completely out of his element and comically perplexed over the meaning of tragedy as he struggles to annotate for the Caliph of Córdoba a translation into Arabic of a translation of yet another translation of Aristotle's *Poetics,* constrained by convention to accommodate its ultimate meaning to the revealed wisdom of the Koran. Never having seen a play, without the slightest idea of what a theater is,[3] Borges has the serious-minded Averroës resolutely veer off course, ultimately masking his ignorance of words like "tragedy" and "comedy" behind an authoritative-sounding rhetorical flourish: "With firm and careful calligraphy he added these lines to the manuscript: 'Aristu (Aristotle) gives the name of tragedy to panegyrics and that of comedy to satires and anathemas. Admirable tragedies and comedies abound in the pages of the Koran and in the calligraphic art of the sanctuary.'" What calls attention to the absurdity of the high-flown solution is the use of three terms (panegyrics, satire, anathema) to define two (comedy and tragedy), only one of which is even remotely pertinent, comedy as satire, permitting us to see that, ironically, it's the Greek words that are giving our Arab physician-cum-translator of Aristotle all his difficulty, leading him to impose "panegyrics" as a definition of tragedy and "anathema" as an equivalent of satire. Prompting this blunder is Averroës's inadvertently "correct" misreading of the *Poetics,* where Aristotle himself makes the distinction that tragedy shows people better than they are and comedy as somewhat worse. Hence tragedy must be a form of praise (panegyrics) and comedy a kind of curse (anathema). In Borges's portrayal, this pathetic "Arab physician," besides being ignorant of the performance dimension of theater, is far too serious a thinker to find even satire to be comic. Borges somewhat cruelly plays Averroës for laughs, setting him up as someone who just doesn't get it; he's so cerebral he can't see what's right before his eyes. Frustrated, and at an impasse under the pressure to turn in this commissioned commentary on what is for him an unfathomable puzzle in Aristotle's text on the poetics of theater, Averroës gets up from his desk and stares out the window, deep in thought:

> He looked through the lattice-work balcony; below, in the nar-
> row earthen patio, some half-naked children were playing. One,
> standing on another's shoulders, was notoriously playing at being
> a muezzin; eyes tightly shut, he was chanting "There is no god
> but the God." The one who was holding him up high, motionless,
> was being a minaret; another, abject in the dust and on his knees,
> was the congregation of the faithful. The game did not last long;
> everyone wanted to be the muezzin, no one the congregation or

the tower. Averroës heard them disputing in their *crude* dialect, that is, in incipient Spanish.

Borges has Averroës gazing out his window at a kind of spontaneous theatrical representation in which some Christian street urchins are playing the role of being Muslims (whether tragically or comically would depend on the faith of the viewer), but *he doesn't see it.* His scholarly mind is elsewhere, set on finding the answer to his translating problem in a book, and so he conveniently resorts to the most sacred of them all, the unquestionable authority of the Koran. He's obviously as poor an interpreter of reality as he is of texts.

Borges finds much the same fault with the mind-set marring a good deal of the academic criticism of his own work. People just don't see what they're looking at. Instead of simply reading what's on the page, they read something else into it. In *Conversations with Jorge Luis Borges* (1969)—an especially candid encounter with writer Richard Burgin, then a Harvard undergraduate—Borges has this to say:

> I want to tell you that some people have no literary sense. Consequently they think that if anything literary pleases them, they have to look for far-fetched reasons. . . . They're trying to think that the whole thing is full of half truths, reasons and symbols. They'll say, "Yes we enjoyed that tale of yours, but what did you mean by it?" They like to think that writers are aiming at something, in fact, I think that most people think—of course they won't say so to themselves or to anybody else—they think of literature as a kind of Aesop's *Fables,* no?

This search for a deep message is the case with almost all the criticism of "The Aleph," a story that has generated reams of what Borges in this interview calls "far-fetched" readings, uncovering ever more recondite layers of meaning. Yet, on the surface, it is consistently funny. Only someone like Averroës could "overlook" the humor in this story, or those whom Bakhtin in *The Dialogic Imagination* calls "*agelasts*" (from the Greek, "people without-laughter"), those who elect "the serious word and reject its comic reflections as a profanation."

Freud, at almost the same point in time, in a 1927 speech on "Humour," updating his earlier book on *Jokes,* had much the same lament: "Not everyone is capable of the humorous attitude . . . many people are without the capacity to enjoy the humorous pleasure that is presented to them." And so it was with all too many of Borges's early readers, who were reluctant to recognize his humor, necessitating Borges's repeated reminders of his humorous intent to all who would listen in his many interviews.

Chapter 2

Having Fun

homo sapiens = homo ludens = homo ridens

The comic intent of Borges is not only manifested in the published conversations but is present throughout his work, although scarcely noted by the "agelast" criticism. For example, "The Aleph," one of his more famous narratives, has been variously interpreted for its relation with the Kabbala, with the "aleph" as the first letter of the Hebrew alphabet, and with *La Vita Nuova* for its story line and the telltale names of its protagonists (Beatriz and her "secret" lover Carlos Argentino Daneri, an Argentine ringer for *Dan*te Alighi*eri*), while its slapstick humor—difficult to ignore—generally goes unremarked.

In this rather straightforward story, a very modest and self-effacing narrator (not unlike Borges himself, self-parodied here as a man who prudently cuts the pages of his own books before giving them to his friends so as not to be embarrassed later on, finding them still intact) is morbidly attached to the memory of Daneri's cousin, the late Beatriz Viterbo, a rather ordinary woman who apes the aristocracy (in contrast to Dante's highborn Beatriz Portinari). The narrator recalls that the Beatriz whom he vainly loved was embarrassed by her tallness and would consequently stoop so as to hide it, making her into a kind of walking oxymoron—distinguished in the text by what he calls a certain "graciosa torpeza" [charming clumsiness]. In homage to her memory, and no longer fearful of being humiliated by her disdain, he makes ritual birthday visits to her "overfurnished" tiny flat on the shabby southside of Buenos Aires, in Quilmes (a district that Argentine readers would recognize as being home to a smelly swill-beer brewery of the same name), where he must endure the vain literary pretensions of her first cousin (who, as we later surprisedly learn, was also her secret incestuous lover).

The narrator's description of Daneri is as ambiguous as it is devastating: "rosado, considerable, canoso, de *rasgos finos*" [pink-faced, overweight, graying, *fine-featured*]. This low to high four-part adjectival sequence is counterpointed by the description of his mental activity, which moves in the opposite direction, from high to low: "contínua, apasionada, versátil, y del todo *insignificante*" [continuous, deeply felt, far-ranging, and completely *meaningless*]. To complete the caricature, and this is "caricaturization," Borges as narrator snobbishly notes that Daneri, although two generations removed from his immigrant origins, still retains an accent and speaks with his hands: "la ese italiana y la copiosa gesticulación italiana sobreviven en él" [the Italian "S" and the copiously demonstrative Italian way of gesticulating survived in him]. In other words, despite the "Argentino" grafted onto his name, he's still a folkloric rube of immigrant origin, and, what is more, he fancies himself to be a poet, a master poet no less. Like a diabolical inversion of the divine Dante, he has set himself the task of putting *La tierra* [The earth] into verse. By way of example, the narrator straight-facedly reports Daneri's progress: "By 1941, he had already *dispatched* several districts of the State of Queensland, more than a kilometer of the course run by the River Ob, a gasworks to the north of Veracruz, the leading shops in the Buenos Aires parish of Concepción, the villa of Mariana Cambaceres de Alvear in Belgrano, and a Turkish bath establishment not far from the well-known Brighton Aquarium." In this chaotic enumeration, each of the components borders on the comical—the vastness of tropical Queensland in northeastern Australia, the annually changing course of a Siberian river, a Turkish bath in the run-down seaside resort of Brighton, England. Taken together they are patently ridiculous, as is the ambitious descriptive task which Carlos Argentino Daneri has set for himself: "versificar toda la redondez del planeta" [to versify the entire face of the planet].

Carlos Argentino's method of literary composition is selective plagiarism and consists of appropriating and combining lines of others that he happens to have taken a liking to. For example, in this sample strophe he has managed to crib from Homer, Hesiod, and the "Savoyard" (Xavier de Maistre, author of the humorous *Voyage autour de ma chambre* [1795]):

> He visto, como el griego, las urbes de los hombres,
> Los trabajos, los días de varia luz, el hambre;
> No corrijo los hechos, no falseo los nombres,
> Pero el *voyage* que narro es . . . *autour de ma chambre*.

[I have seen, as did the Greek, the cities of man, / the works, the days of varied light, famine; / I do not correct facts, nor falsify names, / the *voyage* I narrate is . . . *autour de ma chambre*.]

The Borgesian narrator then goes on to transcribe Daneri's ecstatic explanation

of his own poetry, where he raves about its complex profundities in a series of comparisons that culminate in a skewed allusion to Cadalso, equating his 1772 send-up (*Los eruditos a la violeta*) of how to be a perfect fraud, with authentic academic erudition:

> "A very interesting stanza," he said, giving his verdict. "The opening line wins the applause of the professor, the academician, and the Hellenist, to say nothing of the 'eruditos a la violeta,' a considerable sector of public opinion; the second flows from Homer to Hesiod (an implicit homage, at the very outset, to the father of didactic poetry), not however without rejuvenating a process whose roots go back to ancient Scripture, enumeration, congeries, conglomeration."

This last sequence functions like the previous one, now holding up the Bible as a web of contradictions, a model for the "subtleties" of which Daneri is so proud, appealing to all readers, from the most cultivated to the merely pretentious, revealing his final goal, to attain the immortality of a great poet: "the third [verse]—baroque? decadent? an example of the cult of pure form?— consists of two equal hemistiches; the fourth, frankly bilingual, assures me the unstinted backing of all minds sensitive to the unbridled pleasures of facetiousness." The boasting reference to his bilingual achievement, to this French "chambre" which he torpidly rhymes with Spanish "hambre" is the height of the grotesque, but for Daneri it's the peak of sophistication:

> I'll not even mention the *unusual rhyme,* nor the erudition which allows me, without a hint of pedantry, to cram into four lines three learned allusions covering thirty centuries packed with literature: first to the *Odyssey,* second to *Works and Days,* and third to the immortal bagatelle bequeathed to us by the frolicking pen of the Savoyard. . . . Once more I've come to appreciate that modern art demands the balm of laughter, the scherzo. Decidedly, Goldoni holds the stage!

Daneri, like his poetry, is a hodgepodge of disparate and conflicting physical and intellectual traits. Lacking in looks, charm, and talent, he is obviously a hack, a plagiarist, an unwitting clown. His cumulative incongruities ironically produce the "facetiousness," the "balm of laughter," the "scherzo" so essential to modern art in the inadvertent words of Daneri himself, which so accurately transmit the aesthetic coordinates of this story. These multiple references to varied forms of humor, although uttered by a dunce like Daneri, are textual signposts to the reader, indicating that it is all right to smile, if not laugh.

29

Chapter 2

The mature Borges, commenting on this piece with María Esther Váz-
quez, a former student and later close friend, in a 1973 conversation in the
Argentine National Library (published in 1983 as "Borges igual a sí mismo"
[Borges same as always] in *Veinticinco Agosto 1983 y otros cuentos de Jorge
Luis Borges*), talked about how much fun he had writing it: "*The Aleph*
is a story which I like; I wrote it laughing to myself, because it was very
funny." Of course, one of the things that makes it funny is the absurd contrast
between Carlos Argentino Daneri's poetic aspiration and the dismal failures
it produces; he thinks he's a whiz, we see him to be a nitwit.

As the story develops, complications ensue, in the form of urban re-
newal: Daneri's building and workplace is slated for demolition. In a panic,
he telephones Borges, and we discover that the basis of his poem on "the entire
universe" is none other than "a trip around his room," in reality the basement,
from which he views the universe through an "aleph." When Borges arrives at
the house, Daneri, like a classic "madman" from Hollywood science-fiction
films, instructs him as to just what he'll have to do to see it, lying flat on
his back on the floor of the basement, making ostentatious use of forensic
terminology ("decúbito dorsal," "acomodación ocular"): "As you may know,
a *decubital* position is indispensable. Total darkness, total immobility, and
a certain *ocular adjustment* will also be necessary. You'll lay down on the
tile floor and focus your eyes on the nineteenth step." At this point in the
narrative, we have a kind of reversal, with Borges acting the compliant part of
the clown's dumb sidekick, docilely carrying through the absurd instructions
of Daneri, descending the narrow stairway down into the deep and tiny litter-
filled basement, folding himself up like a jackknife so as to fit into the confining
space, getting exactly positioned so that lying down on the basement floor—
under the stairwell, all the while watching out for rats—he can look up, count
off nineteen steps (*nineteen* steps breaks every building code, being practically
a ski run!), and locate a little crack . . .

All this detail is not just a filler on my part, nor on the part of Borges.
It is rather a way of enmeshing us in the story, preparing us for the surprise.
For just when we reach the "depth" of absurdity, with our seemingly docile
narrator, Borges himself, down on the basement floor, all cramped and folded
into the pit, straining to look up through a chink in the stairwell . . . at this
point, the narrative suddenly shifts us from the comic to the cosmic, as he
unexpectedly sees it, the Aleph:

> Then I saw the Aleph . . . , I saw the teeming sea, I saw daybreak
> and nightfall, I saw the multitudes of America, I saw a silvery
> cobweb in the center of a black pyramid, I saw a ruptured labyrinth
> (it was London) . . . , I saw my empty bedroom . . . , I saw the
> survivors of a battle sending out picture postcards . . . , I saw in the

drawer of a writing table (and the handwriting made me tremble)
unbelievable, obscene, detailed letters, which Beatriz had written
to Carlos Argentino, I saw . . .

And on and on through several pages, a lengthy "chaotic" enumeration of all
that he saw, a description that succeeds where Daneri failed, transmitting the
sensation of the global and the particular, of an enormous vastness perceived
through its fragmented minutia.

But Borges doesn't allow us to get carried away for long with the
lyricism of this contemplation, and suddenly the narrative shifts once again,
launching us back from the cosmic to the comic. Climbing out from under the
cramped stairwell, the narrator has his revenge, his *cachada,* leading Carlos
Argentino to believe he has *not seen the Aleph*:

> "Did you see everything, really clear, *in color?*"* At that very mo-
> ment I found my revenge. Kindly, openly pitying him, distraught,
> evasive, I thanked Carlos Argentino Daneri for the hospitality of
> his cellar, and urged him to make the most of the demolition of the
> house to get away from the pernicious metropolis, which spares
> no one—believe me, I told him, no one! Quietly and forcefully, I
> refused to discuss the Aleph; on saying goodbye, I embraced him
> and repeated that the country, that fresh air and quiet were two
> great physicians.

With calculated cruelty, the narrator takes his leave from Daneri, treating him
like a madman, recommending that he get himself together, that he forget this
craziness, forget about the Aleph and his project to versify the planet, thus
annulling him as a poet.

For the joke to work, it requires a dunce like Daneri, a fall guy who
doesn't realize he's the victim, and a reader who does. The mechanism,
although malicious, creates a one-sided complicity of the audience with the
author, who sets things up for laughs at the expense of a third party—the
hapless Daneri in the fiction of "The Aleph" or the chauvinistic Milleret in
the real-life interview, with both of whom we see Borges to be ever so polite
while devastatingly on target.

Reading or rereading the story of "The Aleph," attuned to its humor, one
can easily "see" many other jokes pimpling the text: Borges's stingy gift to
Daneri of a bottle of domestic cognac ("coñac del país") reappears sometime
later, on the day of the descent to the Aleph, when Daneri brings out the bottle
and cattily offers him a preparatory shot of what he calls "pseudocognac";

* A joke, now frozen in time: in the 1940s, following the success of *Gone with the Wind* (1939),
Technicolor movies were all the rage.

the ultracorrect maid of the tiny flat quaintly referring to her graying bachelor boss as "el niño" (the young master); the marvelous visionary sequence of the Aleph, among whose many disparate details there are things like the "obscene" letters of Beatriz to her cousin Daneri, and a glimpse of soldiers having survived an overseas battle writing postcards back home as though they were tourists.* Here, among all the disparities, there is also a glimpse of the earth containing the Aleph, the decaying cadaver of Beatriz being eaten away by worms, the narrator's own *empty* bedroom, an X-ray vision of his own innards, and suddenly the sight of "you" too, reader: "vi mi cara y mis vísceras, vi *tu* cara" [I saw my own face and my innards, I saw *your* face], a jarring statement this last one, which should make even the dullest of the *agelasts* among us pause for a double take. And when we do, we are completely enmeshed in the momentary illusion of the reality of Borges's fiction.

A favorite Borgesian narrative device that always prompts a second take is the "Postscript," permitting him to change his voice and comment on what has already been told from a slightly different and more knowing perspective, usually cueing the reader up to something even more bizarre, since it is at this point in the narrative that exposition is complete and we have all the coordinates to make the connections. Thus, in the postscript to "The Aleph" we are informed that some six months after the demolition of Daneri's house, the master poet's work, or rather a selection of it, was printed by the Editorial Procusto,† which, true to its name, made a neat procrustean cut of the fifteen thousand verses amassed for his total poem so as better to fit them into a pocketbook edition limited to its "Argentine sections." So much for the project of versifying the entire universe.

There is also a more subdued kind of private joke: self-parody. The doleful Daneri (like Borges at the real-life time of writing this piece) is portrayed as an obscure employee of an "illegible" branch of the Argentine public library system—hypallage again, an interchange of attributes, making the unfrequented reading center "unreadable." Loser that he is, Carlos Argentino Daneri writes his patchwork poem on purloined library letterhead. Here it is interesting to point out that when the manuscript of "The Aleph" was acquired by Madrid's Biblioteca Nacional in 1986 it was the centerpiece of a documentary exhibition of Borges's work. There one could see that some pages of the original manuscript, like Daneri's poem in "The Aleph," are themselves written on letterhead of the equally obscure branch of the Argentine public

* A joke recycled from an earlier piece for *Sur,* a November 1936 review of William Cameron Menzies's film, *Things to Come,* where Borges disparages military recruits who think of war as an opportunity for "turismo gratis" [free tourism].

† Procusto = Procrustes. According to *Webster,* "a giant of Eleusis who forced travelers to fit into one of two unequally long beds by stretching their bodies or cutting off their legs."

library system where Borges was then employed as a cataloger! And too, there is more self-referential disparagement, for Daneri's curriculum is made to include a work called *Los naipes del tahúr* [The Sharper's Cards], the very same title of Borges's own aborted first book project. What is more, the intercalated story of Daneri's being the runner-up for a literary prize also happens to parallel and parody what happened to Borges himself with *El jardín de senderos que se bifurcan*, which, despite the backing of *Sur,* was passed over for an award when it was first published in 1942. All this is chronicled in the July 1942 issue of *Sur* ("Desagravio a Borges" [An Apology to Borges]) with indignant articles in his defense by more than twenty of the most distinguished writers of the time, including Anderson-Imbert, Mallea, and Sábato.

Thus "The Aleph" is many things at once: a criticism of small-time Argentina in the 1940s, a criticism of poetry as insight within the reach of everyone (provided of course that one has an Aleph in the basement), and an autobiographical vignette as self-parody. While larding "The Aleph" with big and little morsels of humor, Borges created in the process a convincing literary representation of what is indeed the *alef,* a "New Math" concept designated by the first letter of the Hebrew alphabet (א) for denoting transfinite numbers, a technical term he had first employed in an article on the Spanish avant-garde writer Gómez de la Serna in *Inquisiciones* [Inquisitions (1925)] to refer to the limitless talent of his friend, assigning to him: "el signo *alef* que en la matemática nueva es el señalador del infinito guarismo que abarca los demás" [the *alef* which in the new mathematics is the sign of the infinite figure which contains all others]. The same mathematical sign was highlighted for all to see on the artist-designed covers of the first and second Buenos Aires editions of *El Aleph* in 1949 and 1952 (first by Attilio Rossi, then by Graví), but most humanists are not mathematicians and so it wasn't recognized by the literati as being anything more than the first letter of the Hebrew alphabet, a circumstance that probably pleased the author of "The Sharper's Cards," showing his hand while putting us on.

■

While Borges's mathematics did not go beyond algebra and plane geometry, this did not keep him from exploring the ramifications of the most advanced ideas of his time, extrapolating proofs *per absurdum.* His source for the mathematical concept of the *alef,* set theory, or "Mengenlehre," as developed by George Cantor (1845–1918), was Bertrand Russell's popularizing *Introduction to Mathematical Philosophy* (1919), a work that he cites in discussing Cantor's ideas in "La doctrina de los ciclos" [The Doctrine of Cycles], a half-serious, half-jesting essay whose principal target is Nietzsche, the "philologist" Nietzsche, ruthlessly ridiculing what Nietzsche ostentatiously claims to

be "his own idea" about the cyclical nature of time as being nothing more (nor less) than an unwitting demonstration of cyclical plagiarism: "that doctrine *whose most recent inventor* [Nietzsche] calls the Eternal Return."

Borges pounds into Nietzsche with unbridled maliciousness, bringing up the Pythagoric origins of this notion and presenting the bombastic German philosopher (or rather, "philologist") as a person so imbued with his messianic role ("the prophetic style doesn't admit the use of quotation marks nor erudite references to other books and authors") that he has to tell us exactly where and how this revelation came to him, and him alone: "the precise place in which the idea of the eternal return visited him: a path in the woods of Silvaplana, near an enormous pyramidal block, at noon in August 1881, at 6,000 feet from man and from time."

Borges included this essay in the ambiguously titled *Historia de la eternidad* [History of Eternity] in 1936. Now, a "history" of eternity is as preposterous an idea as a "*Nueva* refutación del tiempo" [*New* Refutation of Time], the title of a similarly paradoxical 1947 essay collected in *Otras inquisiciones* [Other Inquisitions (1952)]. Both are oxymorons, one paradoxically postulates a closed sequence with a beginning and an end for limitless eternity, the other a sequential order on a time line for the latest refutation of its existence. Needless to say, critics who take the content of these essays seriously haven't been at all troubled by the irony of their titles, just as those who write on "The Aleph" seem to be quite happy making knowledgeable talk about it in the context of the Kabbala and the first letter of the Hebrew alphabet, as though, like Averroës's one-size-fits-all reference to the Koran, that should be sufficient to clear things up.

The mathematical idea of the *alef* as a figure or a point that contains all others has a clever, although nonhumorous, treatment in a lyric poem of *Fervor de Buenos Aires* (1923), Borges's first published book. The poem, simply titled "Guitarra," contains an anticipation of the not so "chaotic" enumeration of the visionary sequence of "The Aleph," and employs the same anaphoric repetition of "vi" [I saw] to create the sensation of a totalizing vision of the entire pampa—the vast grasslands of Argentina's great plains—in the brief strumming of a guitar:

> He mirado la Pampa
> de un patiecito de la calle Sarandí en Buenos Aires.
> Cuando entré no la vi.
> Estaba acurrucada
> en lo profundo de una brusca guitarra.
> Sólo se desmelenó
> al entreverar la diestra las cuerdas.
> No sé lo que azuzaban;

a lo mejor fue un triste del Norte
pero *yo vi la Pampa.*
Vi muchas brazadas del cielo
sobre un manojito de pasto.
Vi una loma que arrinconan
quietas distancias
mientras leguas y leguas
caen desde lo alto.
Vi el campo donde cabe
Dios sin haber de inclinarse,
vi el único lugar de la tierra
donde puede caminar Dios a sus anchas.
Vi la pampa cansada
que antes horrorizaron los malones
y hoy apaciguan en quietud maciza las parvas.
De un tirón *vi todo eso*
mientras se desesperaban las cuerdas
en un compás *tan zarandeado como éste.*

[I saw the pampa / from a patio in Sarandí Street in Buenos Aires.
/ I didn't see it when I entered. / It was curled up / in the depths
of a crude guitar. / It only broke loose / when a hand grazed the
strings. / I don't know what sound rose up / perhaps it was a sad
tune from the North / but *I saw* the pampa. / *I saw* fathoms of sky /
over a stretch of grass / *I saw* a hill on which were piled up / calm
distances / where leagues upon leagues / fall down from above. /
I saw the countryside where / God doesn't have to stoop, / *I saw*
the only place on earth / where God can freely roam. / *I saw* the
weary pampa / once horrorized by Indians on the warpath / and
which today looks pacified by piles of hay. / In a single stroke
I saw all this / while the strings were strummed / in a span *just
like this.*]

The poem, besides being a lyrical representation of the idea of a single point in
time and space that contains all others, is also cunningly literary. It opens much
like Bécquer's well-known Romantic poem (*Rima VII:* "Del salón en el ángulo
oscuro . . .") motivated by an abandoned harp, whose music lays dormant in
the strings waiting for the hand that knows how to awaken them, and closes by
folding back upon itself in the fashion of Lope de Vega's flamboyant sonnet
on how to write a sonnet: "Un soneto me manda hacer . . . / contad si son
catorce y *está hecho*" [I am commanded to write a sonnet . . . / count up and
see if there are fourteen lines and it's finished], "*just like this.*"

However, as always with Borges, while knowing these things—appreciating his allusions or his sources—may make for a richer reading, they are not necessary for a basic enjoyment of his texts. Poem and story, "La guitarra" and "The Aleph," can be appreciated, and indeed have been, by countless readers who have no idea of set theory or of the *alef* as a mathematical symbol.

While Borges is not a mathematician, he does have a mathematical mind, a nonlinear way of thinking that often arrives at a proof or solution to a problem by imagining the absurdity of its counterpart. John Allen Paulos, who is a mathematician—and an insightful humor theorist with a book on *Mathematics and Humor* (1980)—remarked that he first became interested in the subject when he noticed that his colleagues often had a "distinctive sense of humor," prompting him to search for similarities between mathematical thought and humor as complementary forms of intellectual play. In his view, both activities are undertaken for their own sake, "just for the fun of it."

This is the principle at work in the writings of Borges, and I have singled out "The Aleph" as a way of drawing attention to what is a constant throughout his work: the idea of literature as fun, as an occasion for having fun with serious ideas, and sometimes even being funny about them long after the writing is over. Some twenty years after "The Aleph" had become part of literary history, at the end of the English language edition of *The Aleph and Other Stories* (1970), there is a kind of colophon in the form of a commentary by Borges:

> Once, in Madrid, a journalist asked me whether Buenos Aires actually possessed an Aleph. I nearly yielded to temptation and said yes, but a friend broke in and pointed out that were such an object to exist it would not only be the most famous thing in the world but would renew our whole conception of time, astronomy, mathematics and space. "Ah," said the journalist, "so the entire thing is your invention. I thought it was true because you gave the name of the street."
>
> I did not dare tell him that the naming of streets is not much of a feat.

The technique of course is pure put-on, as should be evident to anyone who has tried to track down the "rue Morgue" in the fictional Paris of Poe.

The stories about the Aleph and the Library of Babel are not just occasional forays into humor. The element of humor is present even in his early avant-garde poetry, as for example in his much anthologized "Fundación mitológica de Buenos Aires" [The Mythological Founding of Buenos Aires], originally published in *Nosotros* (May 1926) and later collected in his *Cuaderno San Martín* (1929), a lofty-sounding poem that evokes the arrival of the first Europeans on the muddy banks of the River Plate. Its opening strophes

are designed to appeal to the patriotic imagination, transporting its Argentine readers back to that mythic moment in the past when the sixteenth-century navigator Juan Díaz first touched land in the name of the king of Spain:

> ¿Y fue por este río de sueñera y de barro
> que las proas vinieron a fundarme la patria?
> Irían a los tumbos los barquitos pintados
> Entre los camalotes de la corriente zaina.
>
> Pensando bien la cosa supondremos que el río
> Era azulejo entonces como oriundo del cielo
> Con su estrellita roja para marcar el sitio
> En que *ayunó Juan Díaz y los indios comieron.*

[And was it along this torpid muddy river / that the prows came to found my native land? / The little painted boats must have swirled / among the root-clumps of the horse-brown current. // Pondering things well, let us suppose that the river / was blue then like an extension of the sky / with a little red star to mark the spot / where *Juan Díaz fasted while the Indians feasted.*]

The neat turn of phrase at the end of the strophe conceals/reveals an imbedded joke. The entry for Juan Díaz in my (1991) edition of the *Encyclopedia Britannica* gives his dates (b.1470?, Seville, Spain—d. 1516, Río de la Plata, S.Am.), and goes on to tell us that he was the "chief pilot of the Spanish navy and one of the first explorers to enter the Río de la Plata estuary. . . . Sailing up the river, he landed on the east bank (modern Uruguay) and was attacked by the Charrúa Indians of the region. He and the rest of the landing party, except for one man, Francisco del Puerto, were *killed and eaten* in sight of the remaining crewmen on shipboard." It is in this context that we must read the laconic lines about the "estrellita roja," that bloody spot starred in red where "Juan Díaz *fasted* while the Indians *feasted.*" What makes this joke work is the element of surprise, its carefully crafted delivery. Since Argentine readers should instantly know who Juan Díaz is—and his unfortunate fate—Borges scrupulously postpones mentioning his name, delaying it to the very end where it is then highlighted by making it follow the verb: "ayunó Juan Díaz y los indios comieron." In this way the subject of the first verb becomes the direct object of the second, where it is literally and syntactically consumed.

For people of Borges's generation, indoctrinated with Sarmiento's foundational treatise on *Civilización y barbarie* (1845), the Indian was the scourge of Argentina, the personification of everything barbarous. The earliest version of the poem, as published in the May 1926 issue of *Nosotros,* has a reference to *quillango,* a Quechua word that refers to a blanket stitched together with scraps

of llama skins, a kind of patchwork quilt used by the Indians. Borges originally had employed this word in the opening line to describe the meandering course of the Río de la Plata, the river on whose muddy banks Buenos Aires was founded: "Y fue por este río con traza de quillango?" [And was it along this river with the pattern of a *quillango?*] Obviously, this reference to Indians in the first line defuses the impact of "the spot where Juan Díaz fasted while the Indians feasted," and so it was changed in subsequent editions. The title too was toned down, with "mythological" becoming "mythic."

Borges was a political activist in the 1920s, head of an intellectual committee to support Hipólito Yrigoyen, a twice- elected populist president who initiated many reforms. So it is not surprising that as the poem goes on, peopling the original muddy settlement with gauchos, gringos (Italian immigrants), street-corner toughs, shantytowns, and tango bars, there is an allusion to the ubiquitous campaign posters of the beloved politico: "el corralón seguro ya opinaba YRIGOYEN" [the walls of the neighborhood were already supporting YRIGOYEN].

■

To a humorist, nothing is sacred. And since humor is a form of surprise, it works best in the context of the serious. To this end Borges will camouflage some of his more amusing stories in the guise of essays: an autobiographical account for "Tlön"; a necrology for "Pierre Menard"; a book review for "El acercamiento de Almotásim" [The Approach to Almotasim]. In almost every interview, he delights in recounting how one of his friends fell for the Almotasim hoax, ordering the nonexistent Bombay book from his London book dealer. This is not surprising, given the context of the pseudoreview's initial publication, in the end pages of an otherwise serious collection of essays first published in *La historia de la eternidad* (1936).

The text of "The Approach to Almotasim" looks and reads like a standard book review, elaborating on the publishing history of a best-seller: the details of the original novel, its sources, its variants from the *"editio princeps,"* all the standard stuff of scholarly discourse:

> The editio princeps of *The Approach to Almotasim* appeared in Bombay toward the end of 1932. The paper used was almost the quality of newsprint; the cover proclaimed to the buyer that the book was the first detective novel written by a native of Bombay City. Within a few months the public bought up *four* printings of a *thousand* copies each. The *Bombay Quarterly Review,* the *Bombay Gazette,* the *Calcutta Review,* the *Hindustan Review* (of Allahabad) and the *Calcutta Englishman,* all sang its praise.

The seasoned reader of Borges might here begin to suspect some irony in the uniformly provincial provenance of these dithyrambs over a book with such a meager press run, but back in 1936 there were no seasoned readers. What is more, there was, of course, no such book! No matter, Borges goes on to summarize the plot and comment on its development: a student caught in a riot kills, or *thinks* he kills, a Hindu; he flees to the outskirts of town, crossing "two sets of railroad tracks, or *maybe* the same tracks twice." He scales the wall of a garden and seeks refuge in a nearby tower. When he gets to the top, he comes upon "un hombre escuálido, que está orinando vigorosamente en cuclillas, a la luz de la luna" [a scrawny man, squatting and urinating noisily, by the light of the moon]. The high lyric setting, "a la luz de la luna," jars with the baseness of the action. This man, while urinating, confides that his profession is to rob gold teeth from the cadavers that the Parsees leave in the tower. He goes on to talk of other equally "vile matters" and mentions that fourteen nights have passed since he last purified himself with "bosta de búfalo" [buffalo dung]. Purified himself with *buffalo dung*! Thankfully, no typesetter has cleaned this up, at least not yet.

And, should anyone doubt the comic intent of this abrupt insertion, a couple of paragraphs later there is a real howler. At the thematic climax (on the serious level the piece develops the idea of the "identity of the searcher with the sought," which on the comic level translates into "you find what you're looking for") we have this pompously worded sequence: "In the 1934 version, which I have at hand, the novel sinks into allegory: Almotasim is the emblem of God, and the punctual itinerary of the hero is in some manner the forward progress of the soul in its mystic ascent. Grievous details abound: a *Negro Jew from Indo China,* speaking of Almotasim says that his skin is *dark.*" Just as a Negro Jew (from Indo China, no less) finds everything dark, so a Christian finds the symbol of Christ all around him: "a Christian describes him standing atop a tower with his arms outspread; a Red lama remembers him seated 'like that idol of *yak lard* which I modeled and adored in the monastery at Tashilhumpo.' " An idol of "yak lard"? He's got to be kidding! And, of course, he is. Borges is playing with us, having fun with the earnestness of the reading process, injecting progressively more ridiculous elements into the exotic landscape of this story, bombarding us with absurdities so as to oblige us eventually to get the joke, or to get us into what some jokesters call the "laughing mood." As Arthur Koestler—the closest approximation to a guru of modern humor theory—says in *The Act of Creation* (1964):

> Primitive jokes arouse crude emotions by means of a minimum of ingenuity. But even the coarse laughter in which these emotions are exploded often contains an additional element of admiration for the cleverness of the joke—and also of satisfaction with one's

own cleverness in seeing the joke. Let us call this additional element of admiration plus self-congratulation the intellectual gratification offered by the joke.

This "intellectual gratification" prompts a closer reading of the text and rewards the reader, now attuned to its humor, with a whole constellation of embedded jokes: the student, caught up in the midnight riot among Muslims and Hindus, flees as the mounted police, who "impartially" whack away at the mob, arrive: "atronadora, ecuestre, semidormida, la policía del Sirkar interviene con rebencazos *imparciales*" [thunderous, mounted, still half asleep, the police of Sirkar intervene with *impartial* whiplashes]. Hypallage again, to make us see that, in other words, they strike wildly at everyone in reach. This is irony for a police riot. The fleeing student seeks refuge in a tower; clambering up a stairway that, Piranesi-like, is missing a couple of flights ("faltan algunos tramos"). Yet again, the French and English translators of Borges think this is a bit too much and typically take things into their own hands, rendering "tramo" [flight of stairs] as "steps" or "*marches,*" and proportionately reducing the staircase or *escalier* to a simple ladder or *échelle.* In its own way, the translation is still funny, giving us the incongruous image of what would have to be a somewhat squat tower, scaleable by a simple "ladder," though one that is still *missing* some steps—*the* telling textual detail which makes whatever it is, stairway or ladder, ominously ludicrous.

Borges must have thought a lot about this sight gag, a lot more than his translators at any rate, for in "The Library of Babel" some visiting grand inquisitors try to stay clear of an even more threatening staircase, "una escalera *sin peldaños* que casi los mató" [one *without any steps at all* that almost killed them]. Time and again, throughout Borges's work, readers are obliged to do a double take, to reread the passage in question, to reassure ourselves that we are indeed reading what is written, and in so doing of course to experience that "intellectual gratification," "sudden glory," or "feeling of superiority," sacrosanct terms that humor theorists like to invoke as euphemisms for amusement.

Néstor Ibarra (the Argentine from the Spanish Basque country who just happened to be born in France) translated "The Approach to Almotasim" with Borges's collaboration for publication in Paris in 1939, a circumstance that permitted the addition of yet another comic touch in the guise of an authenticating "Translator's Note," wherein they insert a wild quote, passing it off as an excerpt from one of the (apocryphal) French reviews of the novel, pompously praising it to the skies before letting it crash down to earth: "In France, the book seems to have passed unnoticed. Nevertheless, Benjamin Fondane mentions it in *Europe,* where he describes it in these terms: 'For its diversity, its brio, its accurate details, an art which is precise and ingenious

which manages to deceive as well as satisfy, an innate feeling for the exotic, brimming with talent, attaining at times a force which resembles that of genius. In short, nothing.' " The technique is classic Borges (and a parody of inflated Gallic rhetoric), a rising tension, released by the sudden intromission of the unexpected, the leap into the void, prefaced of course by "voire," that most overworked of rhetorical adverbs in French: "*voire* par moments une force qui ressemble à du génie. Bref, zéro."

Reading and rereading "The Approach to Almotasim" makes one wonder what might have been Borges's objective in writing this spoof of a book review, if not to ridicule the rhetoric of the form. The procedure is indirect, in other words, Borgesian. By means of exaggeration, by *reductio ad absurdum,* the ridiculous is made more apparent than if Borges had made a direct critique of academic discourse. Through humor, the thrust of the text is made more effective.

■

In a 1967 interview with Georges Charbonnier for French radio and television, published as *Entretiens avec Jorge Luis Borges*—the very same straightforward title as Milleret's 1967 book of interviews—Borges brings up the importance of the ludic element in his work:

> I believe that in all my stories there are two elements. The stories are a bit like games. These games are not arbitrary. In any case they are not arbitrary for me. A necessity, if the word is not too strong, is what impels me to write them.
>
> It's that I amuse myself this way. The task of writing a story has never been just a task for me. I have fun. It's a game. A bit like playing chess . . . There are those who can only see my stories as an arid game. But I have fun writing them. I am moved when I write, I sometimes feel that I'm on the edge of a nightmare, but that doesn't bother me, on the contrary, it amuses me! I slip jokes into the text [Je glissais des blagues dans le texte].
>
> In one story which is a kind of nightmare, "The Library of Babel"—I know that there are also some jokes. Perhaps these jokes are a bit secret; perhaps these jokes are just for me, and for my friends.

In the preface, we saw some of the jokes he slipped into "The Library of Babel" and noted that the seed text was an earlier essay on "The Total Library," fertilized perhaps by certain utopian architectural projects of the 1930s avant-garde (Gropius, Le Corbusier). Even in the early and supposedly serious essay though, Borges slipped in some jokes. Playing with an idea once dear to dada

(Tristan Tzara's famous formula for a poem, made of words clipped from a newspaper, dropped into a hat, and randomly tossed out onto a table), and whose ultraist variation in the first *Prisma* manifesto was "Naipes y filosofía" [Playing Cards and Philosophy], a deck of cards made up of "potent words" [imponentes, con entorchados] that deal out novel streams of imagery.

In "The Total Library," he makes reference to a dialogue of Cicero, who, in *De Natura Deorum,* has one of his speakers ridicule those who believe in the chance formation of the universe, saying that "they might just as well believe that by randomly tossing out innumerable characters with the twenty-one letters of the Roman alphabet they could come up with the *Annalium* of Ennius." Borges turns this initial irony inside out, connecting what he calls its "typographical image" with a long line of later thinkers who extrapolated on the element of chance and postulated that the letters of the alphabet potentially *do* contain all that is written and ever will be written, finally attributing to Huxley the humorous conceit that, if indeed this were true, "a half dozen monkeys equipped with typewriters, could easily knock out in a few eternities all the books contained in the British Museum."

The idea is funny enough on its own—with the glib juxtaposition of "a *half dozen* monkeys" with a "*few* eternities"—but Borges ups the laugh quotient with a shift in voice, tacking on a footnote in which he adds with straight-faced aplomb: "In practice, *one* immortal monkey would be more than enough." What makes the final aside funnier is its concision, its *reductio ad absurdum,* using just a single adjective to render the real into an absurdity: "one *immortal* monkey." Now that's something to think about! An immortal monkey, just *one* of which would be "*more than enough.*"

In "The Library of Babel," which repeats the Ciceronian conceit ("By this art you may contemplate the variation of the 23 letters") in the form of an epigraph, attributing it here to the *Anatomy of Melancholy* (by Robert Burton, another master of the humorous aside), Borges returns to this idea of writing as a random and mechanical act, pointing out the difficulty the catalogers have in finding among the myriad books produced by alphabetical chance an occasional coherent line. What in principle is a thought-provoking idea in practice becomes a nightmare, since "for one reasonable line or one straightforward note there are leagues of insensate cacophony, of verbal farragoes and incoherencies."

■

The paradoxes generated by logical thinking are a constant source of inspiration for Borges since they contain the inherent contradictions of all good humor. Simply restating these paradoxes in nonscientific language and situating them in the realm of the everyday can convert them into something

ridiculous, like, say, putting the Aleph down in the basement of a house about to be demolished. In this same vein, the sophisms of Zeno, which were given a nightmarish treatment by Kafka (in *The Castle,* "The Great Wall of China," "The Emperor's Message," and so many other stories), were consistently exploited for laughs by Borges.

The Achilles paradox, designed to prove that the slower mover will never be passed by the swifter in a race, is the subject of "La perpetua carrera de Aquiles y la tortuga" [The Perpetual Race of Achilles and the Turtle] in an early newspaper essay (*La Prensa,* January 1, 1929) first collected in *Discusión* (1932). The young Borges hails this ancient puzzle as "immortal," as a "jewel" of an idea that has resisted twenty-three centuries of repeated "annihilation," and goes on to discuss some of the more renowned refutations, exploiting each for its inherent humor. He summarizes John Stuart Mill's pragmatic approach in this way:

> Suffice it to fix the velocity of Achilles at one meter per second in order to establish the time he'll need. $10 + 1 + 1/10 + 1/100 + 1/1000 \ldots + 1/n \ldots + 1/\infty$ The limit of the sum of this infinite progression is twelve (more exactly, eleven and one fifth; more exactly, eleven and three twenty-eighths), which is never attained. That is to say, the hero's stretch may be infinite and he'll run it forever, but his course will give out before covering twelve miles and his eternity will never see the end of twelve seconds. This methodical dissolution . . . is not really hostile to the problem: rather, it is to imagine it well. Let's also not forget to attest that *the runners grow smaller,* not only because of their visual shrinking through perspective, but also because of *the admirable shrinking to which they are obliged by the occupation of microscopic spaces.*

Again, simply by extrapolating the practical implications of the paradox, he makes it absurdly funny, something like a cartoon illustration, with Achilles and the turtle progressively shrinking away to (almost) nothing!

A decade later, in *Sur* (December 1939), Borges returns to the same paradox with an essay on "Avatares de la tortuga" [Avatars of the Turtle], later collected in the second edition of *Discusión* (1957), where he again restates the problem in a humorous way, this time through the rhetorical repetition of Achille's name, suddenly breaking the purposefully plodding anaphoric pattern of subject plus verb, subject + verb (Aquiles corre, Achilles runs) by the classic device of frustrated expectation, the unexpected substitution of the now anticipated verb with an even more familiar automatic word, Homer's stock epithet for his hero, the "swift-footed," *Aquiles Pies-Ligeros,* whose progress is reported with the frenzied progressively abbreviated rhythm of a

radio sportscaster racing his voice to keep up with the action: "*Achilles runs* ten times faster than the turtle and he gives him a ten meter lead. *Achilles runs* these ten meters, the turtle runs one; *Achilles runs* this meter, the turtle a decimeter; *Achilles runs* this decimeter, the turtle a millimeter; *Achilles the Swift-Footed,* a millimeter, the turtle a tenth of a millimeter." The resultant incongruity of the "swift-footed" Achilles running a meager millimeter is akin to the "admirable shrinking" of the runners in the earlier essay. In both cases Borges produces a kind of visual *reductio ad absurdum* whose result is a laughable image of the mythical Achilles as a kind of midget, growing ever smaller with each step.

Comedy, we are repeatedly told, from Aristotle through Bergson and others, ridicules its subject. And so it does, giving our author a splendid occasion to ridicule Bergson: "in one of whose clumsier refutations of the aporia" he substituted Achilles for a second turtle on the back of the first, simply a rhetorical maneuver to "distract the reader," Borges quips.

Making light of Zeno's second paradox is topped by what he does with the third, that of the flying arrow, which supposedly proves that motion is impossible. The idea is that since at any given moment a moving object occupies a space exactly equal to itself, a flying arrow must actually be at rest. This "problem" is inserted into a poem titled "Cosas" [Things], included in *El oro de los tigres* [The Gold of the Tigers (1972)], a text that unfolds a long and somewhat alephlike enumeration of "things," things that nobody sees "except the God of Berkeley."[4]

The poem, which dates from Borges's mature years, is intensely lyrical, and its lengthy series of free-association imagery is packed with humorous allusions. The overtly comic sequence I am interested in here begins in line twenty-five with a reference to the surviving fragment of the Finnsburg epic (whose beginning and end are indeed missing), the name of which evokes the now extinct society of the Finsbury Archers, which in turn triggers an allusion to Zeno's arrow and from there to the paradox of the turtle.

The seemingly free-flow sequence of associative imagery contains a concatenation of absurdities, each of which are, however, individually bona fide, such as the real-life function of turtles, which back in Borges's youth were believed to certify the purity of the water in an *aljibe,* a kind of storage well in colonial-style Argentine houses with a patio. The turtle indirectly relates back to Zeno of Elea in this carefully organized "chaotic" sequence of *cosas,* things that are and things that somehow cannot be. The turning point that moves us from the serious to the comic is the disjunctive assertion, "lo que *no* puede ser" [what can *not* be]:

> El sueño que he tenido antes del alba
> Y que olvidé cuando clareaba el día.

El principio y el fin de la epopeya
De Finsburh, hoy unos contados versos
De hierro, no gastado por los siglos.
La letra inversa en el papel secante.
La tortuga en el fondo del aljibe.
Lo que no puede ser. El otro cuerno
Del unicornio.

[The dream I had before dawn / and later forgot in the clearing of
the day. / The beginning and the end of the epic / of Finnsburg,
today a few sparse verses / of iron, unwasted by the centuries. /
The mirrored letter on the blotting paper. / The turtle in the bottom
of the cistern. / And that *which cannot be.* The other horn / of the
unicorn.]

Imagine that for a moment, a two-horned unicorn! And since two leads to
three, and follows one, the absurdity of "the *other horn* of the unicorn" leads
to yet another numerical incongruity, that of the Holy Trinity:

El Ser que es Tres y es Uno.
El disco triangular. *El inasible*
Instante en que la flecha del eleata,
Inmóvil en el aire, da en el blanco.

[The Being that is Three in One. / The triangular disc. *The
imperceptible / moment in which the Eleatic arrow, / motionless
in the air, hits the mark.]*

The paradox of the moving arrow, which must also be at rest, is shattered
when it strikes its target.

This is a variant of the closing joke of "La muerte y la brújula" [Death
and the Compass], Borges's parody of the detective Auguste Dupin, the pipe-
smoking know-it-all, himself a comic creation of Edgar Allan Poe. The story,
which ends with a bullet striking its target, dates from 1942 and was first
collected in *Ficciones* (1944). There, the self-styled supersleuth Lönnrot,
analyzing a series of three murders in diverse parts of the city spaced exactly
a month apart, "cleverly" calculates with the aid of a compass—only *after*
receiving a packet containing *an anonymous tip drawn in red on a map of
the city and signed by one "Baruch Spinoza,"* indicating that these three
points in space form an equilateral triangle. Then, in a very *slow* leap of the
imagination, which the text describes as *"more geometrico,"* a Latinism in
the fashion of high-school geometry (à la *More Geometrico Demonstratae* of

Spinoza),* Borges then has Lönnrot, slow thinker that he is, *finally* deduce that the triangle is but one-half of a rhombus, an equilateral parallelogram in whose opposite oblique angle there will be a fourth murder in the fourth month. When he ultimately gets to the appointed spot on the outskirts of town, he *slowly* becomes aware that he is the intended victim and that he has arrived just in time to be a witness to his own execution. Zeno is again invoked as the "shrewd" Erik Lönnrot—a parody of Erik the Red, the bumbling Erik Bloodax, last of the Norse kings?—faces the author of the trap, his archenemy Red Scharlach, a scarlet-clad Jewish gangster version of himself. "Red" Lönnrot sophomorically addresses Red Scharlach: "In your labyrinth there are three lines too many," he said *at last.* "I know of a Greek labyrinth that is a single straight line. Along this line so many philosophers have lost their way that a mere detective may very well get lost." Zeno's first dichotomy paradox, designed to prove that an object never reaches its goal, is used by Borges to give an ironic outcome to his story, as Lönnrot continues with his laborious reasoning: "Scharlach, when in another avatar you hunt me down, stage (or commit) a murder at A, then a second murder at B, eight miles from A, then a third murder at C, four miles from A and B, halfway between the two. Lay in wait for me at D, then two miles from A and C, again halfway between them. Kill me at D, the way you are now going to kill me." In a practical refutation of the paradox, Scharlach then steps back (in a straight line) and shoots: "The next time I kill you—said Scharlach—I promise you such a labyrinth, which is made of a single straight line and which is invisible and unending. He moved back a few steps. Then taking careful aim, he fired." Will the bullet hit the mark, or will it be like Zeno's arrow, "immobile in the air"? We know Borges's answer from the previously cited "Cosas": "Lo que no puede ser . . . / el inasible / instante en que la flecha del eleata / inmóvil en el aire, *da en el blanco*" [strikes the target]. And too, seeing the predicament that Lönnrot has created for himself through his blind devotion to pure reason, we should reread his torpid restatement of the spatial paradox, first recalling one of Bergson's mechanistic ideas in *Laughter* (1901): "Comedy sets before us a character who lays a trap in which he is the first to be caught." Precisely Lönnrot's situation at the end of the story, caught in his own parallelogram. The hapless but persistent sleuth makes his killer promise him a "straight-line labyrinth" for the next time, where he will once again "adroitly" situate himself as the victim in point D. The next time however is also ironically this time, as Scharlach "moves back a few steps" (in a straight line), and "taking careful aim" fires away (in a straight line), giving us that "imperceptible moment" in which the Eleatic bullet, "motionless in the air, hits its mark."

* Whose Euclidean philosophical system Borges elsewhere considers "pathetic" (in "Spinoza, une figure pathétique," the transcript of a 1981 lecture reproduced in *Europe,* May 1982).

This is one of Borges's more elaborate incursions into humor of the absurd, a parody of the convention of implacable logic that sustains the genre of the detective story *après* Poe. Lönnrot, despite all his pompous posturing, discovers absolutely nothing on his own; he is spoon-fed *all* of the information that leads him to his own rendezvous with death. The story is laced with comic effects, both subtle and broad. On one level there are the out-and-out verbal jokes generated by the conversations among the characters; on another more visual, almost cinematic level there are descriptive scenarios of outlandish deportment in various key situations. For example, Lönnrot's muddled reasoning consistently blinds him to the obvious. Thus, toward the story's end, when he arrives at the fenced-in country estate where he has been *led to deduce* that the next murder will occur, he finds the ironwork gate closed. Naturally, shrewd bumbler that he is, he looks for a less obvious way in, and after walking all around the perimeter of the estate, he finds himself once more at the iron gate. Frustrated, he somewhat mechanically touches the handle: "El chirrido del hierro lo sorprendió; con una pasividad laboriosa, el portón entero cedió" [The squeal of rusted iron surprised him; with laborious slowness, the entire gate collapsed]. This is a visual gag, one we've seen countless times in theatrical comedies.

On the strictly verbal level, much of the dialogue is organized as humorous riposte. For example, right at the beginning, what gets the story under way is the murder of a rabbi who is in town to attend an International Talmudic Congress. Since the place of the murder, the rabbi's hotel room, is just across the hall from that of the Tetrarch of Galilee, famous for his jewelry collection, the police commissioner surmises (correctly) that the author of the crime entered the wrong room. Not unexpectedly, the ever clever Lönnrot refuses to entertain such an obvious supposition, preferring instead what he calls a "rabbinical" explanation: "He aquí un rabino muerto; yo prefiriría una explicación puramente rabínica, no los imaginarios percances de un imaginario ladrón" [Here's a dead rabbi; I'd much prefer a purely rabbinical explanation, not the imagined mistakes of an imagined thief]. This sets things up for a Jewish joke of the "ready repartee" variety of which Freud was so fond in his *Jokes and Their Relation to the Unconscious* (1905). For Freud, "repartee consists in the defence going to meet the aggression . . . , in establishing an unexpected unity between attack and counter-attack." In the following exchange there are three speakers: (1) the jaded police inspector Treviranus who declares that he has "no time to waste on Jewish superstitions"; (2) the methodical Lönnrot, "suddenly turned Biblical scholar"; and (3) a shy, myopic reporter for a Jewish daily newspaper. The first speaker is the police inspector:

> "I'm just a poor Christian . . . , I have no time to waste on Jewish superstitions."

"Maybe this crime belongs to the history of Jewish super-stitions," Lönnrot grumbled.

"Like Christianity," the reporter from the *Yidische Zeitung* made bold to add.

Christianity as a "Jewish superstition," a somewhat too hasty case of mistaken identity of the still awaited Messiah! A Borgesian irony that, ironically, has its counterpart in the Bible, where we are told that when Pontius Pilate writes the inscription "Jesus of Nazareth the King of the Jews," this prompted the Jews to protest: "Write not, The King of the Jews; but that *he said,* I am King of the Jews" (John 19:21).

Yet another intended irony, of the type André Breton would collect in his *Anthologie de l'Humour Noir* (1940), is used by Borges in this story from 1942 as a way of drawing attention to the ingrained anti-Semitism of Christian fraternal societies. This one is conveyed through the yellow press accounts of the series of monthly murders, which have so far taken the lives of three Jews:

> The evening papers did not overlook these recurrent disappear-ances. *La Cruz de la Espada* [The Cross of the Sword] contrasted these acts of violence with the admirable discipline and order observed by the last Congress of Hermits. Ernst Palast, in *El Mártir* [The Martyr], condemned "the unbearable slowness of this clandestine and frugal pogrom, which has taken three months to liquidate three Jews."

What's going on here? What's being reported and by whom? The rabid columnist of *El Mártir*—evidently still smarting two thousand years after the crucifixion of his hero, the martyr Jesus Christ—would like this "frugal pogrom" to proceed at a brisker pace. In this same mean spirit, the columnist for the other no less militantly titled paper, *La Cruz de la Espada* (echoing the glorious Crusades), contrasts the disorder provoked by this gathering of Jews in the city with the last major Christian gathering, that of the Eremitical Congress, a euphonic vagary that can mean only what it says, nothing more or less than an incongruous *gathering of hermits* who have abandoned their solitary caves and grottoes to attend an international convention!

This is obviously morbid humor, the grotesque kind of *humour noir* that makes one feel ashamed for having laughed. It is also a cultural critique, a reminder of what is wrong with our rancorous society. Ten years earlier, in 1932—just before Hitler's coming to power—Borges used a courtesy prologue to Roberto Godel's book of poems, *Nacimiento del fuego,* to work in a criticism of Luis de Góngora, Spain's greatest writer of the baroque, for much the same kind of rabid thinking: "hombre de tan atrofiada imaginación que se burla una vez de un auto de fé provinciano, que se limitaba a *un solo* quemado vivo"

[a man of such an atrophied imagination that he once ridiculed a provincial *auto-da-fé* for having *only one* live victim].[5]

In 1934, with Hitler now a reality, xenophobic sentiments become more vocal in Argentina, and Borges is accused of "hiding his Jewishness." He replies with customary wittiness, stating that he has nothing to hide and reasoning that he probably is, or must be, Jewish. After all, doesn't everyone of Spanish or Portuguese descent have Jewish blood? "It is a matter of simple hypothesis," and "it does not displease me to imagine myself as a Jew," he says in his pithy essay of affirmation "Yo, judío" [I, a Jew], in *Megáfono* (April 1934).

■

Moral righteousness aside, however, I return to the subject of Borges's "religious" humor as highlighted through some persecution-complex Catholics in twentieth-century France. The story, "Pierre Menard, autor del *Quijote*" [Pierre Menard, author of the *Quixote*], first published in 1939 and later included in *Ficciones,* relies on one of the basic techniques of comedy: the creation of types such as the miser, the glutton, the liar and the exaggeration of their peculiar characteristics—what in Ben Jonson's time were called "humours." In this modern-day comedy of humours, disguised as a necrology, Borges creates two outlandish types: the adulating critic who worships a single author, and the worshiped author as plagiarist, before ultimately inserting himself into the story and rounding things out with a typical self-parody. First however, he casts the revered author, Pierre Menard, as the writer who writes, or rather rewrites, the classics, a kind of "appropriationist" who even recycles his own work, practicing the postmodernist art of *"re-escritura"*—without, however, bothering to change a single word, not even the punctuation. Menard, a stuffy twentieth-century Frenchman—who is a ringer for Paul Valéry—has the singular distinction of having rewritten *Don Quixote,* word for word, in the seventeenth-century Spanish of Cervantes, a twentieth-century feat, we are facetiously told, that far surpasses that of the novel's original author, for whom everything was supposedly easy by comparison. After all, it's a cinch to write exactly like Cervantes, if you actually are Cervantes!

The story anticipates what has since come to be known as reader response criticism. It even ends with a lesson on what Borges calls "the art of reading." My concern now, however, is not with its ending but rather with its beginning, with how the story gets under way, with what Donald Shaw in a useful and eminently readable book calls *Borges' Narrative Strategy* (1992). The story masquerades, as do so many of Borges's texts, as a document, an obituary for the deceased Pierre Menard. The implied author is not Borges but rather an unnamed admirer of Pierre Menard, someone not unlike what in

English we would call an "effete snob," and what in Spanish would be called a *"cursi,"* in this case, a militant, Catholic-convert variety of snob.

The opening lines of the text, with their supercilious tone, immediately introduce the reader to the comic-parodic nature of the obituary. The quaint capitalizations and typographic emphases in the following quote correspond to the original and emanate from Borges's hysterically effete narrator, the supposed penman of the piece, who, true to his characterization as a passé symbolist, highlights his own hackneyed imagery:

> The *visible* works left by this novelist are easily and briefly enumerated. It is therefore impossible to forgive the omissions and additions perpetrated by Madame Henri Bachelier in a fallacious catalogue that a certain newspaper, whose *Protestant* tendencies are no secret, was inconsiderate enough to inflict on its wretched readers—even though they are few and Calvinist, if not Masonic and circumcised. Menard's true friends regarded this catalogue with alarm, and even with a certain sadness. It is as if yesterday we were gathered before the final marble and the fateful cypresses, and already Error is trying to tarnish his memory . . . Decidedly, a brief rectification is inevitable.

The irony is generated by the contrast between what the writer assumes about himself and what the reader must infer about him. He sees himself to be broad-minded and impartial, we see him as a small-minded bigot.

What makes this work, of course, is the use of a dramatized narrator whose voice in the text supposedly penned by him is decidedly different and distanced from that of its real author, Borges. This text, incidentally, first appeared in the back pages of the literary journal, *Sur,* as though it were a necrology sent in from Nîmes by an admirer of Pierre Menard, a fellow Provençal—like Valéry, the philosophical poet of Sète—from the south of France. In a 1979 interview with Antonio Carrizo (*Borges el memorioso,* 1982), first taped for Argentine radio and television, Borges reveals both his delight and his amazement at how this patently false necrology once fooled both reader and publisher:

> *Carrizo.* "Pierre Menard, Author of the Quijote?"
> *Borges.* Well, that joke [broma] was taken seriously by a lot of people. I recall how Ernesto Palacio told me that he already knew all about Pierre Menard . . . , who must have been a real nut. "He sure was," I replied. I didn't want to tell him that the whole thing was a joke . . . It was published in *Sur* as an article. I didn't tell them that it was a story, and it appeared there among the articles. With all the seriousness and perhaps even some of the tediousness

of an article as well. So lots of people took it seriously, because no one thought of me then as a fiction writer, but rather as an essayist. And, it was taken seriously!

Obviously, what astonished him is that even his readers from the supposedly sophisticated inner circle of *Sur* were taken in by the joke. This is especially amazing in view of the fact that Borges overdetermined the ironic portrayal of his dramatized narrator, having him begin his "rectification" with an allusion to his "high" social connections among the hungry aristocracy of the French Riviera:

> I am certain that it would be very easy to challenge my meager authority. I hope, nevertheless, that I will not be prevented from mentioning two important testimonials. The Baroness de Bacourt (at whose unforgettable *vendredis* I had the honor of becoming acquainted with the late lamented poet) has seen fit to approve these lines which follow. The Countess of Bagnoregio, one of the most refined minds in the principality of Monaco (and now of Pittsburgh, Pennsylvania, since her recent marriage to the international philanthropist Simon Kautzsch . . .

Even the supposedly aristocratic names have a hollow pedigree, for they are based on puns: "Bagnoregio" = *bagno regio* = royal bath; "Bacourt" = *bas court* = public toilet. The technical term for this rhetorical device, which goes back to Roman rhetoric, is *agnominatio,* a word that today obscures rather more than it clarifies. Despite all this, many readers back in 1939, and later in 1944—like many of today—read the text seriously. So, in the second edition of *Ficciones* in 1956, Borges made a few changes, adding, for example, to the mention of the recently married Pittsburgh "philanthropist" Simón Kautzsch (another *agnominatio,* a joke made by wordplaying upon the proper name: "Kautzsch" = *kauz/kautschuk* = owly-eyed "rubber" baron) the following heavy-handed sigh of exasperation by his unconditional admirer: "tan calumniado, ¡ay!, por las *víctimas* de sus desinteresadas maniobras" [alas, so slandered by the *victims* of his impartial manipulations]. Such ungrateful wretches, these fortunate "victims" of "impartial" robber baron capitalism!

Earlier, in 1942, polishing the essay for inclusion in *El jardín de senderos que se bifurcan,* he expanded and made more apparent the shift in authorial voice midway through the text when the stable irony is dropped, and another voice, very much like that of Borges, takes over to speculate on the import of Menard's literary practice, introducing the idea of "un segundo Pierre Menard, invirtiendo el trabajo del anterior" [a second Pierre Menard, inverting the work of the first]. This second voice culminates with the absurdly anachronistic proposition of reading the *Odyssey* as though it were posterior to the *Aeneid,*

or perhaps even attributing to the Jew-baiting Céline a medieval devotional manual like *The Imitation of Christ*. Again, *reductio ad absurdum* is used to oblige the reader to reflect on what is being read. And to make sure of this, he also added one more clue: an ironic self-portrait in the form of a footnote, describing Menard's writing habits in terms of his own: "I remember his square-ruled notebooks, his blacking out words, his peculiar typographical symbols, and his insect-like handwriting. In the late afternoon he liked to go for walks in the outskirts of Nîmes." The allusion is veiled and is solely for Borges's own amusement and that of his friends. No reader of the time outside of Borges's immediate literary circle could possibly be expected to know what his manuscripts looked like, or to have read and remembered "Por los viales de Nîmes" [Along the Roads of Nîmes], an early poem from *Luna de enfrente,* a 1925 edition of just three hundred copies, most of which were still unsold at the time of writing "Pierre Menard." Borges, in the early 1940s, still thought of himself as writing for just a few readers, a select few whom he thought would be perhaps more alert than the pompous Ernesto Palacio—who, let's remember, "already knew all about Pierre Menard"—and whom he thought would be able to enter into his game of transformations, making the serious silly and the silly serious.

■

Thus far we have seen how Borges has taken established forms of writing— the familiar codes of the book review, the detective story, the obituary—subtly transforming them into parodies of their genre, all the while maintaining the public stance of a serious writer. All too many serious-minded critics have been slow in catching up with him, slow in reading what he actually wrote: for example, Gérard Genette of narratology fame, whose essay on Borges in *Figures I* (1969) seems to have missed the irony of the two narrative voices in "Pierre Menard," conflating them into one, and what is worse, assigning the effete voice of Menard's admirer to Borges himself! This, despite what he has to say about the importance of inflections of voice in what he calls "Altérations" in *Figures III* (1972).

Borges's dissatisfaction with academic critics in general was expressed in his interview with Burgin:

> *Burgin.* The people that write about you all write the same things.
> *Borges.* Yes, yes, and they all make things too self-conscious and too intricate at the same time . . . The tale itself should be its own reality, no?

Part of what makes reading Borges fun is the ongoing sensation of discovery, the growing satisfaction of feeling oneself part of the tale, of being up to the

author's expectations. The "sudden glory" of Hobbes? The "intellectual gratification" of Koestler? Perhaps. Although it's one thing to chuckle knowingly with Borges over idols of yak lard, librarians having to defecate in a standing position, or an Aleph down in the basement, and quite another to get out from under the hypnotic spell of the text, to step just far enough away from it so as to appreciate how Borges plots, paces, and even reworks his discourse so that we are obliged finally to "get the joke," to see its really big put-on thanks to the repeated nudges of all the little ones.

The mechanism of how Borges cues the reader, alerting us to the fictional reality of the tale, is most evident in the opening and closing passages of one of his longer and ostensibly more weighty texts, a piece that year by year generates increasingly more ponderous readings: "Tlön, Uqbar, Orbis Tertius," which could be literally rendered as "Tlön, Uqbar, Third World," a story from *Ficciones* that was included in his 1940 *Antología de la literatura fantástica,* a compendium of fantastic literature—recently translated into English under the title *The Book of Fantasy* (1988). The story also appeared at about the same time in the May 1940 issue of *Sur,* the very same journal that printed the bogus obituary of Pierre Menard the year before. It looks and reads like any other article in *Sur,* resembling an essay, or a memoir recounting the search for a missing volume of the *Anglo-American Cyclopaedia* that purportedly contains an entry on "Uqbar." Disguised as an authentic eyewitness account of a disquieting personal experience, almost all the referents are real and would or should have been recognized as such by its original Argentine readers. This time around, though, the dramatized narrator is Borges himself.

Its opening page contains a long, run-on account with no paragraph breaks, thus strategically leaving the reader with no possibilities to pause and reflect on the labyrinth into which we are being led: "I owe the discovery of Uqbar to the conjunction of a mirror and an encyclopedia. The unnerving mirror hung at the end of a corridor in a villa on Calle Goana, in Ramos Mejía; the misleading encyclopedia goes by the name of *The Anglo-American Cyclopaedia* (New York, 1917), and is a literal if somewhat tardy reprint of the 1902 *Encyclopaedia Britannica.* The whole affair happened . . ." Through the accumulation of concrete and seemingly trivial details about the "discovery of Uqbar" in a pirate edition of the *Britannica,* Borges situates us in the realm of everyday reality (without breaking the paragraph):

> The whole affair happened some five years ago. Bioy Casares had dined with me that night and we talked at length about a great scheme for writing a novel in the first person, using a narrator who omitted or corrupted what happened and who generated various contradictions, so that only a handful of readers—a very small handful—would be able to decipher the horrible or banal reality.

53

But isn't this precisely the situation of this piece? A first-person narrative, corrupted, so that at least some alert reader (like ourselves) can decipher it, making us feel part of the select group capable of discovering its "horrible *or* banal reality." The connective "or" that usually links synonymous terms is disjunctive when applied to antonyms, and here serves as an explosive to jolt the complacent reader into a state of alert. The seamless paragraph continues:

> [O]nly a handful of readers—a very small handful—would be able to decipher the horrible or banal reality behind the novel. From the far end of the corridor, the mirror was watching us. And we discovered (with the inevitability of discoveries made late at night) that mirrors have something grotesque about them. Then Bioy Casares recalled that one of the heresiarchs of Uqbar had declared that mirrors and copulation are abominable, since they both multiply the numbers of man. I asked him the source of that memorable sentence,* and he replied that it was recorded in the *Anglo American Cyclopaedia,* in its article on Uqbar.

An exhaustive scrutiny of the copy of the encyclopedia in the rented villa fails to turn up the reference:

> It so happened that the villa (which we had rented furnished) possessed a copy of that work. In the final pages of volume XLVI, we ran across an article on Upsala; in the beginning of volume XLVII, we found one on Ural-Altaic languages; but not one word on Uqbar. A little put out, Bioy consulted the index volumes. In vain he tried every possible spelling—Ukbar, Ucbar, Ooqbar, Ookbar, Oukbahr.

Back in Buenos Aires the next day, Bioy Casares checks his copy of the encyclopedia to find that the reference does indeed exist there, exactly as he had remembered it. Further investigation determines that his copy of the encyclopedia is unique, containing some additional pages with the entry on Uqbar. What follows is a detailed, first-person, eyewitness account of a series of "finds" that leads Borges as the self-reflective reporter to conjecture that a secret society had decided to invent a planet, seeding the world with clues to its existence. As the account progresses, and the details accumulate, the invented planet turns out to have an uncanny resemblance to our own world. It is at this point that Borges gives his narrative an additional twist, revealing to the reader—even the not so "alert" reader—that this is just a fiction, an entirely made-up story. The device is a postscript, an otherwise

* A private joke; it's actually something Borges made up and which appeared in several earlier pieces, most notably in "El tintorero enmascarado" (*Historia universal de la infamia* [1935]).

standard authenticating stratagem. Borges's unique use of the postscript here, though, obliges the reader not only to reflect back on what has just been read but to question what is being read at that very moment.

The story, when it was *first* published in 1940, carried a postscript dated "1947," a calculated anachronism. And, to prevent the reader of the May 1940 issue of the green-covered *Sur* from dismissing it as a typo, Borges drives the point home: "*Postscript, 1947:* I reproduce the preceding article just as it appeared in number 68 of *Sur*—green cover, May 1940—with no omission other than that of a few metaphors and a kind of sarcastic summary which now seems frivolous. So many things have happened since then. I shall do no more than recall them here. In March of 1941 . . ." This is *what he says in the May 1940 issue* of *Sur* 68, green cover, the very same volume the reader would have in his hands!

Writing, for Borges, obviously does not depend simply on *what* is being said but rather on *how* it is being said, and, most important, *how* it is being read. And Borges tried to control the reading of this piece. So, when it was collected in his 1940 *Antología de la literatura fantástica,* he changed the wording of the postscript to refer specifically to the volume then at hand: "*Postscript, 1947:* I reproduce the preceding article just as it appeared in the *Antología de la literatura fantástica,* 1940, with no omission other than . . ."

Eventually though, the calendar overtook him, and the deliberate anachronism could no longer be sustained. Today, most readers, even those who like to think of themselves as "alert," simply take the 1947 postscript for something actually added in 1947, and not in 1940. And that's all right, I suppose, because the real source of the humor in "Tlön, Uqbar" is "*Orbis Tertius,*" the mysterious planet, the "*third world*" which is none other than the earth itself, a third-rate planet in a third-rate solar system invented by a third-rate demiurge, this planet that we inhabit as third-rate figments of the imagination of "the God of Berkeley" destined to vanish when he stops thinking about us: "at times, some birds, a horse, have saved from oblivion the ruins of an amphitheater."[6]

I mentioned earlier the "art of reading." The closing paragraph of "Pierre Menard, Author of the *Quixote*" offers a surprisingly modern, avant poststructuralist lesson on what has come to be called the "phenomenology of reading." The voice is now that of Borges and *not* that of the adulating author of the necrology: "Menard (perhaps without wishing to) has enriched, by means of a new technique, the hesitant and rudimentary art of reading: the technique is one of deliberate anachronism and erroneous attributions."

The "technique" of course is that of Borges himself, in the postscript to "Tlön," in "Pierre Menard," and in countless other texts. The idea is to surprise the reader, to force a reflection on what is being read, and in so doing to generate another, closer reading of the piece. This is Borges's way of having fun.

Chapter 3

Making Fun
of Others

Ridicule is just one phase of humor and is not always the basis for
a laugh, although it's a surefire shortcut.

Mae West

Back in his ultraist beginnings, when Borges was a young firebrand, his
preferred mode of humor was out-and-out ridicule, making fun of what
others took seriously. In a letter of February 2, 1925, he confides to his friend
Guillermo de Torre (1900–71)—the equally young founder and promoter of
ultraism in Spain, who was soon to wed Borges's sister Norah, thus putting a
chill on their friendship—that the next issue of *Proa* (a homemade avant-garde
magazine [1924–26] and vanity press domiciled in the Borges family's Buenos
Aires apartment, 222 Quintana) was going to be a really good one: "somewhat
burlesque, coinciding with Carnival and with lots of nonsense, in the style
of Macedonio,* parodies, epitaphs, light verse in Creole,† calligrams, etc."[7]
The project apparently did not materialize in time for Mardi Gras, although
the April and May 1925 issues of *Proa* (nos. 9 and 10) do contain some
items obviously designed for laughs: a tongue-in-cheek ode to a fountain ("Yo

* An allusion to Macedonio Fernández (1874–1952), an Argentine intellectual idol of Borges's
 generation and author of *Ensayo para una teoría del humor* (1940), whose work reflects a
 humoristic vision of the world.
† Creole [*criollo*] in Argentina, and in much of Latin America, means simply "born and raised
 on national soil" and is used as a noun and adjective to indicate something that is authentic,
 homespun, a true product of the land. As used here, it would mean verse in the style of gaucho-
 speak.

amo tu bronce, fuente" [Fountain, I Love Your Bronze]); a facetious review
of Ortega y Gasset's latest book of essays; and a smattering of pointedly
absurd news stories about various cultural activities in Buenos Aires, some
real and some fabricated, such as the founding of an Argentine "section" of
the *Unión Latinoamericana*—a neat contradiction—and a put-on review of
an art competition whose judges unanimously awarded the first prize to a
masterwork titled "The Jury," which the general public would, however, be
unable to view since it was being "exhibited in a secret room," presumably
the room where the jury had met. An anticipation of the art-as-"happening"
aesthetic of the 1960s?

This same penchant for the put-on is evident in many of the essays
collected in *Inquisiciones* [Inquisitions] (1925), ridiculing some of the sacred
cows of Spanish and Spanish American literature: the pompous Unamuno,
for example, or the copycat followers of the refined Rubén Darío, as well as
the weekend cowboys, the big-city authors of Argentine literature on the rural
gaucho. The idea was to punch holes in anything and everything that was then
being puffed up by others.

■

It was in the *Prisma* manifesto slapped up all over Buenos Aires in 1921 by
Borges and his buddies that the fancy verbiage of *Modernismo*—the Hispanic
variant of later symbolism—was derided for its abuse of certain high-sounding
cliché words like *inefable, azul,* and *misterioso.* In the book of 1925, whose
title plays on the dual meaning of "inquisición" as both an intellectual inquiry
and an inquest of the dreaded Holy Office, these very same clichés become
the subject of an *auto da fé* in the satirical essay, "Ejecución de tres palabras"
[Execution of Three Words]. Borges begins this piece "quemando la palabra
inefable" [burning the word *ineffable*] and ends it by adding to the flames
"azul" [blue], the color code word that had come to symbolize everything
ethereal in fin de siècle poetry. *Azul . . .* (1888), with its suggestively open-
ended ellipsis, was the title of Rubén Darío's foundational text of Hispanic
Modernismo, and had become the be-all and end-all of turn-of-the-century pre-
vanguard poetry, the tuning fork of its sonorous rhyme. Borges accordingly
changes its pitch, turning the assonance of rhyme against itself, introducing
dissonances of meaning to the word-pairing generated by this term, which was
everywhere in the Spanish-language poetry of the time: "*Azul* que apicarado
de gand*ules,* frondoso de abed*ules* y a veces impedido de ba*úles,* se arrellana
por octosílabos y sonetos en los sitiales donde antaño pontificaron los *rojos*
en su arrabal de ab*rojos,* ras*trojos* y demás asperezas consabidas."

A literal translation of this sentence gives us something as nonsensical
as "blue which becomes roguish with idlers, luxuriant as birch trees, and

sometimes even gets blocked by travel trunks, settling itself into octosyllables and sonnets in the very places where before had reigned the reds, with their neighborhood of thistles, stubbles and other well known roughages." Ignoring literal meaning and with the aid of a rhyming dictionary, one might better render it as follows: "Blue which becomes roguish in values, teeming with igloos, and sometimes even gets blocked by slews of glues and hullabaloos, settling into octo syllables and sonnets in the very places where before had reigned the reds, with their hatreds of sweetbreads and their hundreds of bedspreads in threads."

It obviously doesn't take an extraordinary talent to generate this sort of nonsense, and that was Borges's point. However, had he confined his wit to this facile level of mere ridicule, there would probably be no need to remember it now. Ridicule may not always be the basis for igniting a laugh, but as Mae West said, it is a "surefire" start, and Borges's *Inquisitions* do more than that; they submit to the flames of ridicule not only the dead leaves of *Modernista* foliage but also the effigies of its principal cultivators, among them the revered and prolific Miguel de Unamuno (1864–1936), who had come to occupy a pedestal so high that his shadow still looms over us today.

■

Traditionally subdued in its consideration of things Hispanic, the *Britannica* literally gushes over Unamuno, crediting him in its 1991 edition with being an "early Existentialist" and an "accomplished playwright" who, however, was "most influential as an essayist and novelist," and triumphantly ends with the assertion that his poetry is "a superb example of modern Spanish verse." Unamuno, even today, can do no wrong. For the young Borges, though, the old man could then do nothing right. The essay dedicated to him in *Inquisitions,* although blandly titled "Acerca de Unamuno, poeta" [On Unamuno, the Poet], is pitiless in its celebration of his failings. There we learn that *"don"* Miguel de Unamuno (the gratuitous honorific places him among the geriatrics) is one of those who *"practican"* [practice] literature—as though it were a licensed trade like law or medicine. In this context we should remember the great medieval philosopher Averroës, whom Borges downgraded to a "médico árabe"—an Arab physician hopelessly muddled by metaphysics. The essay goes on to comment on Unamuno's "nobilísima *actuación* de poeta" [very noble *actuation* as a poet], as though the old "don" were struggling to act out a difficult role, a role in which he is somehow out of place. For Borges, Unamuno is an "extra-*ordinary*" figure; he is a hybrid, a "philosophical poet," an extremely ordinary writer in whose verses "no hay el más leve acariciamiento de *ritmo*" [there is not the slightest coddling of *rhythm*]. The phrasing is important here, for what starts off sounding like praise for Unamuno's high

poetic standards ultimately ends as a put-down for the total lack of rhythm in his verses. Indeed, everything Borges says about Unamuno is in this same vein, backhanded and ambiguous, generating different and conflicting interpretations in quick succession. This is the "derailment" technique of Max Eastman, where the thrust is straightforwardly positive but, like a swimmer pushing against an ocean liner, the resulting movement is backward. Unamuno in this way comes across as a Bergsonian comic figure, as one whose grandiose efforts amount to nothing; he is forever flailing in the dark.

Borges, pretending to marvel over the "eficacia visual" [visual efficacy] of Unamuno's "philosophic" poetry, cites an example from the *Rosario de sonetos líricos* [The Rosary of Lyric Sonnets]—silly as it sounds, that's a real title, one Borges didn't have to make up—before finally baring his teeth and going in for the kill:

> And since we're talking about images, I'd like to point out the wondrous candor that allows into his poems phrases—and not just a few—like this one:
>
> > Recogí este verano a troche y moche
> > frescas rosas en campos de esmeralda.
>
> [This summer I plucked here and there / fresh roses in fields of emeralds.]
>
> Shame and pity are given off by this metrified feebleness, but it's a convincing testimony of the poet and of how he is a nice man and not a grandiose terrorizer of the innocent.

The devastating conclusion, that Unamuno is not really so bad after all, since he is a "nice man," one whose ideas are completely harmless, is not unlike Borges's judgement of Carlos Argentino Daneri's efforts at poetry: "completely meaningless."

A few years after *Inquisitions,* in 1930, Borges takes another swipe at Unamuno in a halfhearted biography of *Evaristo Carriego,* an early twentieth-century Argentine writer and personal friend who thematically incorporated the lowlifes of Buenos Aires into his poetry. In a chapter dedicated to "La canción del barrio," [Song of the Neighborhood], Borges finds occasion to ridicule one José María Salaverría (1873–1940), then and now an all but ignored Basque author of hundreds of pompously titled philosophical essays and more than a dozen lame and lengthy novels. Utilizing the switching technique of "or" to generate derision, the prolific Salaverría is downgraded to a "journalist, *or* Basque artifact." The real target however is not Salaverría; this is simply a preliminary maneuver to set things up to belittle another equally prolific and much more famous Basque writer, namely Unamuno, who

is alluded to on the next page as "*otro* Salaverría" [*another* Salaverría]—in other words, another "Basque artifact"—in this case, the author of a sometimes celebrated essay on *Martín Fierro* (in *Revista Española,* February 1894), an essay that, in Borges's view, goes on and on about this "ballad singer of the pampa," one who in the "endless calm of the desert," recites to the accompaniment of his "Spanish" guitar the "monotonous *décimas*—ten-line stanzas—of *Martín Fierro.*" Then, once all the pieces are in place, Borges adds this crushing punch line: "but the writer [Unamuno] is so monotonous, *decimated,* endless, Spanish, becalmed, deserted and accompanied, that he hasn't noticed that there are no *décimas* in *Martín Fierro.*" The mistaken "décimas" are used to "decimate" the authority of the older Spaniard, the "Basque artifact," *don* Miguel de Unamuno.

When the news of Unamuno's death reaches Argentina, Borges is prompted to write a necrology. Ironically titled "Presencia de Miguel de Unamuno" [Presence of . . . Unamuno], it begins in this ambiguous way: "Sospecho que la obra capital de cuantas escribió Unamuno es *El sentimiento trágico de la vida;* su tema es la inmortalidad personal" [I suspect that the capital work of the many that Unamuno wrote is *The Tragic Sense of Life;* its theme is his personal immortality]. Citing this book's title in the context of the author's death sets things up for a clash that makes it read like a *humour noir* inscription for his tombstone.

As a satirist, Borges is merciless with his victim. Aristophanes wasn't exactly kind to Socrates when he portrayed him in *The Clouds.* And although there's a lot of time and space separating Unamuno from Socrates, the lofty heights in which they both placed themselves makes the temptation to bring them down to earth understandable. Aristophanes irreverently swings Socrates out on a crane while having him uppily claim that he is walking on air. Borges similarly uses the occasion of Unamuno's real-life death to remind us of his lifelong quest for immortality. Pitilessly, his obituary goes on to recall some of the worst pieties from *El rosario de sonetos líricos,* poems with inane titles like "Hipocresía de la hormiga" [Hypocrisy of an Ant] and "A mi buitre" [To My Vulture], and concludes with this final irony, shrouding Unamuno's "presence" with adjectives of calculatedly conflicting value: "I understand that Unamuno is the top writer of our language. His corporal death is not his death; his presence—argumentative, *prattling,* tormented, at times *intolerable*—is still with us."* Order is important here, yo-yoing us up and down: argumentative > *prattling*; tormented > *intolerable.* So much for Unamuno, even in death

* "Presencia de Miguel de Unamuno," *El Hogar* (January 29, 1937). A somewhat different necrological essay, with the equally ambiguous title of "*Inmortalidad* de Unamuno," was published in *Sur* (January 1937) stating, among other things, that in the view of posterity "there was the *certain* risk that Unamuno's image would irreparably *damage* his work."

his flailing failings continue to haunt us, and if he's "the top writer of our language" it doesn't say much for our rating system. Throughout his writings, Borges will continue to kick away at Unamuno's cadaver, although always with this selfsame thrust of feigned praise that has kept most Spaniards fooled, fueling countless speeches, articles, and even books, on Borges's admiration of Unamuno and things Spanish.[8]

■

Another puffed-up Spanish giant of the moment was Ortega y Gasset (1883–1955), whose authority was such back in the 1920s that he single-handedly managed to put a stop to the avant-garde movement in Spain with his brilliantly wrongheaded *Deshumanización del arte* [Dehumanization of Art] (1925), persuading Spanish poets of the time to back off from their formalist experiments with language and to "humanize" the content of their verses. In other words, he effectively cowed a whole herd of writers, the famous Generation of '27, to follow the lead of Gerardo Diego (1896–1987) who promptly dropped the vanguard experimentalism of *Imagen* [Imagery] (1922) for the more traditional mode of his *Poemas humanos* [Human Poems] (1925). Borges finds Ortega to be an attractive target for derision and in *El tamaño de mi esperanza* [The Measure of My Hope] (1926) downplays his neo-Kantian intellectual project to the simple "Germanization of Hispanic thought."

In the April 1925 issue of *Proa* there is a falsely gushy review of his book on *Las Atlántidas,* hailing it as the latest example of Ortega's "privileged genius" and concluding that, in his case, "It doesn't matter that his discovery seems second-hand and his study trite. For he knows how to dress things up, through the charm of his style, so often exquisite, with a kind of universality." All throughout his work, Borges can be seen poking gibes at Ortega, but the Spaniard was far too agile a stylist to be reduced to ridicule through direct quotation. And so, in "El duelo" [The Duel], a story in *El informe de Brodie* [Doctor Brodie's Report] (1970), which I will discuss more fully in a later chapter, Borges has a budding Argentine artistic talent decide against becoming a writer after having read some pages of Ortega, whose writing style convinced her that "la lengua a la que estaba predestinada es menos apta para la expresión del pensamiento *o de las pasiones* que para la vanidad palabrera" [the language of her birth was less adequate for the expression of thought *or passion* than for wordy vanity]. The punch line here is two-fisted, equating Ortega's writing style with vapid wordiness, and through the tacked-on derisory "or" clause ("el pensamiento *o* las pasiones") downgrading his kind of intellectual reasoning to merely wishful thinking.

■

What Borges does with Ortega, or Unamuno for that matter, is *peccata minuta* when compared with what he does with Góngora (1561–1627), Spain's most celebrated Baroque poet. Góngora, it should be recalled, was singled out for homage in 1927 by the ex-avant-garde poets grouped around the newly "humanized" reviews like *Litoral, Carmen,* and Ortega's own *Revista de Occidente.* The occasion was the third century of his death, and one outcome of the homage was to fix the identity of this group of poets as the Generation of '27. While everyone in the Hispanic world was scrambling to climb onto the Góngora bandwagon, Borges backs off, expressing his "adherence" to the trumped-up occasion with polite sarcasm in a 1927 article, "Para el centenario de Góngora" [For Gongora's Centennial], collected in *El idioma de los argentinos* (1928): "I'll always be disposed to think about don Luis de Góngora every hundred years . . . if ninety-nine years of oblivion and one of slight attention is what is understood by a centennial."

This is the same yo-yo technique of derision he used on Unamuno, first up, then down. The year before, as things were getting under way for the Gongora celebration, Borges devoted a 1926 *Tamaño . . .* essay to one of his poems: "Examen de un soneto de Góngora" [Examination of a Sonnet by Góngora]. Interestingly enough, the text he singles out for scorn is Sonnet 58, the very same poem that poet-philologist Dámaso Alonso—of Generation of '27 fame—would later praise as an example of "reiterative correlation" in his *Estudios y ensayos gongorinos* (1955). This is the sonnet that begins

> Raya, dorado Sol, orna y colora
> Del alto Monte la lozana Cumbre,
> Sigue con agradable Mansedumbre
> El rojo paso de la blanca Aurora.

> [Shine, golden Sun, adorn and color / the luxuriant Summit of the high Mountain, / follow with delightful Docility / the rosy passing of the white Aurora.]

Borges first makes some light fun of its simplistic repetitions, then deviously seems to move on to praise Góngora for the poet's supposedly pure "delight" with emphasis (in much the same way that he had acknowledged that Unamuno was a "nice" man), before finally returning to the simplicity theme, but now only to deride it as childish singsong:

> How can one imagine that in seventeenth-century Spain, trans-fixed by ingenious literature, there might be any novelty in calling the sun *golden* and the mountain *high* and the summit *luxuriant* and the aurora *white*? There is neither precision nor novelty in these obligatory adjectives, but there is perhaps something better.

There is an emphasizing of things and a stressing of them, which is a sign of delight. To say a high mountain is almost like saying a mountainous mountain, since the essence of a mountain is elevation. Moony moon [*"luna lunera"*] is what little girls say in ring-around-the-rosy and it's as though they were saying a moon that's one heck of a moon. "Sigue con agradable Mansedumbre / El rojo paso de la blanca Aurora" [Follow with delightful Docility / the rosy passing of the white Aurora] seems to make counter sense: it's as though we were to admire the delightful docility of the ship that follows its prow and the dog that runs after its bark.

The essay continues in this disparaging way, making fun of the poem verse by verse, almost word by word, and several pages later concludes with a backhanded acknowledgment that one might object that it's easy to pick a thing to pieces through close argument but that he singled out this poem because he wished to show "en la pobreza de uno de los mejores, la miseria de todos" [in the poverty of one of the best, the misery of them all]. A sententious phrase of maliciously calculated equilibrium, the classic formula of escalated reversal: poverty is misery, the worst is one of the best.

For Borges's contemporaries, such as the Spanish poet-philologist Dámaso Alonso, the take on Góngora was just the opposite. Dámaso copiously annotated and explicated practically every word of the *Soledades* for the 1927 centennial edition, praising the baroque poet's creative genius while rhetorically combating his real and imaginary detractors. This circumstance provided Borges with a convenient opportunity to make fun of *both* Dámaso *and* Góngora. In "La simulación de la imagen" [The Faking of Imagery], a 1928 essay directed mainly against the limitations of the experiential esthetics of the guru of the moment, Benedetto Croce, he manages to insert a paragraph that makes Góngora and his latter-day advocate both look foolish. The tone of the passage is falsely elevated, beginning and ending with a sly facetiousness:

The fallacy of the visual holds sway in literature. There are two delightful examples of this power in the unbridled praise of Góngora that Dámaso Alonso has prefixed to his edition, otherwise meritorious, of the *Soledades*. One serves to contradict the "afflictive poetic nihilism" of this rhapsody. It reads as follows: *"In the poetry of Góngora, flowers, trees, animals, birds, fishes, many delicacies . . . are sumptuously laid before the eyes of the reader. What could those who said the Soledades were empty have been thinking of? They are so chockfull that it is difficult for such a variety of things to be contained in so little space."* The ingenuous paralogism is self-evident: Alonso denies the poetic vacuity of the

Soledades, because of their visual load of feathers, fur, ribbons, hens, hawks, beads and corks. (emphases in original)

Borges derides the critic's retort to the alleged "emptiness" of the *Soledades,* finding them instead to be "full" of things, in order to take up the theme of their "obscurity," which Dámaso counters with an assertion of their "radiant" clarity:

> The second example is no less definitive. It's written this way: *"Obscurity no: radiant clarity, dazzling clarity. The clarity of an intimate, profound illumination. Shimmering sea: blue crystal. Sky the color of sapphire, immaculate, constelled with diamonds, or rent asunder by the arched trajectory of the sun."* Here, under the apparent assurance of sententiousness, smarts a similar error: that of inferring that don Luis de Góngora is clear, read perspicuous, for his mentioning things that are clear, read shiny. The nature of this sort of mix-up is that of a *calembour.* (emphases in original)

To reduce Dámaso Alonso's spirited revindication of Góngora to the level of a play on words is downright vindictive. But it is also amusing. And that's what Borges is trying to be as he makes fun of some of the stars of Spanish literature. Right or wrong, as he may be about Unamuno, Ortega, Góngora, or even Dámaso Alonso for that matter, the young Borges begins his literary career by inveighing against tradition. This was a standard tactical procedure in the militant days of the early avant-garde. Marinetti proposed burning down the libraries and gutting the museums; Borges, somewhat more realistically, liberates himself from the load of tradition by simply making light of its biggest heavyweights, reducing them to small fry. Unlike Marinetti, Borges goes on the attack more for the fun of it than out of conviction, which is probably why he consistently ridicules the major figures and lavishes praise on many lesser writers who happen to be his friends. There's no merit in poking fun at an unknown, since no one will have the coordinates to get the joke. Ridicule relies on recognition, on reducing the high and mighty to the level of the ordinary.

■

These youthful forays into giant bashing led him to reflect on the techniques of disparagement, and in one of the early issues of *Sur* (September 1933) there is a witty strategy paper on the "Arte de injuriar" [The Art of Verbal Abuse]. Later collected in *History of Eternity* (1936), it highlights the rhetorical techniques of ridicule and satire, the first of which, according to Borges, is to belittle

your opponent through false respect. Unamuno thus became *don* Miguel de Unamuno, just as Góngora became *don* Luis de Góngora:

> The title "Mister," an imprudent or unusual omission in the oral commerce of men, is derogatory when it is committed to print. "Doctor" is another annihilation. To mention the sonnets "perpetrated" by one "doctor" Lugones, is the equivalent of finding fault with their meter, to question each of their metaphors. At the first application of "Doctor," the semi-god is wiped out and all that remains is a vain Argentine gentleman who uses clip-on paper collars. . . . An Italian, in order to demythify Goethe, did a little article on him in which he never tired of referring to "il signore Wolfgang."

This is exactly what Borges does with some of the big names of Western culture. Hegel, for example, is cut down to size and domesticated as "*Jorge Federico Guillermo* Hegel"; the philosopher Nietzsche is alternately titled "el *filólogo* Nietzsche" [the philologist] or more familiarly and disparately called "*Federico* Zaratustra"; and the Frenchman of humor theory who also penned what Borges calls a "notorious" *Essay on the Immediate Data of Consciousness* is none other than good old "*Enrique* Bergson." In an essay for *El Hogar* in April of 1937, when the Third Reich was on the rise, its feared führer is mocked in much the same way, provincialized by couching his name among other obscure dictators, "desde Gelón de Siracusa a Hitler de Berlín" [from Gelon of Syracuse to Hitler of Berlin]. Practiced by Borges in his youth, this technique of "verbal abuse" remains a constant throughout his work. Thirty years later, in a winter 1967 interview with Ronald Christ for the *Paris Review,* he spells it out again:

> *Borges.* When one calls a poet "Mister," it's a word of haughty feelings; it means Mister So-and-So who has found his way into poetry and has no right to be there, who is really an outsider. In Spanish it's still worse because sometimes when we speak of a poet we say "Doctor So-and-So." That annihilates him, that blots him out.

Thus far we've seen his tongue-in-cheek derision of distant giants like Unamuno and Ortega, but where he really pulls out the stops and applies his "art of verbal abuse" to an exalted contemporary is in an article titled "Las alarmas del doctor Castro" [Doctor Castro Is Alarmed]. This eminent Spanish scholar (Américo Castro, 1885–1972), who emigrated to Argentina in the 1920s and founded the now famous Institute for Philological Studies before moving on to a distinguished academic career at Princeton, in 1941 published *La peculiaridad lingüística rioplatense y su sentido histórico,* a book that

Borges was emboldened to critique for the peninsularity of its reasoning. His ruinous essay-review, first published in *Sur* (November 1941) and later collected in *Otras inquisiciones* [Other Inquisitions] (1952), begins with the assertion that fallacious problems will produce fallacious solutions, and moves on to illustrate this maxim with some wild reasoning that Borges culls from Pliny the Elder, who, wishing to explain why dragons attack elephants only in the summer, "ventures the hypothesis that they do it in order to drink the elephant's blood, which, as *everyone knows,* is very cold." This, according to Borges, is the same kind of fallacious argumentation employed by the famed Spanish philologist, "el *doctor* Américo Castro," who attributes what he finds to be the "peculiarities" of Argentine Spanish to the nation's "gauchophilia," an archaizing infirmity, which, as "everyone knows," is endemic to Buenos Aires. With labored politesse, heightened by parallelisms so as not to "doubt" the scholar's intelligence or integrity, Borges adopts a perspective that would today be called "postcolonial" to prove the fallacy of Américo Castro's incorrigibly Eurocentric reasoning:

> The *Doctor* makes *appeal* to a method that we must classify as sophistic, to avoid casting aspersions on his intelligence; as ingenuous, to banish doubts regarding his integrity . . . *Doctor* Castro *imputes* to us the use of archaisms. His method is curious: he discovers that the most cultivated persons in San Mamed de Puga, in Orense,* have forgotten a certain usage of a certain word; he immediately decides that every one in Argentina should forget it too. On every page of this book, *Doctor* Castro *abounds* in . . .

There are, to be sure, many other factors at work here besides the repeated use of "*doctor*" to deflate the authority of Américo Castro's argument, not the least of which is the strategic use of loaded verbs like *apelar, imputar, abundar* [appeals, imputes, abounds], which make it sound like the poor academic is clutching at legalistic straws to keep his feeble reasoning afloat. Borges himself, in his essay on the art of verbal abuse, spells out the technique ("*cometer* un soneto, *emitir* artículos"):

> *To perpetrate* a sonnet, *to concoct* articles. Language is a repertory of these convenient snubs which are the main currency of controversies. To say that a writer has *discharged* a book, or has *cooked* it up or *grunted* it out, is an easy temptation; rather more effective are the verbs of bureaucrats or shopkeepers: *dispatch,*

* On the surface this is set up to sound like a remote village of Spain, hence pure, but "San Mamed" [Saint Mohammed] is a most unlikely toponym and "Puga" sounds an awful lot like "pulga," or "flea"—not to say "puta," or "whore."

circulate, sell. These dry words combine well with others more
effusive, and the shame of the victim is eternal.

To illustrate how these "dry words" work, Borges offers an example based
on what he calls the "fallacy of confusion": "A una interrogación sobre un
martillero que era sin embargo declamador, alguien inevitablemente comunicó
que estaba rematando con energía la *Divina Comedia.*" [To a question about a
martillero (an auctioneer, literally a man with a hammer), who also used
to recite poetry, someone inevitably responded that he was energetically
knocking off the *Divine Comedy.*] The dry word here is *rematar,* which has
the dual meaning of finishing something off (with say, a needle, a pen, or
a hammer) or closing something out (as at an auction). When it is followed
by the "more effusive" adverbial expression ("con energía"), the result is a
statement going in two directions at the same time, abruptly "confused" into
a single action: an auctioneer incongruously finishing up, or "knocking off,"
the *Divine Comedy.*

■

The joining of the disparate by confusion creates a kind of short circuit that
is akin to the spark that detonates metaphor for the avant-garde. And humor
does function like metaphor. The key element in both is surprise, to suddenly
generate the unexpected. Ultraism was after all an offshoot of dada.

From this perspective it is easy to understand why Borges was an early
admirer of one of the masters of wordplay in his time, James Joyce, favorably
reporting on his own admittedly hopscotch reading of *Ulysses* (1922), and
translating the soliloquy of Molly Bloom for the January 1925 issue of *Proa.*
Admiration did not, however, prevent him from slipping in a jibe about what
for him was the novel's inordinate length: "If Shakespeare—according to his
own metaphor—placed in the timespan of an hourglass the feats of many
years, Joyce inverts the procedure and spreads the single day of his hero over
many days of the reader. *I didn't say many siestas.*" Later, as Joyce's fame
continued to grow, Borges would revise the sotto voce parenthetical punch
line, cleverly saying what he claims not to say, and insert this same joke about
Ulysses' inordinate length and soporific power in several different essays:
"Joyce spreads the single day of Mr. Leopold Bloom and Stephen Dedalus
over the days *and nights* of his reader."*

Boredom, or the mere suggestion of boredom, is one of Borges's more
repeated annulling devices. In "The Art of Verbal Abuse," he offers this

* From a review of *Time and the Conways,* by J. B. Priestley in *El Hogar* (Buenos Aires, October
15, 1937). Substantially the same line is also contained in an earlier review of what he considered
to be a tedious book on "Film and Theater" in *Sur* (November 1936).

example: "un encanto el último film de René Clair; cuando nos despertaron" [a delight the latest film of René Clair; when they woke us up]. Earlier, in 1926, he used a yawn to discredit what he considered to be the French version of the cerebral Unamuno: "las investigaciones de Bergson, ya bostezadas por los mejores lectores" [the analyses of Bergson, already yawned by the best readers]. Here, the trick consists in using an intransitive verb transitively. At other times it is a simple verb substitution as in the noble cliché "morir por la patria" [to die for one's country], which echoes in his compliment to a dutifully viewed Argentine movie (*La Fuga, Sur,* August 1937) that unexpectedly turns out to be interesting, causing Borges to express his relief, this time at least, at not having to "*dormir* por la patria" [*sleep* for his country].

After the publication of Stuart Gilbert's study guide *James Joyce's Ulysses* (1930) detailing the novel's elaborate parallels with the *Odyssey,* Borges's attitude changed from bored admiration to outright derision. Since Borges likes his readers to work at getting a joke or capturing an allusion, he now laments that thanks to Joyce's coaching of Gilbert, the novel itself has become "expendable." This put-down is inserted in an essay on narrative art in *Discusión* (1932), where Borges refers to the forced subtleties of Joyce, asserting that one need only examine "el libro expositivo de Gilbert o, en su defecto, la vertiginosa novela" [the expository book of Gilbert, or, in its absence, the vertiginous novel]. One might counter that Borges had his blind spots, but what is of interest is his insistence on ridiculing the idols of his time. In this way, yet another giant, Joyce, his once admired contemporary, became the butt of many easy jokes. In "The Approach to Almotasim," there is this comic barb: "The repetitious but insignificant contacts between Joyce's *Ulysses* and Homer's *Odyssey,* go on receiving—I shall never know why—the *hare brained* admiration of critics."

And, in a necrological note, "Fragmento sobre Joyce," in the February 1941 issue of *Sur*—Joyce had died the month before, on January 13—Borges is as pitiless as he was with Unamuno. Alluding again to Gilbert's study, he notes the propensity of critics to be dazzled by the insignificant: "The mere announcement of these imperceptible and labored correspondences was enough for the world to venerate the rigorous construction and classic discipline of the work. Of these voluntary 'tics,' the most lauded has been the most insignificant, the contacts of James Joyce with Homer."

In all fairness, however, it must be said that in his mature years, in a moving poem, "Invocación a Joyce" (*Elogio de la sombra* [In Praise of Darkness] 1969), Borges made peace with his contemporary. The poem is long and I cite just the opening lines, but even here though there is humor, directed now not at Joyce but at the "credulous universities" that venerate him:

Dispersos en dispersas capitales,
solitarios y muchos,
jugábamos a ser el primer Adán
que dio nombre a las cosas.
Por los vastos declives de la noche
que lindan con la aurora,
buscamos (lo recuerdo aún) las palabras
de la luna, de la muerte, de la mañana,
y de los otros hábitos del hombre.
Fuimos el imagismo, el cubismo,
los conventículos y sectas
que las crédulas universidades veneran.

[Scattered over scattered cities, / alone and many / we played at being that Adam / who gave names to all things. / Down the long slopes of night / that border on the dawn, / we sought (I still remember) words / for the moon, for death, for the morning, / and for man's other habits. / We were imagism, cubism, / the clans and sects / now revered by credulous universities.]

Thanks to hypallage, "credulous" comes across as something truly incredible.

Borges made a similarly wistful apology to Leopoldo Lugones (1874–1938) when, in 1960, he dedicated *El hacedor,* a collection of new prose and poetry, to the man he had formerly scourged and now wished to recognize as his master. The dedication evokes a fictional and anachronistic scenario, with a sixty-year-old Borges, now blind, making his way to his own office in the National Library—an office he imagines as once occupied by Lugones, author of *El lunario sentimental* (1909)—vaguely aware that, to his left and right:

> Absorbed in their lucid dreams, the momentaneous faces of readers are profiled in the light of their *studious lamps,* as in the hypallage of Milton. I recall having recalled that before, in this very place, while reading that other epithet which also defines through placement, the *arid camel* of your *Lunario . . .* These reflections bring me to the door of your office. I enter; we exchange some conventional pleasantries and I give you this book . . . in which you will recognize your own voice.

A decade later, prefacing *El oro de los tigres* [The Gold of the Tigers] (1972), the older Borges even went on to make peace with Rubén Darío, grouping him with Lugones and somewhat hyperbolically stating that the major influence on his writing came from their highly wrought *Modernismo,* "that enormous

liberation that gave new life to the many literatures that use the Castilian language."

■

The younger Borges however, was so prone to ridicule everything around him that even when he wishes to be benevolent he seems to be cracking a joke at someone else's expense. Such is the case with Enrique Banchs (1888–1968), a celebrated Argentine poet of later *Modernismo* whom Borges truly admired for the classic sobriety of his verses. On Christmas Day 1936, in one of his regular essays for *El Hogar,* Borges decides to commemorate the twenty-fifth anniversary of the publication of *La urna,* Banchs's most important book, comparing the Argentine poet's subsequent reticence with Joyce's volubility. Here, it is a synonym for silence, the word "mute" used as an active verb, that makes the old poet's lack of inspiration sound somewhat funny:

> James Joyce, in 1922, publishes *Ulysses,* which can be equated to an entire literature embracing many centuries and many works; now he publishes some puns which can only be equated with the most absolute silence. In the city of Buenos Aires, in 1911, Enrique Banchs publishes *The Urn,* the best of his books, and one of the best of Argentine literature; then, mysteriously, *enmudece.* Hace veinticinco años que *ha enmudecido.* [He *turns mute.* It is now twenty-five years that *he is muted.*]

Borges's choice of words is calculated, for it is the headline for the article which makes it read like a joke, pairing up a noisy verb ("celebrate") with silence: "Enrique Banchs *Celebrates* His Silver Anniversary in *Silence.*" In this case, the circumstances were right for making a joke. The mounting insignificance, in Borges's view, of Joyce's ever-expanding "Work in Progress," which was ultimately to be published as *Finnegans Wake* (1939), is an invitation to praise Enrique Banchs for his exemplary muteness.

Other circumstances prompt similarly irreverent asides. In 1923, on a return trip to Europe, Borges's ship anchors at Dakar, then a sleepy colonial port on the western extremity of Africa, now the busy capital of modern-day Senegal. Borges sees modernity and tradition side by side on a dusty, sun-baked street, two imported artifacts of culture, a movie house incongruously next to a mosque, and unites them in a poem, "Apuntamiento de Dakar" [Report on Dakar], with an image that resounds like a joke: "La mezquita cerca del biógrafo luce una quieta claridad de plegaria" [The mosque next to the cinema radiating a peaceful clarity of supplication]. Both are awaiting their public, indeed competing for the same public.

At other times it is a single word that explodes on the page into multiple meanings. In his biography of Evaristo Carriego (1883–1912), a minor poet

of the Buenos Aires slums, Borges almost clinically diagnoses his subject's infirm yearning for fame ("adolecía de apetencia de fama"): "To endure in the memory of others, obsessed him. When some definitive pen of steel resolved that Almafuerte, Lugones and Enrique Banchs constituted *the triumvirate—or was it the trinity or the trimester?*—of Argentine poetry, Carriego proposed in the cafés the deposing of Lugones, so that his own inclusion need not alter the *ternary* setup." It is of course the third "tri" term (highlighted by the ambiguator "or") that incongruously stands out—"trimester"—that deflates the pomposity of the others and trivializes Carriego's pretension to occupy Lugones's place.

The candidate for deposition, Leopoldo Lugones, is one of the more solidly canonical figures of Argentine literature. Perhaps for this reason, the youthful Borges consistently held him up to ridicule, although in his mature years, he would reverse this judgement, considering his own ultraist "excesses" to be nothing more than the emulation of Lugones's talent for coining new imagery. Yet in "Palabrería para versos" [Idle Chatter Set to Verse], a 1926 essay in *El tamaño de mi esperanza,* he came down especially hard on Lugones, singling out for ridicule what is now one of his most famous sonnets, included in every anthology of Spanish American literature, "Delectación morosa" [Slow Pleasure]. The poem, a masterpiece of turn-of-the-century decadentism, evokes an afternoon of languid lovemaking into the night in the quiet solitude of a cemetery. By the poem's end, one realizes that the adjective *morosa* doubles as *amorosa,* and its title, "Slow Pleasure," deftly becomes not "slow" but slowly "amorous" pleasure. For the youthful Borges this poem is simply overwritten, and, as he had previously done with Góngora, after introducing it as an example of "adjetivación embustera" [phony adjectivation], he proceeds to pick it apart, feigning the voice of an innocent child so as to more effectively ridicule its otherwise laudable subtleties:

> La tarde, con ligera pincelada
> Que iluminó la paz de nuestro asilo,
> Apuntó en su matiz crisoberilo
> Una sutil decoración morada.

> [The afternoon, with a light brush stroke / that illumined the peace of our sanctuary, / added to its chrysoberyl hue / a subtle tinge of purple.]

These epithets demand an effort at figuration, wearisome. First, Lugones prompts us to imagine a setting sun in a sky whose coloration is precisely that of chrysoberyls [*a yellowish mineral,*

sometimes used as a gem] (I'm no jeweler, so I'll leave it at that), and then having commissioned this difficult chrysoberyl sky, we'll have to touch it up with a brushstroke (and not just any old kind, but a "light brushstroke," free hand) in order to add a purplish tinge, one of those that are "subtle," not the other kind. Well, I'm not playing that way, as the kids say. What a lot of work! I'll not do it, and I can't believe that Lugones ever did it either.

By reading the poem literally, Borges manages to make it sound silly. He is intentionally bringing Lugones down from cloud nine to make him look like a pompous fool.

■

Borges obviously enjoyed making fun of whatever came his way, of the major and minor intellectual figures of the moment, of patriotic and religious beliefs, of anything in fact that others took seriously. Not even God escapes from his satirical take on reality. The Bible in this view becomes an anthology of fantastic literature, and the Christian concept of the Trinity, the Father, the Son, and the Holy Ghost is absolutely mind-boggling. For example, in winding down his playful 1939 essay on "The Total Library," he seems unable to control his urge to work in just one more joke and somewhat gratuitously tacks on a reference to the Trinity, transforming the hallowed concept into a problem for teratology, the so-called "science" of monstrosities: "la *teratológica* Trinidad, el Padre, el Hijo y el *Espectro* insoluble" [the *monstrous* Trinity, the Father, the Son and the insoluble *Ghost*]. The joke is rendered through a simple phonemically linked synonym, "*esp*ectro" for "*esp*íritu." But to a predominantly Catholic reading public accustomed to depositing their savings in an account with the Papal *Banco dello Spirito Santo* or in routinely blessing themselves "In the name of the Father, the Son and the Holy Ghost," the abrupt transformation of the third person of the Holy Trinity into a goblin ("espectro") is indeed a monstrous surprise, and ultimately, although irreverently, funny.

For Borges, the very idea of God as the clumsy creator of this imperfect universe we inhabit was fertile ground for humor. Creation myths from around the globe usually deal with the trial-and-error process of the making of mankind. For the Maya of Central America, man was made first of mud but he dissolved in water, then of wood but he cracked, and finally of corn and he stood tall. In the Judeo-Christian tradition, woman is an afterthought, with Eve being fashioned from a rib of Adam. Medieval Jewish folklore gives us the golem, a man-made figure constructed in the form of a human being, an automaton who comes alive with the right combination of the Hebrew

alphabet. This was the basis for Gustav Meyrink's novel *The Golem* (1915), which promptly spawned a film of the same title that would become a classic of German silent film (1920) and fueled a comic narrative poem by Borges included in *El otro, el mismo* (1964). In this poem, which loosely follows the medieval legend, Borges has Judá León, a Prague rabbi working away at creating someone in his own likeness:

> Sediento de saber lo que Dios sabe,
> Judá León se dio a permutaciones
> de letras y a complejas variaciones
> Y al fin pronunció el Nombre que es la Clave.
>
> La Puerta, el Eco, el Huésped y el Palacio,
> Sobre un muñeco que con torpes manos
> labró, para enseñarle los arcanos
> De las Letras, del Tiempo y del Espacio.
>
> El simulacro alzó los soñolientos
> Párpados y vio formas y colores
> Que no entendió, perdidos en rumores
> Y ensayó temerosos movimientos.
>
> Gradualmente se vio (como nosotros)
> Aprisionado en esta red sonora
> de Antes, Después, Ayer, Mientras, Ahora,
> Derecha, Izquierda, Yo, Tú, Aquellos, Otros.
>
> (El cabalista que ofició de numen
> A la vasta criatura apodó Golem;
> Estas verdades las refiere Scholem
> En un docto lugar de su volumen.)

[Yearning to know what God knows, / Judá León tried out permutations / of letters in complex variations / and finally pronounced the Name which is the Key, // the Portal, the Echo, the Guest and the Palace / over a dummy at which, with clumsy hands / he labored in order to teach him the secrets / of the Alphabet, of Time and Space. // The simulacrum raised its sleepy / eyelids and perceived forms and colors / that it did not understand, lost in sounds / and haltingly began to move. // Gradually it saw (like we ourselves) / locked in the sonorous web of Before, After, Yesterday, Meanwhile, Now, / Right, Left, Me, You, Them,

Others. // (The cabalist officiating as its numen / named his giant creature Golem; / these truths are recorded by Scholem / in a learned passage of his volume.)]

The verse form, a string of quatrains in rigid hendecasyllables bound together by a singsong childish braced rhyme (ABBA), is calculated to distance us from the discourse, to oblige us to read the poem not as a story by Borges but as a verbal hand-me-down, as something we have heard before. Lulling us into submission in this way, he primes us for the first of several jokes. In the next strophe, the rabbi, like a doting father, having created his robot, is teaching him about the ways of the world:

El rabí le explicaba el universo
("Esto es mi pie; Esto el tuyo; Esto la soga")
Y logró, al cabo de años, que el perverso
Barriera bien o mal la sinagoga.

[The rabbi explained to him the universe / ("This is my foot; that's yours; this is a strap") / and he managed, after years of training, that his creature / could do a fair job of sweeping the synagogue.]

Suddenly changing the rhyme scheme in this strophe (from ABBA to ABAB), serves to highlight the punch line about the dumb robot being barely able to sweep the synagogue. As the poem goes on, Borges has the inventor puzzling over what might have gone wrong, questioning how could he, the great rabbi of Prague, have failed so miserably with his creation? This sets things up for the final joke, with God in the heavens looking down on His own imperfect creation, the inept Rabbi of Prague:

En la hora de angustia y de luz vaga,
En su Golem los ojos detenía.
¿Quién nos dirá las cosas que sentía
Dios, al mirar a su rabino en Praga?

[At the anguished hour when the light goes down, / the rabbi's eyes would come to rest upon his Golem. / Who can tell us what God felt then / as He gazed on His rabbi there in Prague?]

God, in this jaundiced view is not the Supreme Intelligence but just one more bumbling demiurge, perhaps embarrassed at how he could have created someone as clumsy as this rabbi. This is not unlike Borges's own view of himself, when he closed out his story about Averroës, expressing his personal sense of failure as author. There, if Averroës, never having seen a play, had no idea what theater was, how could he, Borges, pretend to come up with the

mental workings of a medieval Arab? Having penned the story, he confesses within the text, through an afterword, that he himself suddenly felt "lo que hubo de sentir aquel Dios mencionado por Burton que se propuso crear un toro y creó un búfalo" [what that god mentioned by Burton must have felt when he tried to create a bull and created a buffalo instead]. Making fun of the gods, making fun of others, making fun of himself is Borges's way of having fun.

Later, in a semiautobiographical piece, "Dreamtigers," an essay in *El hacedor,* Borges recalls how as an infant he was fascinated by tigers in the zoo and that these animals continue to haunt his dreams. But when—like the dreamer of "Circular Ruins," the god of Burton, or the Rabbi of Prague—he tries to conjure one up in a dream, he too is a total incompetent:

> Nunca mis sueños saben engendrar la apetecida fiera. Aparece el tigre, eso sí, pero disecado o endeble, o con impuras variaciones de forma, o de un tamaño inadmisible, o harto fugaz, o tirando a perro o a pájaro.

> [Never can my dreams engender the desired beast. The tiger indeed appears, but it's stuffed or flimsy, or with impure variations of shape, or of an implausible size, or all too fleeting, or looking more like a dog or a bird.]

Again, the yo-yo technique of abrupt "or" switching, puffing things up with an exquisite turn of phrase ("harto fugaz"), before dropping down to the banal, "tirando a perro o a pájaro," phonically joined and highlighted by the repeated initial "p" sound.

Having scanned the different varieties of wit present in Borges's poetry and prose throughout his career, from his earliest beginnings to his mature years, let us turn our attention to his masterworks, *Fictions* (1944) and *The Aleph* (1949), the collections of short stories that, while establishing his fame as a serious writer, are nonetheless grounded in humor.

Fun in Fictions
and The Aleph

Extraordinary things happened to me in the United States. For
example, I'm a South American. That's very important in the United
States; they think we're very romantic. And a poet there is viewed
with a certain sympathy. An older poet, even more. And an old poet
who is blind—well, that practically made me into Homer.

Borges, 1980

The canonical Borges texts are *Fictions* (1944) and *The Aleph* (1949). Not
surprisingly, both are in Harold Bloom's short list of major works in *The
Western Canon* (1994), a choice that is more consensual than controversial,
since these two books are the long-standing favorites of readers, critics, and,
for a time, even the author himself. In fact, all nine of the narratives chosen
by Borges for his 1961 *Antología personal* [A Personal Anthology] are from
these volumes; and, despite a somewhat different selection for the 1968 *Nueva
antología personal* [A New Personal Anthology], eight of the ten come from
these same two volumes. It is no wonder then that the mature Borges confided
to his friend María Esther Vázquez that he "easily confuses *Fictions* and *The
Aleph*," thinking of them as one (in "Borges igual a sí mismo," *Veinticinco
Agosto 1983 y otros cuentos de Jorge Luis Borges,* 1983). His critics have
done much the same, echoing one another in their studied concentration on
the metaphysical marvels of this now emblematic repertory, making its tales
into parables and their teller into a modern-day Aesop. As Burgin so candidly
observed—to Borges's hearty agreement—"the people that write about you all

write the same things." That was back in 1969, when reading or writing about Borges was only for the serious-minded. This too, was when filmmakers like Godard and Bertolucci added weight to their already weighty films through direct allusions to his works.

Thus far, and by way of legitimating my approach to the lighter side of Borges, I have been stressing what is broadly comical in the canonical, highlighting some of the more obvious jokes in "The Aleph" and the most studied stories of *Fictions* such as "The Library of Babel," "Tlön," and "Death and the Compass." Probing further into any of these narratives, however, can easily turn up subtler levels of embedded humor, as for example the mention of "towers of blood" and "transparent tigers" in "Tlön," or the nonsense titles of what the librarian pompously plauds as the "best books" to be found in "The Library of Babel": *Trueno peinado, El calambre de yeso* [Combed (i.e., straightened) Thunderclap, The Plaster Cast Spasm]. Equally outlandish is this same librarian's eyewitness account of a philological find in the stacks, mockingly narrated in the laconic long view of historical linguistics where centuries get elided into mere moments:

> *Five hundred years ago,* the chief of an upper hexagon came upon *a book as confusing as all the rest,* but which contained nearly two pages of homogenous lines. He showed his find to an ambulant decipherer, who told him the lines were written in Portuguese; others told him they were written in Yiddish. In *less than a century* the nature of the language was finally established: a Lithuanian dialect of Guaraní, with classical Arabic inflections.

Interestingly enough, a similar chance encounter of a text "as confusing as all the rest," in the late 1940s, would in fact give us the *Jarchas,* the earliest lyric poems in Spanish. Found in a synagogue in Cairo, these are Hebrew songs from the tenth century with verses in Mozarabic, an incipient form of Spanish spoken by Christian Arabs in southern Spain, the same "crude" dialect Averroës heard from the mouths of the Christian street urchins aping Muslim rituals.

That this passage of "The Library of Babel" was intended to be funny, a kind of spoof of the scholarly tradition of such philological "finds," is evidenced by a simple comparison of the variants from its first publication in 1942 (in *El jardín de senderos que se bifurcan*) with its 1944 version in *Fictions.* Such a comparison reveals that Borges modified the passage referring to the odd amalgam of Lithuanian with Guaraní (an indigenous language of Paraguay), so as to make its oddness even more apparent, more patently bizarre, by adding the unlikely qualifier "Samoyed," a term that dog lovers will recognize as the pedigree name for Siberian huskies and linguists will identify as a language group including Eskimos: "a *Samoyed*-Lithuanian dialect of

Guaraní." Either way though, the trigger line is still the trailer, "*with classical Arabic inflections.*"

Borges, writing these texts in the 1940s, knows that his readers, accustomed to the authority of realism, are all too prone to accept everything in print as factual. Hence the need to shock, to periodically jolt the reader into a reassessment of just what it is that is actually being read. One way of accomplishing this is to mine the texts with little shards of absurdity like the impossible dialect or the preposterous book titles; another way is to undermine the authority of the discourse itself. Here, the principal narrative voice is that of an ageless wizened librarian, accustomed to the routine recording of bibliographic details. The thrust of his narration, presented to the reader in the guise of an edited manuscript, is occasionally interrupted by three sets of notes: one by the librarian himself; another attributed to the "editor" (the "translator" in the earlier 1942 version); and a final footnote by none other than Borges himself, citing an outside opinion on all this by a real-life Argentine personality, his personal friend, Letizia Álvarez de Toledo, a high-society lady whose name would be quite familiar to his Argentine readers of the time since her quirks were then the subject of newspaper gossip columns.

This chorus of voices—real and fictional—is orchestrated to frame the librarian's central narrative and to draw attention to our role in the discourse as readers. Twice in fact the reader is addressed directly in the disarmingly intimate "*tú*" form. Once, toward the end ("*Tú,* que me *lees ¿estás* seguro de entender mi lenguaje?*" [*You,* who are reading me, are *you* sure *you* understand my language?]); and earlier, at the climax of a "chaotic enumeration" that begins with an attention-getting absurdity, an affirmation that the Library, "ilimitada y periódica"—like Le Corbusier's *Musée à Croissance Illimitée*—contains everything in all possible languages. Absolutely everything is in this library, one *contradictio in attributo* after another, a chaotic enumeration of logical incongruities along the lines of the earlier *History of Eternity* or "New Refutation of Time" projects: "Everything: the minute *history of the future,* the autobiographies of the archangels, the faithful catalogue of the Library, thousands and thousands of false catalogues, a demonstration of the fallacy of these catalogues, a demonstration of the fallacy of the true catalogue, the Gnostic gospel of Basilides, the commentary on this gospel, the commentary on the commentary of this gospel, *the veridical account of your death.*" A sudden assertion like this ("the veridical account of *your* death"), has to jolt even the dullest of readers, accustomed as we are to live our lives as though we were immortal.

The story, in its subsequent 1944 version in *Fictions,* ends with one more addition that both reveals and stresses its humorous intent: an authorial aside, a footnote by Borges himself containing a variation of his monkey joke from the closure of "The Total Library" (1939). There, it was one immortal monkey,

mindlessly clacking away at the keyboard, who could theoretically type out all the books there ever were or ever will be; here, in a kind of anticipation of "The Book of Sand," a 1975 story about a nightmarishly infinite book that the narrator rids himself of by randomly slipping it into the stacks of the Argentine National Library, Borges tacks on a joking footnote, attributing to socialite Letizia Álvarez de Toledo the trivializing aperçu that the enormous Library of Babel is really useless, since, "en rigor, bastaría un solo volumen . . . , de un número infinito de hojas" [in truth, a single volume would suffice . . . , with an infinite number of pages].

Borges uses the conventions of realism, the verisimilitude of various textual voices to transport us into the realm of the fantastic; and once there, he explodes the artifice through a recourse to commonsense logic, which paradoxically catapults us into the absurd. What makes this fun, and ultimately funny, is our consciousness that we are playing the game, that we are only pretending to take him seriously. Hence the importance of the annotational asides, which function like bluffs in a hand of poker, obliging the reader-players to risk a judgment, leading to further involvement in the intricacies of the game. And this is what makes reading Borges so pleasurable, our awareness that we are involved in a game with a master player. The joking asides are like a steady check on our continued complicity.

■

One of the more complex stories in *Fictions* using annotations and the principle of games (playing according to a given set of rules) is "El jardín de senderos que se bifurcan" [The Garden of Forking Paths]. Again, we have a chorus of narrative voices: (1) a nameless British military historian who reproduces and annotates a "found" document, (2) which is the sworn confession of Yu Tsun, a Chinese teacher of English obliged to spy for the Germans in World War I, a deposition which in turn contains a verbatim account of the declarations of his victim, (3) who is Doctor Stephen Albert, a former Christian missionary to China who went native, becoming an amateur sinologist dedicated to deciphering the mysteries of *The Garden of Forking Paths,* a labyrinthian novel written (we are told) by one Ts'ui Pên, (4) who turns out to be the assassin's great-grandfather. The protagonist-players in this intricately absurd game scenario are brought together by chance. Yu Tsun is recruited by the Germans because he happens to teach English in a *Hochschule* in Tsingtao (another neat contradiction); Stephen Albert (another turncoat) is the victim randomly chosen from a telephone directory because his last name happens to correspond to that of the northern French town in which the British are secretly amassing troops and supplies for an offensive against Germany—a touchstone with reality for what in fact was to be the bloody Battle of the Somme.

Central to the game is Richard Madden, an Irishman in the British Secret Service (yet another jolting contradiction for a story set in the aftermath of the 1916 Easter Rebellion in Dublin), who is in hot pursuit of the Anglicized Chinese spy for Germany. With the deft touch of irony so dear to Borges, precisely because both pursuer and pursued are cowards it is therefore a given that they are determined to prove their bravery, the Irishman for the British Empire he loathes, the anglophile Chinaman for his "odious" Aryan Chief back in Berlin. In the deposition Yu Tsun candidly confesses his personal motives:

> I am a coward . . . I did not do it for Germany, no. Such a barbarous country is of no importance to me, having *obliged* me to the abjection of being a spy . . . I did it because I felt the Chief had no respect for those of my race—of those uncountable forebears that culminate in me. I wished to prove to him that a yellow man could save his armies.

Madden's motivation, as reported by Yu Tsun, is similarly vainglorious:

> Madden was implacable. Rather, to be more accurate, he was *obliged* to be implacable. An Irishman in the service of England, a man suspected of equivocal feelings and maybe even treason, how could he fail to welcome and seize upon this miraculous favor, the capture and perhaps the deaths of two agents of Imperial Germany?

The story, written and published during World War II but set in the time of World War I when England and Germany were once more fighting in France what Borges elsewhere calls their "cyclical battle,"* utilizes the cultural distance of Argentina to ridicule European notions of racial superiority. Hence the Chinaman is proudly (self-referentially) "yellow," in oblique response to the so-called Yellow Peril, which once obsessed both England and Germany in their self-appointed roles as defenders of Western supremacy,[9] and from the perspective of his race he sees the Anglo-Irish Madden as a poor parody of a human being: "el casi intolerable recuerdo del rostro acaballado de Madden" [the almost unbearable memory of Madden's horse face]. Read bucktoothed Briton.

Racism of the early twentieth-century variety is rampant in this piece and serves to enhance its authenticity, adding a cannily logical dimension to

* As in "El otro" [The Other]: "Hubo otra guerra, casi entre los mismos antagonistas. Francia no tardó en capitular; Inglaterra y América libraron contra un dictador alemán, que se llamaba Hitler, la cíclica batalla de Waterloo." *El libro de arena* (1975).

events that on the surface appear to be uncanny. For example, when Yu Tsun's train pulls into the desolate town of Ashgrove:

> No one announced the name of the station. "Ashgrove?" I asked some children on the platform. "Ashgrove," they replied. I descended. A lamp lit the platform, but the children's faces remained in a shadow. One of them asked me: "Are you going to Dr. Stephen Albert's house?" Without waiting for my answer, another said: "The house is a good distance away but you won't get lost if you take the road to the left and bear to the left at every crossroad." I threw them a coin.

An alert reader might well wonder as to why these children respond in this ominously knowing way. Quite simply, Yu Tsun is "yellow," a Chinaman, a figure as odd in provincial Ashgrove as Stephen Albert, the self-styled sinologist who has fashioned his rural retreat there in the form of a Chinese pavilion. For the children on the platform, what else would a Chinaman be doing in this town except making a visit to the eccentric Albert? And Albert's reception of the Chinaman is in the same vein. Not knowing one another, why should Albert, as Yu Tsun remarks, "address me in my language?"

Inversely, at the very beginning of the deposition, when Yu Tsun relates making a phone call to his Staffordshire contact, Viktor Runeberg, he is startled by a voice that answers in German. The voice is not that of Runeberg, however, but of his archenemy, the Anglo-Irish spy Madden, which induces this reflection: "Madden, in Viktor Runeberg's apartment, meant the end of all our work and—though this seemed a secondary matter, or should have seemed so to me—of our lives also. His being there meant that Runeberg had been arrested, or *murdered* [asesinado]." The mere inference that a prisoner might be "murdered" by an officer of the Crown generates an indignant correction by the "editor," the British military historian who is now bringing this document to light. The term "asesinado" in the deposition spurs him to add this (amusing) clarification in a footnote: "A malicious and outlandish hypothesis. The *Prussian* spy Hans Rabener alias Viktor Runeberg drew an automatic pistol on the arresting officer, Captain Richard Madden. The officer, in self defense, inflicted wounds which later caused death. (Editor's Note.)" I have highlighted the term "Prussian" because it serves to peg our prim editor as someone with a mindset from the previous "cyclical" war.

One of the things that makes reading Borges amusing is his alertness to cultural nuance, his ability convincingly to render the time-bound thoughts of people from other epochs and other cultures: a stuffy old Englishman from the high imperial period bringing to light the confession of someone surely not to be trusted, a lowly Asian. That this individual even dares to question the probity of an officer of the Crown is unthinkable, so the accusation of "murder"

is dutifully whitewashed into "self defense." Thus, the officer didn't murder anyone, he simply "inflicted wounds which later caused death." Borges utilizes these changes in point of view, much as a stand-up comedian changes ethnic accents, to provide different and comic perspectives on reality, depending on who is interpreting what. Thus, in the jaundiced ethnocentric view of our equally proud "yellow" Chinaman, the grandiose British Empire is simply "un imperio remoto . . . en una isla occidental" [a distant empire . . . on a Western island] populated by "horse-faced" (bucktoothed) white men like Madden.

The "cyclical" war between Germany and England is merely one of the givens in a test of wits between proxy players who have no commitment to the cause, only to the game. Even minor details used as realistic backdrop to create the ambiance of a country at war are tellingly ironic. In a scene owing much to the technique of cinematic montage, Yu Tsun in the train station notices in quick succession a widow, a student avidly reading Tacitus's *Annals,* and a wounded soldier traveling home from the front. A classic Eisenstein-type "collision," with the common theme of war touching each of them in diverse and ultimately pathetic ways. Now, it's not easy to wring a smile out of pathos, but Borges pulls it off with the aid of literary bathos, adding an extra adjective to the noun, describing the soldier as "herido *y feliz*" [wounded *and happy*]. This last qualifier is momentarily in tension with the first, but only until we realize why the wounded soldier is "happy." He is happy to be still alive. Indeed, for this soldier, the war is happily over. The traveling widow probably collects a pension, and the student at leisure is handily avoiding military service by dutifully studying the cyclical dynastic wars in imperial Rome. The overall thrust of this story is not comic but ironic. The humorous incongruities of the situations of the player-protagonists in this game of war are used to heighten the absurd tragedy of war in a time of war.

■

An even more complex story from *Fictions* that is also informed by irony is "Las ruinas circulares" [The Circular Ruins]. In this one, after many, many tries, a man successfully dreams a son, and at the height of his pride and satisfaction, discovers to his horror that he himself is being dreamed by someone else. This clever reversal has prompted no end of metaphysical speculation on the reality of dreams and Borges's indebtedness to Berkeley's immaterialist philosophy that "existence is *percipi* or *percipere*." A signpost to the story's intended ironic humor is given at the outset in the form of an epigraph, a line from Lewis Carroll's *Through the Looking Glass*: "And if he left off dreaming about you. . . ." Borges neatly cuts the quote at this point, since in the novel it is followed by a giveaway retort: "you'd go out—bang!— just like a candle!"

The story's humorous tack perhaps owes something to *The Golem,* a novel and film that Borges parodied in his poem of the same title, and which we have already discussed in a previous chapter. The "magic project," as it is called in the story, to dream a man, "soñarlo con integridad minuciosa e imponerlo a la realidad" [to dream him in minute entirety and impose him on reality] most certainly grew out of a challenge laid out in an essay from his ultraist days, "Después de las imágenes" [Beyond Imagery], included in *Inquisitions* (1925). The intent of this early essay was to ridicule a literary rival, the Chilean Vicente Huidobro (1893–1948), and the much touted maxim of creationism contained in the *ars poetica* of his 1916 *El espejo de agua* [The Water Mirror] to the effect that the vanguard poet must henceforth be a "little god," singing not to the rose but rather making it flower in the poem. "Invent new worlds," Huidobro proclaims, and by way of illustration opened "El espejo de agua" with these lines:

> Mi espejo, corriente por las noches,
> Se hace arroyo y se aleja de mi cuarto.
>
> Mi espejo, más profundo que el orbe
> Donde todos los cisnes se ahogaron.
>
> Es un estanque verde en la muralla
> Y en medio duerme tu desnudez anclada . . .
>
> [My mirror, fluid at night, / becomes a stream and leaves my room. / My mirror, deeper than the orb / where all the swans are drowned. / It is a green tank on the wall / and in the middle sleeps your nudity anchored . . .]

To all this, Borges said:

> It's not enough any more to say, as all poets have, that mirrors are like water. Nor is it enough to take this hypothesis as absolute and pretend, like any Huidobro, that coolness comes out of mirrors or that thirsty birds drink out of them and the frame becomes empty. We have to move beyond these games. We have to express this whim made into a reality of one mind: we have to show a man who gets into the glass and who persists in his imaginary country (where there are figures and colors, but they are ruled by still silence) and who *feels the shame of being nothing but a simulacrum* which the nights obliterate and which the twilight admits.

The passage is witty in its own right and effectively belittles Huidobro, who then fancied himself to be the godsend of the Hispanic avant-garde.

Borges brings him down to earth with his tested techniques of "verbal abuse," depriving him of singularity by portraying him as but one of many ("*todos* los poetas," "*cualquier* Huidobro") and by reductively literalizing the opening imagery of his celebrated poem. However, what interests me most here is not just another example of making fun, nor the very real rivalry between ultraism and creationism, but the fact that back in 1925, after ridiculing Huidobro's magic mirror, Borges goes on to speculate about the need to make the imaginary real, to people this new reality and to have its simulacrum come to realize his own helpless fictional status. This goes well beyond the humorous idea of the golem (who is simply a blockhead) and is the central irony of "The Circular Ruins": the depiction of a man, a self-styled "mago" or magician, who ultimately suffers the "shame" of being nothing.

To get the story going, Borges lulls the reader into its dreamworld with a tried-and-true rhetorical device: an inordinately lengthy opening sentence that doesn't let us go, carrying us along in its headlong thrust forward. Highly poetic in its pace and power, the run-on sentence is purposefully packed with precise-sounding details about just what *is not*: "*No one* saw him disembark in the unanimous night, *no one* saw the bamboo canoe sink into the sacred mud, but in a few days there was *no one* who didn't know that the taciturn man came from the South and that his home had been one of those numberless villages upstream in the deeply cleft side of the mountain, where the Zend language *is not* contaminated by Greek and where leprosy *is infrequent*."

I will forego the temptation to comment on the many little pranks planted in this poetically charged description—things like a "*bamboo* canoe" sinking into the "*sacred* mud"—in order to move directly on to the extended joke that structures the story and (paradoxically) helps to make it convincing: the dreamer's elaborately meticulous method of forging his simulacrum.

Not unlike Breton and his followers, our would-be dreamer experiences some initial difficulties in getting himself to sleep (insomnia, alas, was the bane of all too many surrealists in their scheduled experimental dreaming sessions). After trying out hemlock and other remedies without success to overcome this handicap, our man prudently decides to abandon all premeditation of dreaming. One day, according to the curiously worded text, "se purificó en las aguas del río, adoró los dioses planetarios, pronunció las sílabas lícitas de un nombre poderoso, y durmió" [he purified himself in the waters of the river, worshiped the planetary gods, pronounced the prescribed syllables of a mighty name, and went to sleep]. Can this be anything other than a fancy way of saying that (like a good little boy), before going to bed, he took a bath and said his prayers? In any case, it does get him off to sleep, and "casi inmediatamente, soñó con un corazón que latía" [almost immediately, he dreamed a throbbing heart]. Satisfied with the method and its result, he continues the same rite night after night, dreaming the same throbbing heart over and over, carefully

limiting himself to its nightly verification from various angles and positions, confirming to his satisfaction its consistent size and color—"garnet," "about the size of a clenched fist," we are facetiously told. Little jokes aside, after many such nights, he finally dares to touch it: "rozó la artería pulmonar con el índice y luego todo el corazón, desde afuera y adentro" [he lightly touched the pulmonary artery with his index finger and then the whole heart, inside and out].

Pleased with his accomplishment, and being ever so prudent, he skips a night of sleep to build up strength, "y emprendió la visión de otro de los órganos principales" [and he undertook the vision of another of the principal organs]. Through this detailed foregrounding, characterizing the dreamer as a very methodical individual, Borges has set the scene for an extended fantasy and now quickens the pace with the aid of the same compressed time formula used to ridicule the bibliographical find in the Library of Babel: "*Antes de un año* llegó al esqueleto, a los párpados" [*in less than a year* he arrived at the skeleton and the eyelids]—a combination as disparate as "Samoyed-Lithuanian." Teetering on the edge of the inane, Borges then has the dreamer fashion the face, in his own likeness, of course.

At this point, having absorbed us with the step-by-step accretion of physical detail in the "arduous task" of dreaming a man in this building-block fashion, Borges releases the tension and springs the first of several howlers: "El pelo innumerable fue tal vez la tarea más difícil" [the innumerable hair was perhaps the most difficult task]. And lest his reader miss the silliness of dreaming each strand of hair, one by one night after night, a few lines farther on Borges adds the observation that, in his quest for absolute perfection, "rehizo el hombro derecho, acaso deficiente" [he reworked the right shoulder, possibly somewhat defective]. The dubitative adverbs ("tal vez," "acaso") serve the double function of enhancing the seeming sincerity of the meditative narrative voice and of drawing the reader's attention to the absurdity of what is actually being narrated: "el pelo innumerable fue *tal vez* la tarea más difícil"; "rehizo el hombro derecho, *acaso* deficiente." In this way the story is both fantastic *and* amusing. Indeed, its deadpan delayed humor is an essential part of its artifice. If the joke works, so does the story. Each is essential to the other, making momentarily real what on reflection is ultimately absurd.

The creator's next task, as in the poem about the golem, is to have his creature do things. While the clumsy golem could barely sweep the synagogue, this creature passes with flying colors every test that he is put to, quite naturally, of course, since that is precisely what any father would dream for his offspring. The creator's concern now becomes how to protect his creature from the "humiliation" of finding out that he is merely a simulacrum. A goal of course at odds with the author's original concern, as first outlined in "Beyond Imagery," which was not only to "show a man who gets into the looking glass and who

persists in his imaginary country" but also to have him feel "the shame of being nothing but a simulacrum." The dilemma of resolution is expediently handled by a forest fire, which mock-menacingly turns the sky "el color rosado de la encía de los leopardos" [the rosy color of a leopard's gum]. Now, there are lots of ways to say "fiery red," but to compare a forest fire to the jaws of a leopard is to call attention to the prose, to the fact that this is an elaborately written put-on.

Concerned about the welfare of his son as the fire entraps our dreamer-father in the circular ruins, he suddenly notices that he is immune to the flames. With this, the story ends in the elegantly poetic way that it began, anaphorically pacing the dreamer's successive perceptions: first relief, giving way to shame, and then fear as he finally comes to realize that it is he himself who is merely the simulacrum: "con *alivio,* con *humillación,* con *terror,* comprendió que él también era una apariencia, que otro estaba soñándolo" [with *relief,* with *humiliation,* with *terror,* he realized that he also was an illusion, that someone else was dreaming him]. The closure neatly harks back to the epigraph: "And if he left off dreaming about you . . . , you'd go out—bang!—just like a candle!"

■

It would be all too easy here to stay with this theme and continue exploring the manifold ramifications in Borges's writing of the topic of dreamer and dreamed, from its earliest appearance in the poems of *Fervor de Buenos Aires* such as "Afterglow," "Amanecer," and "Caminata," but I wish to continue with my main point, the underlying humor that informs even his most seemingly serious stories, and so move on to another canonized tale, "El inmortal" [The Immortal], which opens *The Aleph* and was also included in his personal anthology. Along with "Tlön," it is one of his longer stories, thus enhancing its attraction for critics in search of deep meaning. Like the other weighty stories discussed in this chapter, it has dreams, soldiers who are cowards, and a cyclical war, this one going back to the *Iliad.* It also has some jokes, of course, and again like "Tlön," a bell-ringing postscript from the future, a "Posdata de 1950" in *The Aleph* of 1949. A "1950" postscript that draws even further attention to its deliberate anachronicity by discussing a "1948" study that "denounces" (somewhat ahead of time) the sources plagiarized in the actual 1949 publication! Not a bad way to drive home the theme of a story about "un mundo sin memoria, sin tiempo" [a world without memory, without time].

The central narrative, purportedly the literal translation into Spanish of an English-language manuscript consisting of five numbered chapterlike sequences, is framed by an introductory paragraph in a serious authoritative voice with a characteristically false solemnity, a voice to be sure just like

that of Borges, reporting in detail on how the document came into his hands. We are told that the presumed author of the manuscript is a London antique dealer, from whom the reporter's friend, the "Princess of Lucinge" (another real-life personality: an Argentine heiress impoverished after her marriage to a penniless European "aristocrat," a friend whom Borges had cited for a similar cameo role in the anachronical postscript to "Tlön"), purchased the first edition of Alexander Pope's verse translation of Homer's *Iliad* (1720). The manuscript, "written in English and plagued with Latinisms," was found by the "Princess" in the last volume of the set. The bookdealer's name is Joseph Cartaphilus, not coincidentally one of the names of the "Wandering Jew." *Britannica*'s entry on this figure is typically to the point: "a character doomed to live until the end of the world because he taunted Jesus on the way to the Crucifixion."

The first-person narrative begins in the officious voice of a Roman military commander stationed in Thebes during the reign of Diocletian, a third-century emperor noted for, among other things, the last great persecution of the Christians. This Roman officer—whom we soon learn is called Marco Flaminio Rufo (another flaming "reddish" knave, like Red Scharlach?), and who is later among those fleeing in the tenth-century migrations prompted by the fear of the millennium, and who later still is a survivor at the bloody battle of Stamford Bridge in 1066 among the troops of Harold, the winner (or perhaps it was Harald, the loser)—is also the same man who in 1714 subscribed to the forthcoming edition of Pope's *Iliad.* We soon learn that in yet other incarnations he was also Ulysses, Homer, and Sindbad the Sailor, as well as Joseph Cartaphilus, the London book dealer, originally from Smyrna, alias the Wandering Jew. After all this, it's no wonder that at the manuscript's close its writer wearily yearns to die. At its opening however, he only wishes to live, and for this reason sets out in search of the City of the Immortals, whose shores he is told are bathed by a river that grants immortality to those who drink from its waters.

The narrative is seeded with philosophical conceits familiar to readers of Borges, like "one man is all men" and "in an infinite lapse of time all things can happen to one man," along with pointed hints to Giambattista Vico and the cyclical stages of growth and decay in human society. A pile of riches here for exegetic plunder, and Borges specialists have had a field day picking through them all to find just what they were looking for, while overlooking the all too obvious: Joseph Cartaphilus and the underlying tale of the Wandering Jew, and the deliberate anachronism of the 1950 postscript to the 1949 story. However, once we relax our guard and submit to Borges's intention to be playful here as elsewhere, it becomes eminently clear that the jokes are planted in the text right from the outset. Straightforwardly titled "The Immortal," its multipersoned narrator is a walking incongruity, a warrior who fears death, a

professional soldier who is a coward. Hence his indifference as to whether or not he was on the side of Harold or Harald. For him, what's important is that he survived. At first, he is a seasoned tribune whose legions are comprised of "mercenaries," who were as a matter of course—he knowingly tells us—always "the first to desert." He portrays himself as a stern commander who when learning of a possible mutiny resolutely decides to "exercise severity"—until he learns that the seditious Christians among his troops were "eager to avenge the Crucifixion of one of their own." Under these circumstances, he resolutely (and quite prudently) flees the camp along with his "loyal troops," before ultimately sneaking himself away from these fellow deserters in the "vastness of the night." With this knowledge that our hero is, shall we say, somewhat wanting in courage (like most of Borges's "heroes"), let us go back to the opening of his manuscript:

> As far as I can recall, my labors began in a garden in Thebes Hekatompylos, when Diocletian was emperor. I had *militated (without glory)* in the recent Egyptian wars, I was tribune of a legion quartered in Berenice, facing the Red Sea: fever and magic consumed many men who had *magnanimously coveted the steel.* The Mauretanians were vanquished; the land previously occupied by the rebel cities was eternally dedicated to the Plutonic gods; Alexandria once subdued, vainly implored Caesar's mercy; within a year the legions reported victory, but I managed to *hardly get a glimpse of Mar's countenance.* This privation *pained* me and perhaps caused me to turn to the search, through fearful and diffuse deserts, of the secret City of the Immortals.

Our narrator "managed" to avoid the god of war, militated "without glory," and scorns as fools those who yearned to battle the enemy. "Pained" by his shame, he is afraid to die. No wonder then that he goes off in search of eternal life, the City of the Immortals. Borges presents us with the inversion of a heroic quest, with a mock-hero who is literally running for his life!

After wandering aimlessly through the desert in search of the sacred waters, or just any water for that matter, he dreams Zeno-like that he is trapped in a labyrinth of time and space in whose center there is a jug of water, "mis manos casi lo tocaban, mis ojos lo veían, pero tan intrincadas y perplejas eran las curvas que yo sabía que iba a morir antes de alcanzarlo" [my hands almost touched it, my eyes could see it, but so intricate and perplexed were the curves that I knew I would die before reaching it]. Thus ends chapter 1, with the "hero" embarked on his quest.

In chapter 2, he awakens from this nightmare "en un oblongo nicho de piedra, no mayor que una sepultura común" [in an oblong stone niche no larger than a common grave], part of an underground labyrinth that is none

other than the abandoned catacombs of Christian Rome. Not surprisingly, upon emerging into the light, climbing up and out of what for him is still a "hypogeum" (a Roman burial chamber), he finds this ruined city on the banks of a river to be vaguely familiar, although now peopled by what he calls "troglodytes." In the eyes of a third-century Roman tribune, suddenly flash-forwarded to the fifth century, the brutish Vandals who now roam through the ruins quite naturally look like the legendary cavemen of classical literature. The resplendent ruins of the Rome he once knew, now the Vandal-sacked city on the banks of the Tiber, are then described in Piranesi-like grandeur, *après* the *Antichità Romane,* "cribbed from De Quincey," as Borges himself facetiously points out in the postscript. Our narrator is now immortal, and after fleeing from numerous battles more in successive chapters, he finally arrives at the twentieth century as a London book dealer from Smyrna yearning to be free of what is now his new nightmare, immortality. Again, we have a helpless character who becomes his own victim.

It is in chapter 5, reading over what he has written, "in English, with abundant Latinisms," that our twentieth-century manuscript penman finds that something is gravely wrong. Borges has him observe with appropriate new critical acumen, that although the account seems to have been written by a soldier, "el narrador no repara en lo bélico y sí en la suerte de los hombres" [the narrator does not deal with the incidents of war but with the fates of men]. His judgment is that the story seems "unreal" because it mixes together the events of many "different men," from Homer to Joseph Cartaphilus. Echoing the Chinaman's jibe at the "remote" British Empire in "The Garden of Forking Paths," Borges has the twentieth-century-bookman-turned-literary-critic find it bizarre that Homer, reincarnated as Pope, "descubra, a la vuelta de muchos siglos, en un *reino boreal,* y un idioma bárbaro, las formas de su Ilíada" [should discover, after so many centuries, in a *northern kingdom* and a barbarous tongue, the forms of his Iliad]. A parable-like illustration of the "eternal return," of the endless repetition of historical cycles as witnessed by one man who is all men, "an immortal, who precisely because he is immortal, forgets his past" (as told to Charbonnier in *Entretiens avec Jorge Luis Borges* [1967]).

Not a small part of what makes this story amusing derives from the skill-ful flow of its changing narrative voice, a voice that provides the reader with just enough information to see through and beyond the character-protagonists in each stage of their journey through time, to see through their time-framed eyes far more than they can see. This is the other side of irony, and in this way we come to regard them as comic figures, unaware of their limitations. The reader, knowing more about them than they themselves do, can smile at their incongruities. We know that the haughty tribune is a coward, we know that he awakens to immortality in a paleo-Christian cemetery, we know that his troglodytes are Vandals, we know the historical outcome of the various

battles that he flees from, we know that the barbarian, having forgotten Greek, is Homer, and that the antique dealer from Smyrna is the Wandering Jew; we know, in sum, much more than the characters know about themselves in any of their many incarnations. And this superior knowledge, ironically provided to us through them and by them, is what permits us to laugh at their nescience. Laughter provides us with epiphanies, sudden illuminations regarding the thrust of the story, which is indeed about the plight of what things might be like on the treadmill of immortality.

■

Another story from *The Aleph* that relies on controlled perspective for its humor and insight is "La casa de Asterión" [The House of Asterion]. Borges told Burgin in their *Conversations* (1969) that he dashed this one off in a single day back in May 1947, because he was then the editor of a magazine (*Los Anales de Buenos Aires*) which was about to go to press with "three blank pages yet to be filled." This too is a first-person monologue, framed by an epigraph (a truncated quote from Apollodorus: "And the Queen gave birth to a son, who was called Asterion . . ."), and a coda in the voice of Theseus: "Would you believe it, Ariadne? The minotaur barely put up a fight." Thus, it is only at the very end of this necessarily very brief text that the reader learns that the simple-minded speaker is a monster, half man, half beast, the mythical minotaur, the illicit offspring of Queen Pasiphaë and the Cretan bull, and that his "house" is the famous labyrinth constructed by Daedalus on the orders of King Minos. The purpose of this strategy of delay is to keep the reader guessing as to the identity of the speaker, who is cast to come across at first as a nuttily arrogant misanthrope out to set the record straight regarding all the false rumors about his being shut up in his big house: "I know they accuse me of arrogance, and perhaps of misanthropy, and perhaps of madness. Such accusations (which I will avenge in due time) are derisible. It is true that I don't go out of my house." His boasting references to his enormous house with its many patios, wells, and troughs would give Borges's original Argentine reader the impression of a huge hacienda. The first reading would thus produce a jolt at the end, when it abruptly identifies the speaker at the conclusion of his monologue not as a rustic rancher but as the legendary Cretan minotaur, a monster with the head of a bull on the body of a man, a ram awaiting his "redemption" by some Lord's Prayer-like creature that he in turn may "deliver from evil": "Will he be a bull or a man? Will he perhaps be a bull with the face of a man? Or will he be like me?" In other words, a man with the face of a bull. This speculative self-revelation is capped by the coda with Theseus remarking to Ariadne that "the *minotaur* scarcely defended himself."

Most of Borges's stories withhold some vital clue until the end. Sometimes the effect is simply surprise, causing us to reflect back on what we have

read, chuckling, say, at the image of Homer in "The Immortal," reincarnated as a barbarous troglodyte, the future author of the epic sagas of Beowulf, Roland, or the Cid—a man who had lived so long he forgot who he was. In this way, we are prompted to reread the stories, and it is in the second reading that what was once serious now becomes funny. It is in a second reading of Asterion that we can knowingly delight in the speaker's self-delusion regarding his royal lineage, a kind of extended illustration of Hobbes's theory of laughter as "sudden glory" arising from a "conception of some eminency in ourselves by comparison with the infirmity of others." It is only once we learn who and what Asterion is do we have the "gratification" of laughing at him as he boasts that, contrary to public opinion, he's not a prisoner. In fact, he says, his "house" is always open, having no closed doors or locks or keys; and, what is more, he's even ventured outside, turning back only because of the awe he registered on the faces of the common people: "caras descoloridas y aplanadas, como la mano abierta" [colorless and flattened faces, like an open palm]. Faces, in other words, very unlike his own, but very much like ours, at least from the point of view of a minotaur (who might perhaps have felt more at home among Yu Tsun's horse-faced Englishmen). And, what did these palefaces do that night when they first laid eyes on this man with the head of a bull? In the ingenuously arrogant words of Asterion himself: "The sun had already set, but the helpless wail of a child and *the crude supplications of the herd [las toscas plegarias de la grey]* showed that they recognized me. They uttered prayers, they withdrew, they dropped to their knees; some clambered up to the colonnade of the Temple of the Axes, others gathered stones. One, I believe, hid himself beneath the waves." Gestures of fear, self-defense, desperation, and suicide by drowning, prompted by his monstrous appearance, all are bovinely misinterpreted as acts of reverence to his regal person. After all: "*Not for naught was my mother a queen*; I cannot mingle with the crowd, even though my modesty would wish to. The fact is that I am unique." This is straightaway comedy, but it is only so the second time around, once we have all the coordinates to register the disparities Borges has cleverly planted in the discourse. Then, even something as tangential as a footnote becomes central. Asterion, throughout his monologue, refers to the many portals, patios, and other things in his house and life as numbering "fourteen," which our "editor" repeatedly corrects in parentheses to "infinite." His reassuring footnote reads: "The original says *fourteen,* but there is ample reason to infer that, in Asterion's mouth, this adjectival numeral stands for *infinite.*"

Sophomoric readers routinely get hung up on numerology, attributing all kinds of arcane importance to any repeated number, assuming that if someone like Borges says that nine men were periodically sacrificed to the minotaur while legend has Athens sending a tribute of seven youths and seven maidens there must be a profound meaning for the deviation. When questioned by

James Irby in "Encuentro con Borges" (1962) as to the significance of nine sacrificial victims as opposed to seven plus seven, Borges told his interviewer that there was absolutely none, that "nine" just happened to be the number he remembered, gleaned perhaps from some handbook on Greek mythology. What our editor's pseudoerudite note about the number "fourteen" does tell us though is that just as Asterion, the man with the head (and brain) of a bull has not been able to learn to read (Borges has him self-confidently assert that "nothing is communicable by writing" since he's "never been able to see the difference between one letter and another"), he is also *unable to count.* His bovine mind is like that of a child, who counts one, two, three . . . , a lot—that is, fourteen, or "infinite," as the footnote smirkingly points out. Borges explained all this to Irby by way of a joke, specifying that he thought of his minotaur as a "half-wit," as someone who doesn't realize what he is saying, adding that his Asterion is somewhat like a lady he once knew who "boasted about being an ace at bridge, but confessed that she always lost because she couldn't be bothered with the details of the game." Similarly, Asterion vaunts that it was his "generous impatience" that saved him from the "tedium" of learning to count.

■

Another intentionally funny story that is centered around a labyrinth, and that Borges himself ultimately felt compelled to explain as an out-and-out joke, is "Abenjacán el Bojarí, muerto en su laberinto" [Abenjacán el Bojarí, Dead in his Labyrinth]. This overwritten tale was added to the second edition of *The Aleph* in 1952. Its protagonist is a know-it-all detective, Unwin (un-win, or loser), a pipe-smoking proponent of deductive reasoning, a parody of Auguste Dupin. True to form, he lords his powers over his more practical-minded sidekick, Dunraven, who is also cast as a loser, a wishful thinker who "se sabía autor de una considerable epopeya que sus contemporáneos casi no podrían escandir y *cuyo tema no le había sido aún revelado*" [knew himself to be the author of an extensive epic poem that his contemporaries would scarcely be able to scan and *whose theme had yet to be revealed to him*]. In other words, he hasn't even thought about what he'll write in the book he fancies he'll one day author. These two are on the trail of a red-bearded Arab vizier who fled to Cornwall with his black slave and an African lion to hide out in a scarlet red labyrinth that he had constructed on the top of a hill overlooking the sea. Some hideout! Here's how Borges explained it in his "Commentaries" to the English translation of *The Aleph and Other Stories:*

> When I wrote "Abenjacán," it became a cross between a permis-
> sible detective story and a caricature of one. The more I worked
> on it, the more hopeless the plot seemed and the stronger my

need to parody. What I ended up with I hope will be read for its humor. I certainly can't expect anyone to take seriously or to look for symbols in such pictorial whims as a black slave, a lion in Cornwall, a red-haired king, and a scarlet maze so large that on first sight its outer ramparts appear to be a straight blank wall.

There are many straight-out jokes in *Fictions* and *The Aleph* that should need no explanation, such as "El milagro secreto" [The Secret Miracle], which tragicomically portrays the plight of a Prague man of letters about to be executed by the Gestapo. He is a would-be playwright, another writer who doesn't write, "autor de una *inconclusa* tragedia" (author of an *unfinished* tragedy, his own), whose curriculum consists of paid translations of the work of others and grandiose creative projects of his own, none of which he has yet put to paper: "The problematic practice of literature constituted his life; like all writers, he measured the worth of others by what they had written and expected that they measure him by what he was *envisioning or planning.*"

Or "El Zahir," where the metaphor of a common figure of speech, "algo *inolvidable*" [something *unforgettable*], is taken literally. This is a story of an obsession, an "unforgettable" magic coin, which is a rewrite and a parody of his previous encounter with "The Aleph," right down to its description of another high-society wannabe, a pretentious young woman who spent herself into poverty, committing the "solecism" of dying in a slum, and with whom the Borges-like narrator, "moved by that most sincere of Argentine passions, *snobbery,* was hopelessly in love." Or that of yet another obsession with memory, "Funes el memorioso" [Funes, the Memorious]. The exact opposite of the immortal Homer who forgot everything, Funes is the tale of a man who remembers everything, *absolutely everything,* and whose prodigious indiscriminating memory he himself likens to a garbage dump, a "vaciadero de basuras."

■

Borges's steadily growing readership in the 1950s warranted second editions of *The Aleph* (1952) and *Fictions* (1956), to which he added some new stories that had meanwhile been published in *Sur* and other journals of Buenos Aires. Since his readers were still a bit slow in picking up on his jokes, he tried harder. The effort shows in "La secta del Fénix" [The Sect of the Phoenix], a short essay that made its first appearance in *Sur* (September 1952), craftily sandwiched between the magazine's lead article by Martin Heidegger ("What Does it Mean to Think?") and a poetically evocative essay ("Sixtine") by Marguerite Yourcenar on the aging Michelangelo strapped to the scaffold while painting the Sixtine Chapel. Borges's piece fits right in, adopting the weighty tone of a cultural historian discoursing about his research into the

origins of an ancient ritual that is still practiced today. It opens in this learnedly obfuscating way:

> Those who write that the sect of the Phoenix had its origin in Heliopolis and derive it from the religious restoration which followed upon the death of the reformer Amenophis IV, cite texts from Herodotus, Tacitus and the monuments of Egypt, but they ignore, or prefer to ignore, that the designation "Phoenix" is not prior to Hrabano Mauro and that the oldest sources (the *Saturnales* of Flavius Josephus, let us say) speak only of the People of the Custom or the People of the Secret. Gregorovius had already observed, in the Conventicles of Ferrara, that any mention of the Phoenix was very rare in oral language; in Geneva, I have dealt with artisans who did not understand me when I inquired if they were men of the Phoenix, but who admitted, in the next breath, to being men of the Secret. If I am not deceived, the same is true of the Buddhists.

Just what is this secret sect, which dates back to most ancient times, surviving into the present, and is even practiced by Buddhists? I recently heard an eminent scholar who has written much about Borges lecture on this text as an example of the enduring quality of literature itself, which despite dire forecasts to the contrary steadfastly refuses to die. This is a plausible hypothesis that is, however, undermined by the text itself, for on reading further, we learn that its nefarious practitioners are seemingly "ubiquitous," that in a Jewish environment they even manage to resemble Jews, and—first joke, or rather second—that "just a few days ago," no less an authority than the backlands "*Doctor* Juan Francisco Amaro, of Paysandú, admired the facility with which they assimilated our Creole ways."

Just who are these extraordinarily adaptive yet strangely mysterious people whose eternity is guaranteed "by practicing a certain rite, whose secret is passed on from one generation to another?" By way of pseudoclarification, Borges adds some firsthand personal information: "I have compared the testimony of travelers, I have conversed with patriarchs and theologians; I can testify that the performance of the rite is the only religious practice observed by the sectarians. The rite constitutes the Secret. This Secret, as I have already indicated is transmitted from generation to generation." Yet, the more information we get, the less we really know as to just what this rite might be as Borges goes on and on expressing his astonishment over how something so secret has managed to survive the vicissitudes of centuries of wars and migrations, still finding practitioners today. The essay ends in an even deeper level of mystery about the subject than it began, with a ringing closure about its persistence right into the present, a circumstance—Borges adds—that has

prompted someone to affirm that it is now instinctive, "alguien no ha vacilado en afirmar que ya es instintivo."

My personal experience with this clever essay in the classroom has been that *no one* cracks the mystery of the Sect of the Phoenix. Which is not very surprising, since this was apparently the case with Borges's first generation of readers until someone had the nerve to ask him just what was the secret of the sect. He evidently enjoyed the idea of keeping his readers in the dark about this mystery, because his response to the critic's question is coy, basically telling him to "sleep on it" and "I'll tell you tomorrow." The next day, when asked again, Borges still beats around the bush. Finally—since a lady is present— he coyly whispers in the critic's ear that "it is what Whitman says the divine husband knows, from the act of fatherhood," adding that when he first heard about it, as a little boy, he was shocked to think that his mother and father had performed it: "it is an act of immortality, a rite of immortality, isn't it?"*

Once we learn that the secret "it" is copulation, along the lines of Cole Porter ("Birds do it, bees do it"), everything fits into place and we can then go back and read with knowing satisfaction, or belated "glory," passages such as this:

> The rite constitutes the Secret. This Secret, as I have already indicated is transmitted from generation to generation, but custom does not have mothers teaching it to their sons, nor should priests; initiation into the mystery is the task of individuals of the lowest order. A slave, a leper or a beggar can serve as mystagogues. Also, one child can indoctrinate another . . . There are no temples especially dedicated to the celebration of this cult, but a ruin, a cellar, or an entryway are considered propitious places.

Everybody does it, whenever and wherever they can, yet no one talks about it:

> There are no decent words to name it, but it is understood that all words refer to it or, rather, inevitably allude to it, and thus, in a conversation I say something or other and the adepts smile or show discomfort, for they realize that I have touched upon the Secret.

Indeed, Borges explains, there are whole poems written about it, poems whose nominal subject might be the sea or a sunset but which the initiated know to be

* As reported by Ronald Christ in *The Narrow Act: Borges' Art of Allusion* (New York: New York University Press, 1969), 190. Readers of an earlier story in *The Aleph*, "Emma Zunz," will recall the wording of her simple-minded thoughts as she gave her body to the lusty sailor: "Pensó (no pudo no pensar) que su padre le había hecho a su madre la cosa horrible que a ella ahora le hacía."

"symbols of the Secret"—like, for example, the Lugones poem, "Delectación morosa," which he had earlier ridiculed.

Realizing that the version of "The Sect of the Phoenix" as originally published in *Sur* was too cryptic, Borges made some changes, inserting a new penultimate paragraph to it when he included the piece as an addendum a few years later in the second edition of *Fictions,* in which it is revealed that some of the sect's most fervent initiates, like St. John of the Cross, even practice the secret with the divinity. But even here he hedged, Saxonizing the name of the Spanish mystic poet to "John of the Rood," and as a consequence the joke was still hidden: "Those who deliberately renounce the Custom, and carry on a direct commerce with the divinity, are highly regarded; these practitioners, in order to express this commerce, do so with figures from the liturgy; thus John of the Rood wrote . . ." And thus, the secret remained obscure until the young Ronald Christ came along and boldly asked Borges what it was. Ever since, this textual clue, like knowledge about the sexual act itself, now passes from reader to reader. Perhaps that was what Borges was really after all along: to create a sect of knowing readers anxious to reveal the secret to the unknowing.

Ironically, the clue to the secret, like the identity of Asterion, is given to us in the final line with the affirmation that its practice is "instinctive." And too, as with Asterion, this simple fact, coupled with the giveaway name, "phoenix"—the mythical bird, symbol of immortality, which after burning to death has the ability to rise up from its ashes with the freshness of youth— should have made readers think of what the French call "la petite mort." *Should,* but didn't. Some jokes need to be explained. This is one of them.

■

Not wishing to turn this chapter into a dumping ground for every embedded joke in these now canonical writings, I will turn our attention to the pleasures of the later fictions in which Borges practiced a somewhat different kind of humor. But before doing so, it will be useful to backtrack a bit to examine a book that went unnoticed when it was first published in 1935 and which has since come to be considered essential to Borges's development as a writer of fiction, *Historia universal de la infamia* [A Universal History of Infamy].

Chapter 5

Writing to Be Funny

The real beginning of my career as a story writer starts with a
series of sketches titled *Historia universal de la infamia,* which I
contributed to the columns of *Crítica* in 1933 and 1934, and which
were in the nature of hoaxes and pseudoessays.

Borges, 1970

Borges began his literary career in the 1920s as a poet and as a prankster, having fun with some writers and making fun of others. The next step was to try being funny on his own. The opportunity came in 1933, in the form of a commission to write a column for a weekly literary page in *Crítica,* a newly founded yellow-press tabloid geared to readers whose intellectual parameters were defined by sports and sensationalism, what Mencken called the "booboisie." The outcome was a series of comic sketches of outlandish characters, a rogues' gallery of swindlers, gangsters, and pirates, some real, some fictional, all paraded into print under the banner of a "Universal History of Infamy."

After turning out some half dozen, Borges tired of the project, and the sketches were collected in 1935 in a slim volume with the same outsize title, *Historia universal de la infamia.* Despite the backing of a rave review by Amado Alonso in November of that year (in where else but *Sur?*), touting the debut of a new voice on the narrative scene with the signpost title "Borges, narrador," these sketches were soon forgotten, and critics only began to pay them some attention when they were republished in 1954, in the wake of

the success of *Fictions* and *The Aleph.* Ever since, they have been mythified by Borges scholars into the testing ground for his narrative techniques— as points of reference to plot his "progress" as a storyteller, to track his variants against their sources, and to marvel over some of the wholly made-up pieces as though authorial invention were something hitherto unheard of in literature. Borges has contributed to this mystification, insisting in his prologues and interviews that they were simply the "exercises" of a timid young man who did not yet dare to write straight fiction. It was only in 1970, after translating these pieces into English with Norman Thomas di Giovanni, that Borges admitted that they were hoaxes, and therefore creative works, not mere exercises.

■

Whatever the motive for the mystification, which probably goes no deeper than Borges's habitual delight in manipulating his readers, the fact is that these pieces are funny. Not subtly or covertly funny, as in *Fictions* and *The Aleph,* but overtly so. Their titles alone, all based on oxymoron, hit the reader over the head with their absurd self-contradictions. The opening piece, purportedly an account of a white man's scam to induce Mississippi slaves to run away repeatedly so as later to resell them back to their masters to collect the reward and thereby build up a nest egg for an eventual life of freedom, is called "The Dread Redeemer, Lazarus Morell." By definition, of course, a redeemer should be anything but dread. This cross-eyed view of things is followed by six others, equally outrageous, like "The Implausible Imposter, Tom Castro" (a clever reworking of the *Britannica* account of the case of the Tichborne claimant), "The Widow Ching, Faithful Pirate" (about a swashbuckling Chinese lady buccaneer), "The Disinterested Killer" (Billy the Kid), and "The Purveyor of Iniquities" (the saga of a New York contract hit man, Monk Eastman), before closing out the volume with a filler anthology of miscellanea, a hodgepodge of exotic "found" passages, ranging from Swedenborg's candidly naive conversations with angels in Latin to bogus travel reports about strange practices and beliefs around the world.

The book's last page masquerades a "List of Sources," some of which are real (or *almost* real); most of which are not. And while it may be fun to track them down, it is even more so simply to read the accounts, whose wittily overwrought prose keeps us constantly keyed to laugh at the foibles of its subjects. Thus, in none of these accounts is the reader allowed to forget that Borges is intentionally writing to be funny.

For example, the opening piece about the dreaded redeemer, Lazarus Morell, is set in the Mississippi delta, loftily limned as a "worthy theater

for this incomparable *scoundrel.*" This particular series of words is a perfect illustration of what Mark Twain called a "stopper," a corrective comic insertion at the end of an otherwise serious sequence that catches the reader completely unawares. True to Twain's model, the pace of the prose is progressively encomiastic, until we get to the unexpected final word, "scoundrel." Here is the full descriptive sentence, in all of its Ciceronian majesty: "El Padre de las Aguas, el Mississippi, el río más extenso del mundo, fue el digno teatro de ese incomparable *canalla*" [The Father of Waters, the Mississippi, the longest river in the world, was the worthy theater for this incomparable *scoundrel*]. The stopper sets us up for the more expansive description of the scenario, also solemnly paced, but strategically laced with unexpected words and expressions:

> It is a river of *mulatto* waters; more than 400 million tons of muck *insult* each year the Gulf of Mexico, disgorged by it. All this *ancient and venerable garbage* has built up a delta, where gigantic swamp cypresses grow out of the debris of *a continent in perpetual dissolution,* and where labyrinths of mud, dead fish and reeds, extend the bounds and the peace of their *fetid domain.* Upstream, between the Arkansas and the Ohio, is another stretch of lowlands. These are inhabited by *a sallow race of squalid men,* prone to fever.

Not a pretty picture of the deep South and its sweaty white trash living on the garbage heap of "a continent in perpetual dissolution." The description is not meant to arouse indignation in the fashion of the social realist exposé fiction of the 1930s but rather laughter at the lowliness of this seat of white supremacy, where, as we later read, gallant white men sally forth from their riverbank mansions, pseudo–Greek Revival structures "with porticoes of white pine," not enduring white marble columns, as in ancient Greece, but plain old knotty pine. When one of their slaves would run away, it would be the occasion for a collective chase, and from these porticoed verandas, "hombres de barba entera saltaban sobre hermosos caballos y los rastreaban fuertes perros de presa" [full-bearded men, would spring onto beautiful horses and hunt them down with sturdy dogs], a vulgar inversion of an aristocratic fox hunt.

What makes this prose sparkle is its burlesque exaggeration, with just enough verisimilitude to ensure recognition. It reads like a parody of Faulkner (whom Borges was then translating for *Sur*), moving in two directions at the same time, impassively solemn in tone, outwardly ridiculous in tenor, provoking a laugh as it forces surprising connections among disparate things, the kind of unexpected incongruity Schopenhauer defines as the source of all humor.

Lazarus Morell—the "Dread Redeemer"—is born into poor white trash. Not favored with good looks, he matures into the spitting image of a Kentucky colonel, indirectly making us think that perhaps all southern gentlemen are white trash in disguise. This is accomplished through two parallel constructions, the first describing Morell's origins: "On abandoned farms, on the outskirts of towns, among the thick canebrakes and in the abject bayous, lived the poor whites, the *white trash*. They were fishermen, occasional hunters, horse thieves. From the blacks they would beg bits of stolen food and even in their lowly condition they maintained a certain pride: that of their untainted, unmixed blood. Lazarus Morell was one of them." The second describes his maturation: "He was not favored with good looks as a young man and his eyes which were too close together and his straight lips were not prepossessing. The years, however, conferred upon him that majesty peculiar to *white-haired scoundrels*. He was an old Southern gentleman." Borges is not simply parodying an elevated style. He is rather using it to advantage as a vehicle of ridicule. We don't laugh at the style but at the images it surprisingly conveys. Earlier, it was a cliché pair of high-sounding adjectives like "ancient and venerable" that provoked a smile by being used as modifiers for "garbage." In the paragraphs quoted above, it is the sequential parallelism of their phrases, each ending with a stopper, a variant meaning of "canalla," (trash/scoundrel), imagistically linked together by their whiteness that makes them effective. And too, it is the melodious periods of both paragraphs, each ending sententiously ("Lazarus Morell was one of them," "He was an old Southern gentleman"), that prompts a recognition of their intended irony.

These are devices of classical rhetoric being used with the strategy of an avant-gardist to bring together distant or disparate realities. As an ultraist, Borges had used this technique to create new and startling images; as a humorist, he now uses it to spark incongruity, illuminating the ridiculous: Lazarus Morell and Kentucky colonels are one and the same. In a similar way, he will fast-forward to create a link between Morell and the gangsters of the 1930s, whose villainous exploits were the standard fare of his readers in *Crítica.* Thus, the gangland discipline of Al Capone and Bugs Moran is mentioned in one paragraph, quickly followed by a description of Morell's method of dealing with those hapless slaves who catch on to his scheme. To prevent them from squealing, they were thrown into the river "con una segura piedra a los pies" [with a secure rock about their feet]. Hypallage again ("segura piedra") reverses the expected syntactic relation between these two words, highlighting the ironic kind of deathly "security" provided by the rock (which is most assuredly not that of Prudential) secured to their feet. In this way we laughingly come to recognize a common denominator: gangsters all. Morell is a nineteenth-century version of Al Capone, one

more variation of one man who is all men living out the cyclical repetition of history.

■

In the story of real-life gangster Monk Eastman, "The Purveyor of Iniquities," which Borges freely adapted from Herbert Asbury's 1927 book on *The Gangs of New York,* he uses another kind of parallelism for a humorous surprise effect. The gang fights of New York are likened to the knife fights among Buenos Aires *compadritos* (tango-mimicking urban toughs), and both in turn are placed in the legendary context of the Trojan War. A gangland war over territory is thus described in epic terms.

In the example quoted below, each of the anaphoric repetitions of numerical precision—a standard oral device of epic narration to create an eyewitness effect of expectation and continuity of action—is systematically followed by a mocking description of the supposedly heroic contenders. The reader cannot help noticing that this is written to be funny. Tension is maintained, however, and our laugh is suppressed until the end of the sequence by the classical narrative expedient of delaying the appearance of the main verb. We don't really know what is going on until we get to the very end of the sentence, where the carefully crafted rhetorical artifice is detonated with a Mark Twain stopper:

> *A hundred heroes,* vaguely different from their photographs fading away in police files, *a hundred heroes* reeking of tobacco smoke and alcohol, *a hundred heroes* wearing straw hats with colored bands, *a hundred heroes* afflicted, some more, some less, with shameful diseases, tooth decay, ailments of the respiratory tracts or kidneys, *a hundred heroes* as insignificant *or* splendid as those of Troy *or* Junín, *let loose* this black feat of arms under the shadow of the arches of the "Elevated."

Borges's scene is an epic battle waged under the arches of the Brooklyn El. It is a gangland turf war waged by "a hundred heroes," Prohibition-era thugs, physical wrecks, all older ("vaguely different") than their mug shots. These heroes, all uniformed for combat with Panama hats sporting their respective colors—like the pendants of medieval knights, like the flag of Iwo Jima— are simultaneously ennobled and ridiculed when their battle is situated in the and/or context of others as disparate, and as similar, as those over Troy *or* Junín. (The Battle of Junín, for Argentine readers of Borges, is as familiar as Bunker Hill for Americans). The shock of recognition is what makes us see what fools men are.

The real-life Monk Eastman was arrested and jailed, being released to the Army for rehabilitation as an ambulance driver in World War I. Herbert Asbury makes him into a Hemingwayesque figure, fearlessly rescuing the wounded; Borges alters this biographic reality in the interest of poetic symmetry, having him get rearrested after his discharge from prison: "El ocho de setiembre de 1917 promovió un *desorden* en la vía pública; el nueve, resolvió participar en otro *desorden* y se alistó en un regimiento de infantería" [On the eighth of September 1917 he caused a *disturbance* on the public street; on the ninth, he decided to participate in another *disturbance* and he enlisted in an infantry regiment]. The same word ("desorden" [disturbance]) drives home the same Borgesian message: for someone like Monk Eastman one war is the same as another. And, truer to his character, instead of showing him as distinguished for bravery as an ambulance driver, Borges puts him into combat, where we learn that he "disapproved" of taking prisoners, and so with the butt of his rifle he put a stop to this "deplorable practice"—without wasting a single bullet.

■

Humor often has a dual function, making us learn through laughter, where it is akin to an epiphany. The oft mentioned Battle of Junín, for Borges, is as silly as it is serious, not unlike his earlier poem on the "Mythological Founding of Buenos Aires." In fact, his great-grandfather, Colonel Isidoro Suárez, fought in that battle and is mentioned in many of Borges's poems, essays, and stories. The earliest is in *Fervor de Buenos Aires,* where he is the subject of a wistful "Funeral Inscription": "Dilató su valor sobre los Andes . . . / Hoy es un poco de ceniza y gloria" [He spread his valor all over the Andes . . . / Today he is a handful of dust and glory]. More recently, under the dictatorship of Juan Domingo Perón in the 1950s, when people were being jailed for their beliefs, Borges brings his great-grandfather's voice back to life:

> Su bisnieto escribe estos versos y una tácita voz
> desde lo antiguo de la sangre le llega:
> —¿Qué importa mi batalla de Junín si es una gloriosa memoria,
> una fecha que se aprende para un examen o un lugar en el atlas?
> La batalla es eterna y puede prescindir de la pompa
> de visibles ejércitos con clarines;
> *Junín son dos civiles que en una esquina maldicen a un tirano,*
> *o un hombre oscuro que se muere en la cárcel.*

[His great-grandson is writing these lines and a silent voice / comes to him out of the blood of the past: / —What does my

battle at Junín matter if it is only a glorious memory, / or a date or a place learned by rote for an examination? / The battle is eternal and can do without the pomp / of visible armies with trumpets; / *Junín is two civilians cursing a tyrant on a street corner, / or an unknown man dying in jail.*]

The cyclical battle is the same, but it is ennobled in the context of man's eternally renewed opposition to tyranny. This poem was published during the worst period of Peronist repression, artfully camouflaged under the guise of celebrating a patriotic holiday: "A Page in Memory of Colonel Suárez, Victor at Junín" (*Sur,* January 1953).

■

Perón had earlier used his own kind of pointed humor to punish Borges's outspoken opposition to his regime. As a government employee of the Argentine public library, Borges had a kind of job security. Technically, he could not be fired without being reinserted somewhere else in the civil service system. So, in August of 1946, after Perón had consolidated his power, Borges's boldness in likening the rise of Peronism in Argentina with Nazism in Germany was rewarded with a "promotion," from lowly cataloger in an obscure branch library to Chief Chicken Inspector in the public market. The irony was of course calculated. Perón also delighted in making a *cachada,* catching an opponent unawares, in this case putting his brave antagonist in charge of the "chickens." Not wishing to twist in the workaday wind of public ridicule, Borges resigned.

By his own account, it was during the Perón years that, forced by circumstances, he overcame his shyness and learned to speak in public, eking out a living as a lecturer on literature, an activity that in turn helped to promote his visibility as a writer. People began to buy his books, and this period (1945–55) witnessed second editions of *Fictions, The Aleph,* and *A Universal History of Infamy.*

There are several underground texts from this period, written with the parodic panache of the sketches of infamous people. The most notable of these is "La fiesta del monstruo" [A Celebration of the Monster], feignedly exalting Perón and voiced in the street slang of one of his lumpen "descamisados" [the shirtless ones]; it describes a political rally where some Monk Eastman–type head-bashing takes place against the opposition. Significantly dated November 24, 1947, the day of a particularly demagogic radio speech, it was written jointly with Adolfo Bioy Casares (b. 1914), a younger Argentine writer with whom Borges had first collaborated in 1936 in a pseudoscientific publicity pamphlet ("with recipes") to promote the use of a then exotic new dairy product, *La leche cuajada de La Martona: Estudio dietético sobre las*

leches ácidas [The Curdled Milk of La Martona: A Dietetic Study on Milk Acids], a kind of yogurt being marketed by "La Martona," a chain of dairy bars owned by Bioy's family.[10]

Their feigned praise, "Celebration of the Monster," written in 1947, is told in the macho voice of a goon from one of the government's strong-arm squads who breathlessly brags to his girlfriend about his previous day's activities in support of the "Monster," his affectionate term for Perón, "el gran *laburante* argentino" [the great Argentine "woikah"]: "Te prevengo, Nelly, que fue una jornada cívica en forma" [I'm telling you, Nelly, it was an all-out civic day]. It was a day when he and the boys had a real workout, painting Perón slogans on the houses in the posh neighborhoods, turning over a bus to burn it, and stoning to death a "miserable four-eyes" (read Jew), before finally gathering with other goon squads in the Plaza de Mayo to cheer "la palabra del Monstruo" [the words of the Monster]: "Estas orejas la escucharon, gordeta, mismo como todo el país, porque el discurso se trasmite en cadena" [These ears heard him, honey, just like the whole country, 'cause the speech was broadcast on national radio]. Morbid humor is used to highlight the grotesque mob actions of these "civic-minded" political thugs.

■

One of the strengths of the comic Borges is his ability to characterize his narrators instantly through their peculiar ways of speaking. We have already seen how this was used to humorous advantage with voices as diverse as that of the effete snob who eulogized Pierre Menard and with that of the pathetically stupid minotaur. He first displayed this talent in "Hombre de la esquina rosada" [Street-Corner Man], a nostalgic monologue in the swaggering voice of a former *compadrito*, a has-been, a faded street fighter. Originally published in *Crítica* (September 1933) under the title "Hombres de las orillas" [Men from the Outskirts], and later included in *A Universal History of Infamy*, it has since come to be his best-known piece, having been made into a ballet, a play, and two films. Naturally, Borges finds all this popularity "embarrass-ing," and he belittles the story, calling it "stagy and mannered" in his 1970 "Autobiographical Essay."

While not exactly written to be funny, this early story does rely on a jokelike flash of recognition at the very end when we learn that the teller of the tale, in the guise of celebrating his legendary bravery, inadvertently reveals his own cowardice. This story also marks Borges's first *known* use of a pseudonym, "F. Bustos," not so much to hide his identity as author as to support the "as told to" structure of the piece in which Borges, or some city slicker named Borges, is the listener. In this scheme, Bustos, under whose name the piece was first published, would be the one who wrote it down.

This is what the Russians call *skaz,* a written narration that uses the illusion of an authentic oral tale to make the reader aware that the teller is aware of our presence, that the story is self-consciously being told to impress us, and perhaps even to fool us.

Like "Celebration of the Monster," it is told in a kind of dialect with unusual syntax and faulty grammar imitating the language of a street-smart tough who relates an important moment in his life, the moment when he becomes a man, killing a rival in a knife fight. It begins like an overheard conversation, with the tough speaking out to a wider and somewhat younger audience, as though in a bar:

> Don't you guys try telling me, of all people, about the late Fran-
> cisco Real. I knew him personally, even though he wasn't from
> around here because he used to strut around the Northside, that
> whole stretch from the Guadalupe pond to the Armory. I never
> dealt with him above three times, and these three were all on the
> same night, but that's a night I'll never forget, 'cause that's when
> La Lujanera came over all by herself, to bed down in my shack
> and Rosendo Juárez took off from the Arroyo, never to return.
> Of course, you guys don't have enough experience to recognize
> that name.

As the speaker goes on, adding audience-directed flourishes like a jongleur, we begin to suspect that he has told this story many times before. These flourishes also alert the reader that his audience is gradually shifting from the plural generic "ustedes" at the outset to the singular polite "usted, señor" and finally to just one individual, directly addressed as "Borges," who at the end is the sole listener. In the course of the tough's narrative performance, we learn that he was the youngest and smallest member of Rosendo's gang (Rosendo Juárez el "Pegador," alias "The Slasher") and that on the night in question they were all out partying at a local red-light tango bar similar to the one in which he is telling the story. Suddenly the music stops and the door is kicked open Hollywood Western–style by Francisco Real (el "Corralero," alias "The Butcher"), who makes his way for Rosendo, challenging him to a duel. When Rosendo's girlfriend, La Lujanera dutifully hands him his knife, saying, "I think you'll be needing this," he tosses it away and walks out. Our narrator is suddenly ashamed at the unmacholike behavior of his idol, even more so when the music starts up and Lujanera slides into the arms of the intruder, Francisco Real, and they dance their way out of the bar, "cheek to cheek, as though floating off on the wave of the tango." Thinking that they're probably "going away at it in some ditch," our narrator shamefacedly leaves the bar. When he returns not long afterwards, he is another man. A few moments later, a bloodied Francisco Real stumbles into the bar followed by

Lujanera, but before he can get a word out he drops dead. Everyone assumes that Lujanera faithfully (and fatefully) stabbed him. Our narrator speaks up for her, saying she couldn't have ("she's only a woman"), and she is allowed to leave. Before the police arrive, he and the gang toss the cadaver out the window and into a ditch (after first cutting the ring off its finger), and the dance goes on, as though nothing had happened. End of the story, or almost. In the closing statement, now that "Borges" is the only listener, our narrator sotto voce reminds him that this is the night La Lujanera came to his bed: "I started walking coolly back to my shack, which was just three blocks away. A light was burning in the window, then all at once it went out. I swear I hurried to arrive when I saw that. Then, Borges, I took out again the sharp little knife I usually carry in my vest, just under the armpit, and I gave it another slow lookover, and it was just like new, innocent, and there wasn't the slightest trace of blood." The way the narrator talks, and what he says (and doesn't say) is what permits the reader at story's end to conclude that the braggart is really a coward, an assassin who knifed his rival in the back. And this is precisely what makes the tale so enjoyable, prompting us to read between the lines.

■

Although Borges routinely disparaged this story, even going so far as to say that its language was too literary, and hence inauthentic, he couldn't restrain himself from reworking it and including it in both of his Personal Anthologies. And in 1969 he rewrote it completely, from an entirely different point of view, that of Rosendo Juárez, the man who originally walked away from the fight, leaving behind his Lujanera as a prize for a braver (more macho) man. In the retelling, the setting is almost the same, although the years have taken their toll and the neighborhood bar is now a modern cafeteria with tables. When Borges comes in, an older man who is sitting alone invites him to have a drink: "You don't know me except maybe by reputation, but I know who you are, Sir. I'm Rosendo Juárez . . . Well now that we have nothing better to do, I'm going to tell you what really happened that night. The night 'The Butcher' got killed. You, Sir, put what happened down in a novel, which I'm not equipped to appreciate, but I want you to know the truth about that trumped-up stuff." Rosendo Juárez tells Borges how he came to fame as "The Slasher," the chance outcome of a drunken quarrel with a friend when both men "stepped outside" to settle their differences. In this account, eye to eye and knives drawn, they are dutifully distancing themselves from the bar when the friend trips and Rosendo jumps him, stabbing him in the back. Since no one saw this villainy, but only the cadaver it produced, Rosendo became known as "The Slasher," the toughest guy in the neighborhood. This fame brings him the "loyalty" of Lujanera, the admiration of the younger would-be toughs who become his

gang, and occasional strong-arm duties to the ward boss who got him out of prison. He is thus on the top of the pile when Francisco Real, "The Butcher," arrives to challenge him to a duel. Realizing the futility of it all (and his woeful lack of knife-fighting experience), he prudently walks out, fleeing to neighboring Uruguay, where he gets a job as a teamster.

Retired now, and back in Buenos Aires, he wants to set the record straight, telling Borges that he didn't wish to live (or die) the role that fate had staked out for him, the fake tough-guy role assumed by the nostalgic narrator of "Street-Corner Man." The new story, the "Historia de Rosendo Juárez" as told by Rosendo himself, ends with typical Borgesian irony: "To get away from that life, I took off for Uruguay, where I found work as a teamster. Since coming back to Buenos Aires I've settled here. San Telmo has always been a respectable neighborhood." San Telmo is one of the oldest neighborhoods of Buenos Aires, and like New York's Lower East Side or London's Soho, then still one of its roughest, as illustrated in these verses from a popular song:

> Soy del barrio de San Telmo
> donde llueve y no gotea
> a mí no me asustan bultos
> ni grupos que se menean.

[I'm from the neighborhood of San Telmo / where it rains for real and doesn't just drizzle / I'm not scared by any hulks / nor the gangs that strut around.]

Everything is relative. San Telmo is great in comparison to the outskirts of town where Rosendo grew up.

Something of Borges's motivation for retelling the story is contained in an explanation he appended to the English translation of "Rosendo's Tale" in *The Aleph and Other Stories:*

> This story is, obviously, a sequel and an antidote to "Street-Corner Man." The earlier story was mistakenly read as realistic; the present one is a deliberate surmise as to how events might actually have happened on the night Francisco Real was murdered. When I wrote "Street-Corner Man," I was—as I pointed out at the time— fully aware of its stagy unreality. As the years went by, however, and that story became embarrassingly popular, I wanted people to understand that I was not quite the fool I was being admired for.
>
> I had been rereading my Browning and knew from *The Ring and the Book* that a story could be told from different points of view. Rosendo Juárez, the seeming coward of the first version,

might perhaps be allowed to have his own say. So, instead of the braggart of "Street-Corner Man," we get a Shavian character who sees through the romantic nonsense and childish vanity of dueling, and finally attains manhood and sanity.

Borges's version of the "antidote" adds a new irony to its interpretation: it takes more courage to walk away from a fight than into one.

The story of Rosendo was originally published in *La Nación* (November 9, 1969), Argentina's leading daily, a kind of New York or London *Times* newspaper of record—a world apart from the yellow-press pages of *Crítica*—and was included the following year in *El informe de Brodie* [Doctor Brodie's Report], an unexpected volume of new stories that critics in 1970, inadvertently echoing Amado Alonso's praise of thirty-five years earlier, hailed as Borges's "return to narrative."

In the "Prologue" to this 1970 volume, he boasts that he has finally found his voice and is now "resigned to be Borges." This new voice, he says, is less baroque, more direct, and free of dialect. By way of illustration, he tells a joke about Roberto Arlt (1900–42), an Argentine novelist of urban lowlife who was faulted by the establishment critics for his poor use of "lunfardo" (the dialect of the slums). To this, Borges says, Arlt cleverly replied: "I was raised in the slums, among poor people and rogues; I never really had the time to study such a thing." By way of clarification, Borges adds: "the lunfardo language is, in fact, a literary joke [una broma literaria], invented by the authors of tangos, and of which the slum locals are ignorant, except for what's been indoctrinated through recordings."

Thus, our former street-corner man is still characterized by his speech, although without the "rhetorical excesses" of 1933: "Usted, señor, ha puesto lo sucedido en una *novela, que yo no estoy capacitado para apreciar"* [You, Sir, put what happened down in a *novel, which I'm not equipped to appreciate*]. A roundabout way of saying that he's never seen the *story* since he can't read, another veiled irony. Borges, after all, is writing to be funny.

Chapter 6

Fun in the Later Fictions

In all my stories there's an element of humor, a bit of a joke, even
when I deal with the most serious subjects.

Borges, 1970

B orges's slow but steady emergence to international visibility was recognized in 1961 when he shared the Formentor Prize with Samuel Beckett, and was accompanied by an equally slow but implacably steady loss of his eyesight. True to character, he joked about this too. When he was appointed director of the Argentine National Library, following the fall of Perón in 1955, he was almost totally blind. This gave him cause to mock-celebrate the occasion with what he called a "Poem of the Gifts," in which he wryly commented on the "majesty" of God, "who with magnificent irony granted me at the same time books and blindness."

Unable to write and revise in the meticulous manner that was his custom, he abandoned narrative and returned to poetry, since with the aid of rhyme and meter he could rework the wording in his head, before finally dictating a completed text to his mother or a friend. Several books of poems (mostly rhymed sonnets) ensued, culminating with the ironically titled *Elogio de la sombra* [In Praise of Darkness (or, rather, In Praise of Blindness)] (1969), before he surprised his readers with a new book of stories in 1970, *El informe de Brodie* [Doctor Brodie's Report]. And when he did return to narrative, his style had changed, becoming more plainspoken, less writerly, and hence more seemingly sincere, as in "Rosendo's Tale."

111

Actually, the earliest of these later fictions, "La intrusa" [The Intruder], was published in 1966, although almost clandestinely in a private printing limited to just fifty-two copies, "con destino a los amigos del autor" [solely for the author's friends]—probably because this is not a text for everyone's taste. It is a summary account of two hard-living gaucho brothers who lust after the same woman. To thwart disharmony, they first share her, then remove her from their midst, selling her off to a house of prostitution in a distant town. Unable to stay away from her, they separately invent all kinds of excuses to go into town, until they realize that they're "wearing out the horses" and prudently decide to buy her back. When this doesn't work, they decide to get rid of her for good, killing her.

This is a macabre tale of brotherly love, laced with morbid humor. For these archetypical men of the Argentine plains, a woman is an intrusive thing, "una cosa," as the text dryly points out. Ironically, the story was dictated by Borges to his mother, who, although she "loathed" its misogyny, was nonetheless responsible for its final macabre touch, adding the tough-voiced snippet of dialogue that brings it to a close as the brothers, rather than digging her a grave, cold-bloodedly toss the body into a ditch: "A trabajar, hermano, después nos ayudarán los caranchos" [Let's get back to work, brother, later the buzzards will take over].

For many twentieth-century theorists, from Freud through Arthur Koestler (*The Act of Creation* [1964]) and Viktor Raskin (*Semantic Mechanisms of Humor* [1985]), all humor is ultimately aggressive, since jokes are always made at the expense of someone else. Depending on the audience, some jokes, instead of a laugh, will produce a groan. For at least half of the human race, "The Intruder" is sure to be a groaner, which is probably why its first printing was so short and so private. When collected in *Doctor Brodie's Report* a few years later, perhaps to be on the safe side, Borges couches it as a true story that contains a lesson, what he calls a "tragic mirror" of the hard-bitten character of the Argentine plainsmen of yesteryear. That it is also meant to be a joke, a kind of gallows humor story, should be patent from the outset, where we are straightaway informed that the story was supposedly first told by one of the brothers at the funeral of the other!

I begin this chapter with "The Intruder" because it chronologically marks Borges's return to narrative and because it was also the lead story in the original Spanish edition of *El informe de Brodie* (in Giovanni's English-language edition it is prudently displaced to the middle) and to underline the fact that Borges's sense of humor has changed. Or, to put it another way, he has widened the window on what he wishes the public to see of his humor. In the "Afterword" to the translation, published only months after the original Spanish, Borges tells us that these are the first narratives he has attempted since 1953, and he singles out "The Intruder" as the first written of these new

stories, one that "haunted me for some thirty years before I set it down." Its offensiveness was probably one of the reasons it was kept in the closet so long.

■

Sandwiched between the serious-minded smugness of the postwar years that saw his rise to fame and the self-censoring political correctness of our own time, there was the 1960s, a period that saw the rise of morbid humor around the world and in the United States, with comedians like Lenny Bruce and writers like John Barth, Thomas Pynchon, and Richard Stern. Borges and Bioy had blandished this blatantly irreverent brand of humor with *The Chronicles of Bustos Domecq* in 1967, openly listing themselves as the authors. Not surprisingly, many of Borges's later fictions continue in this same vein, occasionally crossing the line from morbid humor into sick humor, without, however, abandoning the staid style of delivery that often keeps this particular kind of derision just out of laugh's reach for the serious-minded. Borges's jokes were never really intended for what might be called a general audience; rather, it seems that his intention was always to fool some and amuse others, since he consistently made an effort to keep some of his funnier pieces almost private. He maintained a straight face, for example, in 1939 when historian Ernesto Palacio, the know-it-all director of *Sur*,* told him that he was of course familiar with the nuttiness of Pierre Menard, and he tried to put off Ronald Christ as he persisted in drilling him about the mysterious Sect of the Phoenix.

All humor may ultimately be aggressive, with the jokester saving the last laugh for himself over the gullibility of his public, but Borges was remarkably restrained with some of his jokes, often (and successfully) preferring to stave the reader off on the first reading while providing just enough interest and ambiguity to prompt a second one. This is the red herring technique, designed momentarily to distract. The full import of "The Intruder," for example, is delayed and thwarted by an intentionally slim epigraph alluding to a certain verse and chapter of the Catholic Bible: "2 Reyes, 1:26." Nothing more, no quote whatsoever, simply book, verse, and chapter. It is only when a serious "agelast" goes to the Bible (Samuel 1:26, in the Protestant version), that one reads the passage that refers to David's expression of love for his dead brother: "I am distressed for you, my brother Jonathan; you have been very pleasant to me; your love for me surpassed the love of women." And so, in the shifting game of mirrors so dear to Borges, what purports to be a parable, "un breve y trágico cristal de la índole de los orilleros antiguos" [a brief and tragic mirror of the character of yesterday's rural Argentines], turns out to be a parody of an Old Testament attitude. Knowing this, in the second reading we can smile

* Which is probably why he inserts him in another story, as Ernst Palast, the editorial writer for *El Mártir,* who lamented the "frugal pogrom" in "Death and the Compass."

at the opening sentence, where we are informed at the very beginning of the story that it was first told by one brother at the wake of the other, now taking it not as the lead line for a sick joke but as an allusion to David's eulogy of Jonathan in the Bible. Either way, the story works not so much as a celebration of male bonding but as a satire of the extremes to which it can lead.

■

In Borges's earlier fictions, we saw a pattern of injecting humorous elements into an otherwise serious story; now it is more a question of telling a patently ridiculous story in a serious way. More than half of the eleven narratives in *Doctor Brodie's Report* are humorous, some grotesquely so. This is true of another biblical story, "El evangelio según Marcos" [The Gospel According to Mark], where the do-good protagonist, Espinosa, a studious city fellow on holiday at a relative's cattle ranch, finds himself marooned with a family of illiterate farmhands after a surprise rainstorm inundates the fields. To while away the time, he reads aloud to them from one of the few books at hand, a family heirloom, their own English-language copy of the Bible (which of course, they are unable to read). The others were classics of gaucho literature (which, of course, being real gauchos, they found "unconvincing"). Impressed by his knowledge and kindness, they see him as a kind of miracle man and hastily wolf down their dinner each night so as to enjoy his dramatic reading of the first book of the New Testament, the Gospel according to Mark, which vividly chronicles the Crucifixion in all its gory details. After a few days, when he finishes with this book of the Bible, and wishes to go on to another, they ask him to read it over again, so that they can "get it right."

This story depends on regression, man's march backward to a more primitive state. Regression is one of Borges's favored mechanisms for thought-provoking humor. By way of illustration, to show how it works, I offer a regressive joke, a citation from a statement Borges made in the "Prologue" to a collection of his *Prólogos* (1975), about the importance of French when he was growing up: "When I was a boy, to ignore French was practically to be an illiterate. Over the course of time we have passed from French to English and from English to ignorance, without excluding that of Spanish." The first sentence sets things up, equating a knowledge of French with culture, or conversely a lack of such knowledge with ignorance. The second sentence runs this "ambiguator" in a progressive regression, passing from French to English to an ignorance of one's native language. Not unlike the minotaur's proud ignorance of the alphabet, which spared him the tedium of reading.

And, too, we should recall the "Creole" protagonists of "The Intruder," the illiterate Nelson brothers, redheaded descendants of Nordic immigrants (once called Nilsen) whose only link with their past was in their blood;

they had forgotten everything their forebears once knew. Similarly, the near-Neanderthal "Creoles"* of "The Gospel According to Mark," the Gutres, who take the account of the Redeemer to heart, are being read to from their own family Bible, whose print they are now incapable of deciphering. Indeed, they are barely able to speak Spanish, or any language for that matter. Here's how Borges tells the story of Baltasar Espinosa, our marooned student vacationer among the grunting Gutre family:

> Exploring the house, still encircled by the flood, Espinosa came across an English Bible. In its end pages the Guthries—such was their original name—had left a handwritten account of their lineage. They were natives of Inverness, they had arrived in this continent, no doubt as common laborers, in the early part of the nineteenth century, and had intermarried with Indians. The chronicle broke off sometime during the eighteen-seventies; they no longer knew how to write. After a few generations *they had forgotten English; Spanish,* at the time Espinosa came to know them, *gave them trouble.*

This is, or could be, a reality. Borges attributed a very similar progressively regressive history to that other family of Argentine redheads, the Nelson brothers in "The Intruder:" "In Turdera they were called the Nilsens. The priest there told me that his predecessor remembered having seen in the house of these people, somewhat in amazement, a worn Bible with a dark binding and Gothic type; in the end pages he saw some names and dates written in by hand. It was the only book in the house. The chancy chronicle of the Nilsens, lost as one day all things will be lost . . . I know that they were tall, with bushy red hair. Denmark or Ireland, *which they probably never heard of,* ran in the blood of these two Creoles."

History repeats itself. These New World descendants of the Old, cut off from their origins, will relive the stories of the past. The pattern for the Nelsons is the brotherly love of David and Jonathan. The Gutres will enact yet another biblical episode, that of the Crucifixion, taking the kindly Espinosa for Christ himself. When at story's end, observing that the flood waters are receding, Espinosa announces that "it won't be long now," his listeners, unbeknownst to him, are already convinced that he is the Redeemer incarnate. The student's last pronouncement, referring to the receding flood— "It won't be long now"—is the ambiguator for the final joke, a cruel one on the hapless victim:

* An inside, Argentine joke, which merits a footnote. These families of Anglo/Nordic descent are *both* real *and* unlikely "Creoles"; having been born and raised in Argentina they are as authentic and as odd to an old-line Argentine like Borges as were *Los gauchos judíos* (1910), the subjects of a volume of short stories by Russian immigrant Alberto Gerchunoff (1883–1950).

> "It won't be long now," Gutre repeated, like an echo. The family of three had been following him [Espinosa]. Dropping to their knees on the stone pavement they asked for his blessing. Then they mocked at him, spat on him and shoved him toward the back part of the house. The girl wept. Espinosa realized what awaited him on the other side of the door, for when they opened it, he saw a patch of sky . . . The shed was without a roof; they had pulled down the beams to make a Cross.

Morbid humor is both funny and tragic. The horror of what he and we know is about to take place and the victim's helplessness to alter the outcome are what turn tragedy into comedy, much like the banana peel awaiting the innocent pedestrian in a cartoon strip.

Those who are above this sort of grim humor will find other things to smile at in this story, such as Borges's cleverness in giving his victim the name of Espinosa, a subtle *agnominatio* that not only echoes that of the Jewish Spinoza (pronounced as *Es*-pinosa in Spanish) but also has the literal meaning of "thorny" so as better to highlight his crowning I.N.R.I. What is more, Espinosa's first name is Baltasar, which is also the name of the Babylonian king who while profaning the temple of Jerusalem saw some strange words on the wall that were interpreted by the prophet Daniel as forecasting his death, which occurred that very evening. Hence, it was not for naught that Borges gave the name of Daniel to Espinosa's cousin who invited him to the ranch, nor is it insignificant that he attributes his Christlike Espinosa with "an unlimited kindness and a capacity for public speaking," a thoughtful man who at the ringer age of *thirty-three,* "still lacked credit for graduation." Some readers revel in recognizing such allusions, others what they lead to, such as the allusion to Christ as something of a late bloomer or a retard.

∎

In an odd twist of aesthetics, owing much to the vogue of morbid humor in the 1960s, the tragic stories in this collection are also the funnier ones. The most grotesque of them all, the one that is guaranteed to offend everyone's sensibility, male and female, while at the same time provoking a grim laugh, is enticingly titled "El *otro* duelo" [The *Other* Duel] and is situated in the volume so as to be read in sequence with the story that immediately precedes it, "El duelo" [The Duel]. The second of the two, "The Other Duel," deals once again with that most frequented of Borges's themes, the rugged rivalry between two men who are destined to fight to the death over nothing: a card game, a woman, a footrace. Its counterpart, "The Duel," deals with the more subtle sparring between two highborn society ladies who are lifelong friends.

In both stories, the rivalry of the protagonists is what binds them together, linking their fates and controlling their actions.

The more grotesque of the two is "The Other Duel." Set in the border zone where the Argentine and Uruguayan grasslands spill over into Rio Grande do Sul, the gaucho zone of southern Brazil, it highlights the final confrontation of two lifelong rivals conscripted into the army and obliged to fight side by side in one of the many civil and territorial wars (another kind of senseless rivalry) that plagued the region during the nineteenth century.

Like most of the stories in this volume, it is an "as told to" narrative with the blind Borges as the final teller giving a composite account of the many versions he has supposedly heard over the years. This format justifies the necessarily oral nature of his later narrative mode and lends the tale an additional kind of epic veracity. The names of the protagonists in "The Other Duel," as to be expected, are significant, with the two Uruguayan rivals having Brazilian surnames, Cardoso and Silveira, tagging them as outsiders in their own (newly adopted) country. Both men are the butt of yet another Creole outsider, an ironfisted military commander with the Irish immigrant name of Juan Patricio Nolan, who is locally known as a "bromista," a prankster. This story relates one of his many devilish pranks, the "diabluras" for which he is infamous. First, to create the ambience, we are informed by Borges of the mindless cause of the rivalry between Cardoso and Silveira, which echoes the misogynist motif of "The Intruder": "Cardoso, less out of love than out of boredom, took up with a neighbor girl, La Serviliana; that was all Silveira had to know for him to court her in his style and bring her back to his shack. A few months later he threw her out because she got in his way. The woman, thus spited, sought refuge at Cardoso's; he spent the night with her and dispatched her in the morning. He didn't want the other man's leftovers."

Yet, despite repeated affronts, they somehow *never* actually come to blows, which is another form of a standard joke about Latin tough guys, be they Spaniards, Argentines, or Italians: two men in a barroom brawl, instead of raising their fists and going at one another, drop their arms and fall back on their companions, shouting, "Hold me back, before I kill him!" Borges embellishes the familiar formula in this way: "In those rough places and in that time, man squared off against man and steel against steel; a peculiar twist of this story is that Manuel Cardoso and Carmen Silveira must have crossed blades with one another more than once, at sundown or at dawn, and *never fought it out to the very end.*"

In fact, when they are forcibly conscripted, they are both playing cards at separate tables in the same tavern, and as soldiers they will also fight side by side. When their regiment, which *outnumbers* the enemy—more Borgesian irony—*surrenders* to Nolan the "bromista," he carefully plans the execution of all the prisoners down to the last detail. Having heard of the long-standing

rivalry between Silveira and Cardoso he decides to have some fun with these boys, giving them the chance finally to show which of the two is the better man ("el más toro").

Juan Patricio Nolan's creole version of the gladiatorial fight to the finish is a footrace between the two, which however they will only begin to run at the precise moment that they are simultaneously slaughtered: "You're going to be able to show who's the toughest. I'm going to stand you up and have your throats cut and then you'll run a race. God already knows who'll win." This "prank" is gruesome enough, but to make it more convincing (and consequently funny), Borges piles on the factual details, each one more soberly ludicrous than the last. For example, the defeated troops, scheduled for execution *before* the race to get them out of the way, are nevertheless curious to know the outcome of this long delayed confrontation between Cardoso and Silveira, and respectfully ask to be executed *after* the race. When this permission is magnanimously granted, they set themselves to betting on their favorite as if there were no tomorrow (which in their case there won't be). In a final touch of grim kindness, because it is such a hot day, the race is delayed a few hours, so that it needn't interfere with anyone's siesta.

Borges relates all this gentlemanly reasonableness, tongue in cheek, of course:

> Nolan had planned that the race would crown the afternoon execution, but the prisoners sent him a representative to tell him that they too wanted to watch it and wager on the outcome. Nolan, who was a reasonable man, let himself be convinced; the bets were laid down, money, riding gear, sabers and horses, which in due time would be handed over to the widows and next of kin. The heat was unusual; so that no one would miss his siesta, things were delayed until four o'clock.

Borges continues to lay on macabre details such as these, which because of the matter-of-fact tone of their delivery, are increasingly funny. Decency and logic are thus zanily made to go hand in hand with the cruel and the absurd, as in the description of the race itself.

In the style of an Olympic event, as Cardoso and Silveira toe the mark, their respective commanding officers (scheduled, let's remember, for a mass execution along with their men immediately after the race), pep the two of them up, calling on each to do his best, "porque les tenían fe *y las sumas que habían apostado eran de mucho monto*" [because everyone was counting on them *and the sums they had bet amounted to quite a lot*]. The twisted high and low reasoning, drawn from manly battle speeches and sporting events, is at once familiar and farcical. When Nolan gives the starting signal, the heads of Silveira and Cardoso are summarily lopped off and they dash forward a

few steps, before tumbling to the ground. In a final touch of irony, since one of them spread his arms as he fell, "había ganado y tal vez no lo supo nunca" [he had won and perhaps never knew it]. Such is the trajectory of "The Other Duel," a show-offy showdown between two brutish men before other brutish men. Gruesomely silly and absurdly veritable, within the tradition of *humour noir,* it is tragically funny.

Readers who like this sort of humor, where grown men literally lunge into their tragicomic destiny, will find even more pleasure in "El encuentro" [The Meeting], where the narrator is a city boy (a stand-in for the young Borges) who is taken to a weekend bachelor barbecue at a posh ranch out in the country and witnesses the grown-ups getting drunk and rounding out the bash with a card game that turns into a knife fight with "museum-quality daggers" selected from the ranch owner's prized collection. Neither of the weekend warriors knows how to wield a knife. No matter though; these knives have fought before: "las armas, no los hombres, pelearon" [the weapons, not the men, fought it out], and when one man is killed, the other, his friend and aggressor, breaks down and cries. Both inept knifemen are the hapless victims of the banana peel code of manly conduct that fate has strewn in their path.

■

In contrast, the duel between the two highborn women in "El duelo" is more delicate and ladylike, not along the Nora Ephron lines of who gives the best party or bakes the best soufflé (although it does have its share of competitive soirées) but rather in terms of which of the two can be outwardly kinder to the other in each of their several confrontations. It is significant that this story about women is titled "El duelo," *the* duel, and that its companion piece, about men, is called "El otro duelo," the *other* duel. The fact that they are so paired obliges that they be read in sequence and compared. One sets the pattern for the other, with the story about female rivalry being as senseless, and as inevitable, as that of men.

Both women are intelligent, although uneducated (their readings don't go beyond what the glossy magazines happen to put within their reach, "a su alcance"), and like most upper-class women of their time and place (mid-twentieth-century Buenos Aires), they have what is euphemistically called "a knowledge" of languages. One speaks some English, the other can make small talk in French. Originally of immigrant stock, like most everyone in Argentina, the aristocratic Marta Pizarro's family presumably hails from Spain (let's not forget though that the conquering Pizarro was formerly a swineherd), and Clara Glencairn de Figueroa (another "flaming redhead") from the hills of Scotland. At the time of the story, Clara is a recent widow and Marta never married. Neither of course works for a living. That would not be fashionable.

Marta fills her time painting realistic street scenes of old Buenos Aires and portraits of national heroes, which, given her social connections, are duly acquired by the pertinent "Museo Provincial."

The origins of their friendly rivalry date back to an affair that Marta's sister, a divorcée, may have had with Clara's husband, a former ambassador. When he dies, Clara decides to take up painting, and since her friend/rival Marta is a traditional realist, opts for something entirely different, abstractionism. They both however belong to the same society for the "advancement" of the arts, the quaintly anachronistic "Giotto Circle," and from its conservative bulwarks they politely protect and promote the work of one another. Or so it seems. Their subdued rivalry is centered around little tokens of recognition like prizes and exhibitions, and finally comes to a head over which of the two will be chosen to represent Argentina in a so-called "international" congress of Latin American artists in Colombia, South America (an echo of the "Argentine *section* of the *Unión* Latinoamericana"). When one is chosen over the other, it is the loser who graciously gives the farewell party. Borges uses this interweaving structure of escalating politesse not so much to poke fun at the antagonists but rather as a vehicle to satirize Argentine high culture, its slavish dependence on foreign fads, its provincial chauvinism, and its deep-rooted misogynism.

Long before feminism became an issue in the Hispanic world, Borges was sensitive to the straitjacket imposed on women. Just as his male protagonists are socially bound to act out a tough-guy role, stupidly stabbing one another at every turn, so also are the women in his stories reduced to the passive roles society has laid out for them. In this story Borges ridicules those roles, not the women who are condemned to play them. Thus, Clara and Marta are uneducated not because they are stupid but rather because it was not considered proper for a lady to study anything but foreign languages. In this scheme of things, painting as a profession is all right because it is really just a pastime that one can exercise in the privacy of the home. As for prizes and recognition, these are equally unthreatening to the patriarchal social order since "everyone knows" they are awarded to women not for their merit but out of chance or default. Witness this amusing inside account of how Clara Glencairn came to win her first prize:

> Around 1960, "two brushes of international stature"—may we be forgiven the jargon—were in the running for a first prize. One of the candidates, the elder, had dedicated solemn oils to the depiction of awesome gauchos of a Scandinavian stature; his rival, quite young, had harvested both praise and scandal through a deliberate incoherence. The members of the jury, all well past fifty, fearing that people would impute outdated standards to them,

tended to favor the younger painter, though deep down they rather disliked him. After some tenacious debates, politely at first and finally worn out, they could not reach an agreement. In the course of their third meeting, one of them remarked: "B seems quite bad to me; really, he seems to me even worse than Mrs. Figueroa" [*la señora de Figueroa*]. "Would you actually vote for her?" said another juror, with a trace of scorn. "Yes," replied the first, who was now irritated. That very afternoon, the prize was unanimously awarded to Clara Glencairn de Figueroa.

So much for Clara's merits (who incidentally is always referred to by the jury as "la señora de Figueroa" or "la señora del Embajador," that is, as someone's wife), and for the criteria of the old men on the jury who voted her the prize, whose sexist in camera reasoning is facetiously summarized as follows: "era distinguida, querible, de una moral sin tacha y solía dar fiestas que las revistas más costosas fotografiaban" [she was distinguished, likable, of impeccable moral standards and usually gave parties that were photographed by the most costly magazines].

An opportunity further to lampoon this socially ingrained sexism comes up when Borges suddenly brings the story to an end with Clara's death at the height of her career:

> The columns of the newspapers devoted long obituaries to her, of the kind that are still quite common in our country, where *a woman is regarded as an example of the species, not an individual.* Aside from some hasty mention of her dabbling in painting and of her exquisite good taste, she was praised for her religious devotion, her kindness, and her constant and almost anonymous philanthropy, her illustrious lineage—General Glencairn had fought in the Brazilian campaign—and her outstanding position in the highest circles of society.

Antifeminism is not the only theme highlighted for ridicule in this story. We also have national chauvinism. When Marta is sent to Cartagena de Indias to represent Argentina at what this crumbling colonial Colombian city pompously (and provincially) bills as the First *International* Congress of *Latin American* Plastic Artists (the term "artista plástico" is pretentiously used in Spanish to distinguish painters and sculptors from their supposedly more vulgar counterparts, "artists" of the stage and screen), her participation there is reported back home as nothing short of "brilliant," at least according to the "testimonio *imparcial* de los corresponsales de Buenos Aires" [*impartial* testimony of the correspondents from Buenos Aires]. A neat implied contradiction.

At the core of the story is a parody of the art world, with its fashionable fluctuations regarding what's in and what's out. In this, Borges portrays Argentina as a close follower of the fashions, hence always a little behind: "todo, según se sabe, ocurre inicialmente en otros países y a la larga en el nuestro" [everything, as everyone knows, occurs first in other countries and eventually in our own]. In this context, it is worth recalling that a skeptical attitude with regard to cultural trends and trendiness in Buenos Aires and around the world was the main thrust of the parodic *Chronicles of Bustos Domecq,* which Borges and Bioy had published only a few years before, in 1967.

This same wry view of high culture is carried over into this story, which lampoons the then reigning mode (in Clara Glencairn's mid-1950s Argentina) of *pure* abstraction, what the New York art critic Clement Greenberg had baptized in 1955 as "color field painting," to enshrine the single-toned canvases and painted stripes of Barnett Newman and Mark Rothko. Borges turns Greenberg's deftly conceived concept inside out, inventing for the purpose one Lee Kaplan, and making him out as a wild-eyed zealot of the iconoclastic "sect," a pure abstractionist who rigorously reasons *per absurdum* that: "His canvasses, which so outraged the bourgeoisie, actually followed the biblical proscription, shared by Islam, that human hands shall make no idols of living things. The iconoclasts, he argued, were restoring the genuine tradition of pictorial art, falsified by heretics like Dürer and Rembrandt." Painting anything recognizable is a heresy; what counts is pure color.

When Clara, cast as a simpleminded dilettante, takes up painting, she must of course be behind the times, so Borges has her naively practice a kind of painting that the Argentine hotshots of the time mistakenly condemn as the dernier cri of yesterday, abstract expressionism, mono-colored canvases with ever so faint gradations of tone and texture. When she exhibits her work in a fashionable Buenos Aires gallery, "although the general criticism was benign," the stalwarts of what Borges calls the "latest sect" condemn "esas formas anómalas que, si bien no eran figurativas, sugerían el tumulto de un ocaso, de una selva o del mar y no se resignaban a ser austeros redondeles y rayas" [these anomalous forms which, although they were not figurative, suggested the tumult of a sunset, a forest or the sea and did not resign themselves to being austere circles and stripes].

Poor Clara! Her idol was not Newman or Rothko, of whom she presumably knew nothing, but Turner, the British Romantic painter once famed for his wistful rendering of ruins and landscapes, and now revered around the world as the secret painter of fogs and early morning dawns where forms are barely discernible in canvases of a single color, in short, a forerunner of abstraction thanks to a 1948 traveling exhibition that exhumed this forgotten legacy from the storage basement of London's Tate Gallery.

It is curious that Borges, despite being blind, was so up-to-date regarding

the visual arts and enjoyed poking fun at its fads and fashions.* Or perhaps not so curious, for a few years before, he and Bioy had done much the same with the then current fad in literature, "objectivism," as championed by Alain Robbe-Grillet. When the critical adulation of the French New Novel was at its height in the 1960s it became the direct butt of amusement in one of their *Chronicles,* "Una tarde con Ramón Bonavena" [An Afternoon with Ramón Bonavena], which portrays a writer who, like Robbe-Grillet (author of *Les Gommes* [1953]), has imperiously banished the Balzacian trivia of plot and character in order to better detail objectively observable reality: in this case, the north-northeast quadrant of his desk, with its inkwell, its pens, its pencils, its papers, its erasers.

■

In his mature years, Borges's humor seems to be less private and considerably more bookish than that of the pranks and hoaxes of his youth. International fame and the assured readership that goes with it probably had something to do with this change. What remains constant, however, is his determination to be funny, to be not merely clever but amusing as well. Indeed, more than half of the stories in *Doctor Brodie's Report* are seeded with this new kind of wry humor. Hence, it is the more pathetic tales that are tailored to be funny.

In "La señora mayor" [The Elder Lady], we have a senile poorer relative of "la señora de Figueroa," whom Borges places in a tiny flat over a button shop in the slummy part of town, and whose dotage is suddenly invaded by government and press when Clara spreads the word that she is about to turn one hundred. This poor dowager, like the Nelsons and the Gutres, has lost or forgotten everything except her family name, but she is nonetheless a "Daughter of the Revolution," the last surviving offspring of a colonel who, like so many of Borges's heroes, participated in the *defeat,* yes, "la *derrota* de Cancha Rayada" (a battle that Argentine history books euphemize as "el *desastre"* [disaster] de Cancha Rayada), as well as a more famous victory. Although, we are cattily told, this more famous "Argentine victory" is usually attributed to Simón Bolívar by Venezuelan historians, "always envious of our glories," Borges's old standby, "el observador *imparcial,* el historiador argentino, no se deja embaucar y sabe muy bien que los laureles corresponden al coronel" [the *impartial* observer, the Argentine historian, doesn't allow himself to be taken in and knows only too well that the laurels correspond to the coronel]. Faithful to the sick joke formula of cruelty, all the attention over her centenary does the old girl in, and she falls mute at the ceremony, dying in her sleep when it is all over. The press, however, steadfast in its clichés, celebrates

* Borges in fact visited the Tate, in 1948, accompanied by his flame of the moment, María Esther Vázquez, who reports "describing" Turner's paintings to him in *Borges, esplendor y derrota.*

"la casi milagrosa retentiva de la hija del prócer, que es 'archivo elocuente' de cien años de la historia argentina" [the almost miraculous memory of the hero's daughter, who is an "eloquent archive" of a century of Argentine history]. Eloquently mute, of course.

■

There are other similarly subdued and cruelly funny stories in this collection, such as "Guayaquil," which confronts two historians who are doubles for the heroes of South American Independence (San Martín and Simón Bolívar), one a pusillanimous Argentine and the other an intrepid Jewish immigrant named Zimmerman, "thrown out of his country by the Third Reich." His vita reveals that back in Germany in the 1930s he had authored an essay maintaining that governments should be neither visible nor emotional, which, we are told, prompted a decisive refutation by none other than Martin Heidegger of "What Does It Mean to Think" fame, the essay that preceded Borges's "Sect of the Phoenix" when it was first published in *Sur* back in 1952. Once more Borges shows himself to be up-to-date with developments in the intellectual world, for he uses this to take a humorous revisionist swipe at the then revered existentialist "who demonstrated, using photocopies of newspaper headlines, that the modern chief of state, far from being anonymous, is rather the protagonist, the choragus, *dancing David,* who acts out the drama of his people, aided by the pomp of stagecraft and resorting, without vacillation, to the hyperboles of the art of oratory. He also proved that the lineage of Zimmerman was Hebrew, not to say Jewish." So much for Heidegger, whose pro-Hitler activism was usually discreetly ignored. And too, so much for Hitler, incongruously cast as "el David danzante" of his people. As Borges told Charbonnier, "I enjoy slipping jokes into the text."

■

The final story, "Doctor Brodie's Report," which lends its title to the 1970 volume, resorts to an old technique, that of the "found manuscript," and is told in the stilted voice of a nineteenth-century Scottish Presbyterian missionary who repeats the voyage of Gulliver among the Yahoos and describes their peculiar practices with the enlightened eye of a post–Lévi Strauss cultural relativist: it's okay to eat your own excrement! These primitive Yahoos, who are strangely (or not so strangely) akin to Borges's ever-present bugbear—crude gauchos—adore a god "cuyo nombre es Estiércol" [whose name is Dung], and like Asterión they have a limited knowledge of arithmetic: "Four is the largest number in their arithmetic system. On their fingers they count thus: one, two, three, four, *many.* Infinity begins at the thumb."

These are recycled jokes. And these Yahoos (gauchos), our Presbyterian missionary narrator assures us, are not unlike "las tribus que merodean en las

inmediaciones de Buenos-Ayres" [the tribes who roam around the outskirts of Buenos-Ayres]. The mature Borges is going back to an earlier theme, making fun of his compatriots and the mythology of what it means to be an Argentine. Back in 1932, in an essay titled "Nuestras imposibilidades" [Our Impossibilities], he said that the Argentine was a "peculiar creature" who belittles the United States while "celebrating the fact that Buenos Aires has a higher homicide rate than Chicago," and who gorges himself at ritual dinners with organ meats: "que deglute en especiales noches de júbilo, porciones de aparato digestivo o evacuativo o genésico, en establecimientos de aparición reciente que se denominan parrillas" [one who gulps down on certain festive evenings, portions of the digestive or evacuative or reproductive tract in recently created establishments called steak houses]. In short, being a "real Argentine" means eating an enormous steak with grilled sweetbreads, tripe, and Rocky Mountain oysters. Another version of the "Mythological Founding of Buenos Aires."

■

The next major collection, *El libro de arena* [The Book of Sand] (1975), is equally irreverent, although now his penchant to be funny seems to rely more on jokes of the ready-made variety, and the narrative voice, although masked by a variety of pseudonyms, is ultimately that of Borges. In "Ulrica," a story that deals with casual sex, 1970s style, he works in a joke by Schopenhauer to pick up a Norwegian tourist over breakfast in a hotel dining room in York, England. They had previously engaged in small talk in the lobby: "Ulrica invited me to her table. She told me that she liked going out for walks alone. Recalling a joke of Schopenhauer's, I replied: 'So do I. The two of us could take a walk together.' " And so they do, before ultimately bedding down in another hotel, at the other end of town.

Another ready-made joke is inserted in "El congreso" [The Congress], a story in which a youthful Borges and some friends from Buenos Aires visit a remote ranch in the backlands of Uruguay. While out riding, one of the guests, a tenderfoot, falls off his horse and the Uruguayan foreman nastily snips: "El porteño sabe apearse muy bien" [the Argentine really knows how to dismount]. These jokes are based on aggression, on one-upmanship: a witty line for a pickup, an Uruguayan horseman putting down a tenderfoot from Buenos Aires.

In "The Congress," whose title is laden with sexual innuendo, there is another tryst, this one with a sexually liberated English woman whom the narrator meets in the British Museum while examining a book titled *The Analytical Language of John Wilkins,* an allusion of course to an early essay of his own from *Otras inquisiciones* (1952), which contains Borges's most

often cited humorous passage, ever since it was celebrated by Foucault as the "laugh-inducing" point of departure for *Les Mots et les Choses* (1966). This is the passage that holds up to ridicule the absurdity of classificatory systems, giving as an example "a certain Chinese encyclopedia" in which it is written that animals are divided into:

> (a) those belonging to the Emperor, (b) embalmed ones, (c) those that are trained, (d) sucklings, (e) mermaids, (f) fabulous ones, (g) stray dogs, (h) those included in the present classification, (i) those that tremble, (j) innumerable ones, (k) those drawn with a very fine camel's hair brush, (l) others, (m) those that have just broken a vase, *(n)* those that from a distance look like flies.

This of course takes us to the *nth* degree in a neat alphabetical sequence, an illustrated illusion of the order of disorder.

In "The Congress," the Borges-like narrator is an appointed congressman in a hypothetical World Congress conjured up by a self-made Uruguayan millionaire—a forerunner of Ross Perot—to assuage his defeat in a local election. One of his salaried congressmen persuades the feisty tycoon that they need a Library of Congress (just like the one in Washington) and the sponsor dutifully purchases all the books recommended by the congressman's friend, a fellow called Nierenstein, who happens to work in a used book shop. Nierenstein at first provides a select variety of reference works, including, to be sure, "a certain Chinese encyclopedia," and finding no opposition to his broad acquisition policy, greedily moves on to "the indiscriminate purchase of bound volumes of the daily press, of thirty-four hundred copies of *Don Quixote* in various editions, of the complete works of General Mitre, of Ph.D. theses, of old account books, of bulletins and of theater programs," a "chaotic enumeration" whose ordering idea is the Library of Congress as a true depository, a random collection of uncatalogable junk.

Erudite readers have preferred to view these stories in an erudite context, and echoes of the "Library of Babel" and the secret society of "Tlön" (but not yet their humor) have been registered in "The Congress." Following a clue in the epigraph, "Ulrica," situated in York, has been read in the context of an episode in the Völsung Saga where a sword is laid between the two lovers. In fact, there's even a little book on the subject (Osvaldo Sabino, *Borges, una imagen del amor y de la muerte* [1987]), ingeniously making this witty account of a one-night stand into reality.

Real personages sometimes do become fictional through Borges's stories, and a woman called Ulrica was first mentioned in "La otra muerte" [The Other Death] as someone who made a "supernatural" conjecture on the motives for one of the characters in that tale of jealousy and revenge included in *The Aleph*. Bioy Casares, in his *Memorias* (1994), recalls Borges invoking

this good friend Ulrica to play a joke on the imperious Victoria Ocampo, who wanted to show off her contacts with the power elite on an agonizing trip they all made to New York together in 1949:

> Before leaving New York, we offended Victoria once again. When she announced that she would introduce us to some writers from the *Partisan Review* we were obliged to tell her that Ulrica had already introduced us to them. Because of her friendship with Borges, Ulrica was our agent in the United States. It seemed quite natural to us that in a country which considered South American writers to be somehow *unreal,* we should have a *fictitious agent.*

She may be a "fictitious agent," but she is a real person, alive and well today in Mallorca. In 1949, after returning from New York, Borges dedicated one of the stories in *The Aleph* ("Historia del guerrero y de la cautiva") to this selfsame Ulrike von Kühlmann, then a Marlene Dietrich look-alike, born in Bavaria in 1911.*

■

In "Utopía de un hombre que está cansado" [Utopia of a Tired Man], the autobiographical motif is again present, although as usual in the context of a self-parody—here, in the form of a "back-to-the-future" fantasy. Crossing the "pampas" of Oklahoma, the Borges-like narrator encounters a violent rainstorm and seeks refuge in a desolate house. At first there is some difficulty in communicating with its sole inhabitant. After many tries in various languages they are finally able to converse in Latin. Borges then identifies himself as a writer of fantastic stories. At this point, his semiliterate interlocutor, a gigantic Nordic type (a post-twentieth-century version of the troglodytes in "The Immortal") graciously recalls having read two fantastic books: "the travels of a certain Captain Gulliver, *which many people take to be true,* and the *Summa Theologiae,*" thus putting Swift and Saint Thomas in the same vexing category of authors of fantasy fiction. The working principle, although subdued, is still forced incongruity.

The utopia of this story projects us into a future that is not entirely ignorant of its past; and in this world where Latin has been restored as the lingua franca, people like the host are vigilant that it not "degenerate once again into French, Lemosi, or Papiamento," driving home the point of how arbitrarily relative such things really are. This conversation permits Borges to work in some amusing reflections on the strange twentieth-century world he has left behind, a Gutenberg galaxy governed by print, a world enslaved to the daily news:

* Vázquez reproduces a stunning 1950s photo of her in *Borges, esplendor y derrota.*

In my strange past, the superstition prevailed that every day, between evening and morning, certain acts occur which it is shameful to ignore. The planet was populated by collective ghosts, Canada, Brazil, the *Swiss* Congo, and the Common Market. Almost no one knew anything of the prior history of these platonic entities, but rather the most minute details of the most recent congress of pedagogues, the imminent breakdown of diplomatic relations and the statements sent back and forth by their presidents . . . All of this was read to be forgotten, for a few hours later they were blotted out by other trivialities.

In this world, politicians are a special breed, "a kind of cripple whom it was necessary to cart around in long, noisy vehicles, ringed by motorcyclists and awaited by eager photographers." Recycling a joke recounted in many Borges interviews, the narrator simplistically relates that his mother observed that these dignitaries must be cripples because in the photographs it is clear that "their feet had been cut off." This same ingenuous view of the world that harks back to Swift and the travel literature of the enlightenment, permits a jab at advertising with the observation that this was a time and place "where people judged merchandise to be good because its manufacturers claimed so over and over again."

When the storm abates and Borges proceeds to go on his way, exiting the time warp ("first turn to the left," the standard formula to make one's way through a labyrinth), he notices a strange tower crowned by a cupola. His man from the future tells him it's a monument, called the crematorium: "adentro está la cámara letal; dicen que la inventó un *filántropo* cuyo nombre, creo, era Adolfo Hitler" [inside there is the lethal chamber; they say it was invented by a *philanthropist* whose name, I believe, was Adolf Hitler]. In this typically Borgesian cross-eyed view of the world, everything is relative, depending on where we view things from. Humor is also relative. Indeed, some theorists say that one must be in a laughing mood in order to be amused by a joke. While others, like Freud and Bakhtin, acknowledge that some people are never disposed to laugh. And of course, calling Hitler a philanthropist is not funny in and of itself. It becomes so only in the context of the speaker's imperfect knowledge of a remote past that is our yesterday where his ingenuous remark becomes an incongruity for us readers of today—something like the earlier reference to the "Swiss" Congo.

Incongruity is at the heart of humor. For it to work, it must be perceived. In these pages I have tried to highlight some of the devices Borges uses to render the imbedded incongruities of his writing perceptible, the ambiguators that make his puns, parodies, paradoxes, paralogisms, and practical jokes evident to the reader, switching us from the serious to the silly through

caricature and contradiction, through ridicule, riposte, and the *reductio ad absurdum.* As he says, he did all this "just for the fun of it," and it is in this same spirit that I have attempted to share some of the fun that I have had in reading him. Having made my point—that a significant part of what makes Borges fun is that he is funny, and that he is funny precisely because he is so serious—it is time to conclude.

■

Borges died in Geneva in 1986, dictating articles, poems, and stories almost to the very end. Since it would be sad to close a book on what makes Borges fun with his death, and counterproductive to belabor the fact that he is funny, exhausting the reader's patience in the process, in this closing chapter I have dealt only with his two major collections after returning to narrative in 1970. As we have seen, a good half of these later fictions are out-and-out humorous, thus continuing the tradition of his previous collections, a tradition that he maintained throughout his career. As always, even in those stories that are not overtly funny, Borges continued to inject humor as a kind of subtle reminder to the reader that what is being read is an artifice, a fiction.

And so it is here that I will abruptly conclude with a quote culled from Borges's friend and idol, Macedonio Fernández, closing his 1940 *Essay on the Theory of Humor*: "And so here I abruptly conclude, so that no one can say about me: 'that he spent his whole life perfecting his theory of humor and shouldn't be faulted for not having had the time to tell a few jokes that merit being remembered.'"

AFTERWORD

To say that life is a novel is as adventurous as saying that it is a
colophon or an acrostic.

Borges, 1945

As I'm readying this book for the press, I think of other ways that it
might have been done. It could have been cast as an exposition of Borges's
theory (or theories) of humor, but he was not very consistent, and save for his
1933 essay on "The Art of Verbal Abuse" he never really devoted much space
in print to a systematic formulation of what makes humor work.

Another approach might have been chronological, showing that Borges
was a humorist from beginning to end, starting with his very first article,
published in French from his family's wartime refuge in Geneva, where he
takes a poke at the latest book of Azorín, *Entre España y Francia,* putting it
down as a bore, "le livre le plus *calme* qu'ait inspiré la *guerre"* [the most
tranquil work inspired by the *War*] (*La Feuille,* August 20, 1919). Such
a strategy would, or could, conveniently end with one of his last writings,
almost any of the poems in *Los conjurados* [The Conspirers (1985)], where
he takes a wry view of history. In the opening poem, for example, "Cristo en
la cruz" [Christ on the Cross], Borges imagines a dying man who doesn't at
all resemble his holy picture image. Neither idealized Greek nor Roman, he
is rather "áspero y judío" [rough and Jewish]. Writhing under his crown of
thorns, he yearns to quit this life, having no idea about the absurd chain of
events that is to follow his death:

> Cristo en la cruz. Desordenadamente
> piensa en el reino que tal vez lo espera,
> piensa en una mujer que no fue suya.
> No le está dado ver la teología,
> la indescifrable Trinidad, los gnósticos,
> las catedrales, la navaja de Occam,
> la púrpura, la mitra, la liturgia,
> la conversión de Guthrum por la espada,

la Inquisición, la sangre de los mártires,
las atroces Cruzadas, Juana de Arco,
el Vaticano que bendice ejércitos . . .

[Christ on the Cross. Confusedly / he thinks of the kingdom that
perhaps awaits him, / he thinks of a woman who was not his wife.
/ It is not given to him to foresee theology, / the undecipherable
Trinity, the Gnostics, / the cathedrals, the Razor of Okham, /
the purple vestments, the miter, the liturgy, / the conversion of
Guthrum by the sword, / the Inquisition, the blood of the martyrs,
/ the atrocious Crusades, Joan of Arc, / the Vatican that blesses
Armies . . .]

This chaotic enumeration makes Christianity into a tragicomedy.

Although thematics and chronology do offer nice structuring frames, the
fact is that we now live in an age of complexity theory, and the straight-line
determinism of metanarratives of this sort are suspect. For this reason, I have
taken a somewhat more chaotic approach, jumping back and forth from the
cusp of reason between Borges's unexpected boutades and his more calculated
levities, pointing out along the way some of the mechanisms at work in what
makes them funny.

Although humor is a constant presence in his writings and conversa-
tions, it is both fruitless and impossible to attempt to impose any pattern of
consistency on what, for Borges, was mostly a whim: the caprice to inject
into even the most serious of his disquisitions a bit of comedy. Borges was
not a Woody Allen, nor an Aristotle. Neither a born jokester nor a systematic
theorist, he was rather a bookish man of our time who thought seriously about
the absurdity of the world in which we live, but who refused to take it, or
himself, seriously. Precisely for this reason, his comic side erupts often, and
often unexpectedly, in even his densest writings. My purpose, in these pages,
has been to highlight this facet, to help his readers see him for what he was,
a serious writer with a sharp sense of humor, someone who, in 1960, with
the onset of fame, published an autobiographical vignette, titled "Borges and
Myself," wryly looking upon himself as the "other":

It's to the other man, to Borges, that things happen. I walk along
the street of Buenos Aires, stopping now and then—perhaps
out of habit—to look at the arch of an old entranceway or a
grillwork gate; of Borges I get news through the mail and glimpse
his name among a committee of professors or in a dictionary
of biography. I have a taste for hourglasses, maps, eighteenth-
century typography, the roots of words, the smell of coffee, and
Stevenson's prose; the other man shares these likes, but in a

showy way that turns them into stagy mannerisms. It would be an exaggeration to say that we are on bad terms; I live, I let myself live, so that Borges can weave his tales and poems, and those tales and poems are my justification. It is not hard for me to admit that he has managed to write a few worthwhile pages, but these pages cannot save me, perhaps because what is good no longer belongs to anyone—not even the other man—but rather to speech or tradition. In any case, I am fated to become lost once and for all, and only some moment of myself will survive in the other man. Little by little, I have been surrendering everything to him, even though I have evidence of his stubborn habit of falsification and exaggeration. Spinoza held that all things try to keep on being themselves; a stone wants to be a stone and the tiger, a tiger. I shall remain in Borges, not in myself (if it is so that I am someone), but I recognize myself less in his books than in those of others or than in the laborious strumming of a guitar. Years ago, I tried ridding myself of him and I went from myths of the outlying slums of the city to games with time and infinity, but those games are Borges's now and I will have to turn to other things. And so, my life is a running away, and I lose everything and everything is left to oblivion or to the other man.

Which of us is writing this page I don't know. (El hacedor)

There is always more than one dimension to a Borges text. We now know that this self-reflective essay, first published in *El hacedor* in 1960, was actually begun in 1940, long before anyone, save the intimate coterie of *Sur*, knew who Borges was. The original copybook for "Tlön, Uqbar, Orbis Tertius"—that upside-down parody of our own world—contains a half-page of scribblings dealing with the concept of two Borgeses, the seed of "Borges y Yo."* Until recently, only one side of Borges has received critical attention; it is now time to recognize the other, the comic side of Borges.

* Donald Yates, one of Borges's earliest biographers and translators, had access to this copybook and described its contents in "Behind 'Borges and I.' " *Modern Fiction Studies* 19.3 (1973).

NOTES

1. Walter Gropius (1883–1969), as an unwilling spectator to another kind of total action, the histrionics of Hitler, curtained these plans, and his *Totaltheater* survives as one of architecture's unbuilt wonders. A man of limitless ideas, he emigrated to the United States, and while dean of the architectural school at Harvard, one of his "patents" finally made him a fortune: prefabricated housing by the General Panel Corporation, of which he was vice president.

2. Néstor Ibarra (b. 1908) translated "Acercamiento de Almotásim," a pseudoreview of a nonexistent novel, first published in 1936 in the end pages of *Historia de la eternidad,* as "L'Approche de caché" for the April 1939 issue of *Mesures.* Under the guise of a "note by the translator," he and Borges added to the hoax a brief apocryphal resumé of the novel's fortune in France—an episode that is more fully discussed in the next chapter. Here, I should like to add that Ibarra had a unique affinity for Borges's subtle use of humor; when he later translated the collected poetry, *Oeuvre Poétique* (1970), Borges was moved to remark that "Ibarra ne se méprend pas sur les connotations d'ironie." Indeed, in *Borges et Borges* (1969), an expanded version of a clever interview with himself originally prepared for the Borges Cahier of *L'Herne* (1964), Ibarra is not only the first but also the most astute in his consideration of the importance of humor in Borges's writings. He was followed by Louis Andrew Murillo (*The Cyclical Night: Irony in James Joyce and Jorge Luis Borges* [1968]) and Father John Dominic Crossan, S. D. (*Raid on the Articulate: Comic Eschatology in Jesus and Borges* [1976]), and of course some individual studies on major themes that tangentially acknowledge the humorous element of one piece or another.

3. Theatrical representation was of course prohibited by the iconoclastic strictures of Islam, and although some theater texts of classical antiquity were known and had their readers during the middle ages, they went unrepresented in Europe until the end of the fifteenth century. Indeed, when Filarete (1400–69), an Italian renaissance architect and city planner, takes ancient Roman cities as a model to lay out for Count Sforza his ideal city of Sforzinda, he routinely includes a theater structure, although confessing that he "knows little about theaters, nor what they were used for." Not until a full century later, following the stagings of tragedies

and comedies of Plautus, Terence and Seneca, does Palladio design and construct the first renaissance theater in Vicenza (1579).

4. Bishop George Berkeley (1685–1753), an Anglo-Irish philosopher, author of *An Essay Towards a New Theory of Vision* (1709), who held that things exist only in the mind at the moment of being perceived ("esse est percipi"). This eminently logical empiricist notion that nothing exists unless it is perceived by the senses and only as long as it is so perceived provided Borges with numerous occasions for amusement, as for example in "Amanecer," a 1923 poem that has the speaker returning home in the wee hours of the morning after a night on the town. The streets are deserted, but thanks to his late-night vigil, Buenos Aires wasn't wiped out of mind: "el mundo se ha salvado . . . y con algún remordimiento / de mi complicidad en la resurrección cotidiana / solicito mi casa."

5. An allusion to Góngora's Sonnet 45, "Al auto de la fe que se celebró en Granada" (1585), whose closing tercet refers to "five victims in effigy, only one in person" [cinco en estatua, sólo uno en persona, / encomendados justamente al fuego, / fueron al auto de la fe en Granada]. An *auto-da-fé* with only one heretic to be burned would be as disappointing to the public as a modern-day bullfight with only one bull.

6. During the Middle Ages, the ruins of abandoned amphitheaters—such as those of Arles, which Borges visited on his second trip to Europe in 1923—were used as holding pens for cattle, which grazed in the sodded over grandstands. Thus, the chirping of a bird or the whinny of a horse could bring to life the magnificent acoustics of these monumental structures created for grandiose theatrical events. An ephemeral circumstance of historical change is ironically highlighted in these closing lines from "Tlön," how things there (here) are changed and transformed over time.

7. The handwritten letter, in Borges's minuscule script, is partially reproduced in facsimile in the album of memorabilia compiled by his nephew Miguel de Torre, *Borges: fotografías y manuscritos* (1987).

8. Even Jean-Pierre Bernès, the editor of the Gallimard edition of Borges's complete works, falls into the trap, qualifying this essay on Unamuno as "un èloge appuyé" [sustained praise] and adding by way of *mis*confirmation a statement by Borges culled from his 1967 interview with Milleret: "Á cette époque je lisais Unamuno, qui m'a fait beaucoup de mal aussi; j'ai tâché d'imiter sa prose . . . , en faisant exprès des phrases maladroites, en feignant d'être maladroit, ce qui n'est que trop facile, hélas." In other words, it's all too easy to achieve such clumsiness. Some "praise" indeed!

9. A role that at the time of writing this story (1941) had been assumed by the United States. The "Yellow Peril" was a favorite subject of the Hearst newspapers and had created an attitude regarding the racial inferiority of Asian peoples that was widely shared in the West. So much so that a recent issue of *Time* magazine (August 7, 1995) dedicated to the fiftieth anniversary of the "War of the Worlds" recalls that General Douglas MacArthur was convinced that "white mercenaries had flown the Japanese planes" that destroyed his fighters on the ground in the Philippines. In this context, I am compelled to draw attention to a minor textual detail. Borges's

original text, explaining the motivation of Yu Tsun, reads: "lo hice porque yo sentía que el Jefe *tenía en poco* a los de mi raza," which literally translates as "gave little importance" or "had no respect for my race." The typesetters for subsequent editions, exercising a racially subtle kind of "political correctness" *avant la lettre* changed this to read, "temía un poco," which has variously been translated as "feared" (Donald Yates for *Labyrinths* [1964]) and "had some fear" (Temple and Todd for *Ficciones* [1962]). In *Obras completas* (1974), the correct (although not politically correct) "tenía en poco" was miraculously restored.

10. At about the same time they semiclandestinely cooked up three sporadic issues of a humorous magazine called *Destiempo* [Out of Phase, or Untimely], whose legal registry was the street address of Bioy's Buenos Aires apartment and whose director was listed as one Ernesto Pissavini, actually the janitor of the building. This meeting of minds soon generated a voluminous *Antología de la literatura fantástica* (1940), prepared with the aid of Bioy's wife, Sylvina Ocampo, and published by her sister Victoria in *Sur*. In 1942, under the pseudonym of Bustos Domecq, a composite name drawn by Bioy and Borges from remote branches of their family trees, they published yet another volume in *Sur*, a hoax called *Seis problemas para Don Isidro Parodi* [Six Problems for Isidro Parodi]. Written as a parody of the implacable logic of detective fiction, these "problems" are cerebrally resolved by an armchair detective from the confines of his jail cell. The hoax was not revealed until years later when they resurrected the pseudonym for a volume of *Crónicas de Bustos Domecq* (1967), feigned critical essays lampooning a wide range of then trendy topics in the arts, ranging from nouvelle cuisine to the modern movement in architecture and the French *Nouveau Roman*.

Borges's collaborative writing with Bioy (and others) has been collected in a multivolume set, *Obras completas en colaboración* (1981). With Bioy, Borges could easily make jokes; with others it was difficult. He recounted to Milleret his frustrating experience with Alicia Jurado in a projected book on Buddhism: "We could never reach an agreement, because she wanted to convert people to Buddhism; if I found something amusing, she'd say that this would alienate people; she wanted to weed out everything that makes it exotic for we Westerners in order to make a kind of Buddhist catechism, while I wanted to highlight its strangeness." Although the successful collaboration with Bioy is an important facet of Borges's work, and certainly contributes to what makes him fun, its range and variety merits a study apart.

BIBLIOGRAPHY

Excellent annotated bibliographies exist on Borges and on humor studies: David William Foster, *Jorge Luis Borges: An Annotated Primary and Secondary Bibliography* (New York: Garland, 1984); and Don L. F. Nilsen, *Humor Scholarship: A Research Bibliography* (Westport, Conn.: Greenwood, 1993). In neither of these, however, do we find much on Borges *and* humor.

For the convenience of the reader, I list below those works by Borges to which I have made specific reference, followed by a guide to the availability of Borges in English translation and a listing of frequently cited secondary sources.

WORKS IN SPANISH (FIRST EDITIONS)

Poetry
Fervor de Buenos Aires. Buenos Aires: privately printed, 1923.
Luna de enfrente. Buenos Aires: Proa, 1925.
Cuaderno San Martín. Buenos Aires: Proa, 1929.
El otro, el mismo. Buenos Aires: Emecé, 1964.
Elogio de la sombra. Buenos Aires: Emecé, 1969.
El oro de los tigres. Buenos Aires: Emecé, 1972.
Los conjurados. Madrid: Alianza, 1985.

Essay
Inquisiciones. Buenos Aires: Proa, 1925.
"Prólogo" to *La calle de la tarde*, by Norah Lange. Buenos Aires: Sarnet, 1925.
El tamaño de mi esperanza. Buenos Aires: Proa, 1926.
El idioma de los argentinos. Buenos Aires: Gleizer, 1928.
Evaristo Carriego. Buenos Aires: Gleizer, 1930.
Discusión. Buenos Aires: Gleizer, 1932.
Historia de la eternidad. Buenos Aires: Viau y Zona, 1936.
Otras inquisiciones 1937–1952. Buenos Aires: Sur, 1952.

Fiction
Historia universal de la infamia. Buenos Aires: Megáfono, 1935.
El jardín de senderos que se bifurcan. Buenos Aires: Sur, 1942.

Bibliography

Ficciones 1935–1944. Buenos Aires: Sur, 1944; second edition, amplified, Buenos Aires: Emecé, 1956.

El Aleph. Buenos Aires: Losada, 1949; second edition, amplified, Buenos Aires, Losada, 1952.

El informe de Brodie. Buenos Aires: Emecé, 1970.

El libro de arena. Buenos Aires: Emecé, 1975.

WORKS IN ENGLISH

Poetry

Selected Poems, 1923–1967. Translated by Norman Thomas di Giovanni. New York: Dell, 1973.

In Praise of Darkness. Translated by Norman Thomas di Giovanni. New York: Dutton, 1974.

The Gold of the Tigers. Translated by Alastair Reid. New York: Dutton, 1977.

Essay

Other Inquisitions. Translated by Ruth L. C. Simms Austin: University of Texas Press, 1964.

Evaristo Carriego. Translated by Norman Thomas di Giovanni. New York: Dutton, 1984.

Fiction

Ficciones. Translated by Anthony Kerrigan et al. New York: Grove, 1962.

Doctor Brodie's Report. Translated by Norman Thomas de Giovanni. New York: Dutton, 1971.

A Universal History of Infamy. Translated by Norman Thomas di Giovanni. New York: Dutton, 1972.

The Book of Sand. Translated by Norman Thomas de Giovanni. New York: Dutton, 1977.

The Aleph and Other Stories. Translated by Norman Thomas de Giovanni. New York: Dutton, 1978.

Collected Fictions. Translated by Andrew Hurley. New York: Viking Penguin, 1998.

Miscellaneous

Labyrinths: Selected Stories and Other Writings. Edited by Donald Yates and James Irby. New York: New Directions, 1962.

Dreamtigers. Translation of *El hacedor*, 1960, by Mildred Boyer and Harold Morland. Austin: University of Texas, 1964.

A Personal Anthology. Edited by Anthony Kerrigan. New York: Grove, 1967.

Borges: A Reader. Edited by Emir Rodríguez Monegal and Alastair Reid. New York: Dutton, 1981.

SECONDARY SOURCES

Burgin, Richard. *Conversations with Jorge Luis Borges*. New York: Holt, Rinehart & Winston, 1969.

Carrizo, Antonio. *Borges el memorioso*. Mexico: Fondo de Cultura Económica, 1982.

Charbonnier, Georges. *Entretiens avec Jorge Luis Borges*. Paris: Gallimard, 1967.

Christ, Ronald. *The Narrow Act: Borges' Act of Allusion*. New York: New York University Press, 1969.

Eastman, Max. *Enjoyment of Laughter*. New York: Simon & Schuster, 1936.

Grau, Cristina. *Borges y la arquitectura*. Madrid: Cátedra, 1989.

Irby, James. "Encuentro con Borges." *Revista de la Universidad de México*, June 1962.

Koestler, Arthur. *The Act of Creation*. New York: Dell, 1964.

de Milleret, Jean. *Entretiens avec Jorge Luis Borges*. Paris: Belford, 1967.

Raskin, Viktor. *Semantic Mechanisms of Humor*. Boston: Kluwer, 1985.

Reverdy, Pierre. "l'Image." *Nord-Sud* (Paris), March 1918.

Schopenhauer, Arthur. *The World as Will and Idea*. 1819. Translated by Haldane & Kemp. London: Paul, Trench & Trübner, 1907.

Shaw, Donald. *Borges' Narrative Strategy*. Liverpool: Melksham, 1992.

de Torre, Miguel. *Borges: fotografías y manuscritos*. Buenos Aires: Renglón, 1987.

Vázquez, María Esther. *Borges, esplendor y derrota*. Barcelona: Tusquet, 1996.

INDEX

Index

Books in the Humor in Life and Letters Series